Jane Brocket has an MA in Victorian Art and Literature from Royal Holloway, University of London. In 2005 she created her successful and popular yarnstorm blog to write about domesticity, textiles, design, art and literature. This led to her first book, the best-selling *The Gentle Art of Domesticity*. Since then, she has written a further seventeen books on a variety of creative and cultural themes. *How to Look at Stained Glass* is the culmination of years of visiting churches and marvelling at the quality and variety of English stained glass. Jane lives in Berkshire with her husband and three children.

# HOW TO LOOK AT
# STAINED GLASS

### A Guide to the Church Windows of England

JANE BROCKET

HERBERT PRESS

HERBERT PRESS
Bloomsbury Publishing Plc
50 Bedford Square, London, WC1B 3DP, UK
29 Earlsfort Terrace, Dublin 2, Ireland

BLOOMSBURY, HERBERT PRESS and the Herbert Press logo are trademarks of
Bloomsbury Publishing Plc

First published in Great Britain in 2018
This edition published in 2023

A catalogue record for this book is available from the British Library
Library of Congress Cataloguing-in-Publication data has been applied for

Every attempt has been made to gain permission for the use of the images in this book.
Any omissions will be rectified in future editions

References to websites were correct at the time of writing

ISBN: PB: 978-1-78994-233-0; eBook: 978-1-83860-869-9; ePDF: 978-1-83860-870-5

2 4 6 8 10 9 7 5 3 1

Text design and typesetting by Tetragon, London
Printed and bound by CPI Group (UK) Ltd, Croydon CR0 4YY

To find out more about our authors and books visit www.bloomsbury.com and sign
up for our newsletters

*For Simon*

# CONTENTS

*Acknowledgements*                                    ix

Introduction                                           I
Exploring a Church                                     5
How a Stained-Glass Window Is Made                     8
A–Z of Stained Glass                                  II
50 Places to See Stained Glass                        210

*Further Reading*                                     212
*List of Images*                                      215
*Index of Churches*                                   223

# ACKNOWLEDGEMENTS

I have been extremely fortunate to have Philippa Brewster as my editor, and I would like to express my gratitude for her enthusiasm for the project and her thoughtful questions. I am grateful to David Campbell and the team at I.B.Tauris, and to Alex Billington of Tetragon, who have all been very helpful and organised. Sarah Terry copy-edited the book with superb attention to detail, and I am indebted to Alex Middleton for his careful proofreading.

My agent, Jane Graham Maw of Graham Maw Christie, has been unfailingly supportive, and once again I thank her for all she does on my behalf. I would also like to thank Professor Fran Lloyd of Kingston University for her suggestion of a survey of English church stained glass, which created the groundwork for the book and yielded so many good finds. Susie Harries was generous with information and insights, as was Henry Hinchcliffe, whose book on Harry Stammers came out at just the right time. At West Dean College, Sasha Ward taught me how to make stained glass; she has also shared her vast knowledge of the subject, both technical and artistic. Friends have helped by means of conversations about stained glass and its themes, and I thank Nicola and Chris Beauman, Dr Chloë Evans, and Neil Philip and Emma Bradford.

The book could not have been written without access to innumerable churches, and I am immensely grateful to all those whose efforts and

dedication keep them open, and to the many volunteers and members of the clergy who kindly agreed to open a church or chapel for me.

I count myself very lucky to have the support of Tom, Zoë, Alice and Phoebe. As ever, my deepest gratitude goes to Simon, who has been the perfect travelling companion on trips to look at stained glass, and who makes it all possible.

# INTRODUCTION

It doesn't require a lot to enjoy and appreciate stained glass: a pair of eyes is all you need to get started. This is good to know, because there is a huge amount of bold and beautiful stained glass waiting to be enjoyed and appreciated by anyone who is willing to have a good look. In return, you will discover one of the world's most fascinating but underrated arts, fabulous examples of which pop up everywhere from remote villages to huge cities, from residential suburbs to busy town centres, where they are often surprisingly easy to access and usually free to view.

Stained glass is a historically important means of creative – as well as religious – expression, a unique mix of art, craft and design, a material which is fragile and breakable yet can withstand the elements, last hundreds of years, and be seen by generation after generation. Although it offers vast possibilities for telling stories and stirring emotions, it has acquired a rather fusty, dowdy, churchy, old-fashioned image. Nevertheless, for centuries it has attracted, and continues to attract, many superb artists, designers and craftsmen who have taken up the challenge of designing with light and colour and producing awe-inspiring windows. However, because so few people nowadays are familiar with the references, symbolism and stories in many windows, I think it is time to look at stained glass in a new and different way. My approach is thematic: by exploring a wide range of subjects appearing in windows from the medieval to the modern era, I reveal,

explain and connect techniques, iconography and narratives. I begin with the idea that our churches and cathedrals are amazing galleries with priceless collections of stained glass. I look at it as a public art form which can be enjoyed by everyone, and this guide is written to appeal to every church visitor and admirer of stained glass. My focus is not on the 'best', but on the most intriguing, interesting, colourful, fascinating, entertaining and visually stimulating examples of the art form.

My own fascination with stained glass began with one huge window and one very small pair of shoes. These two stained-glass windows completely altered my perceptions.

In Coventry Cathedral I saw – or, more accurately, experienced – the Baptistry Window (1962). At 22 metres high and 18 metres wide, and composed of almost 200 individual, abstract lights designed by John Piper and made by Patrick Reyntiens, it is enormous. Because of the cathedral's size, there is plenty of room to stand back and admire the whole window. Standing there, I understood for the first time ever the effect that stained glass could have on a viewer. The window was utterly alive, glowing and changing every moment according to the light outside. It made me realise that the artists work not only with glass and colour, paint and lead, but also with light itself, and in this case Piper and Reyntiens had used light to create a glorious, uplifting and magical effect.

But even when I subsequently began to take a closer look at stained glass, I still found it difficult to appreciate, decode and understand the contents of many windows. That is, until I wandered into St John, Hoxton, London, and found at eye level a lovely 1950s Children of All Nations window (maker unknown) which looked just like an illustration from a storybook I might have read as a child. What struck me were the shoes that the little English girl is wearing: they are Mary Janes, the classic, sensible, Start-rite shoes that lots of girls wore and continue to wear to this day. I was astounded that such an unremarkable, ordinary detail could be included in what I had always considered an exclusively ecclesiastical art, one which I had

thought of as being completely religious, historical and a long way above earthly things.

From then on, I began to look at stained glass with new eyes. Instead of puzzling over Bible stories and references and trying to read a window as a whole, I started to look for common details: patterns, borders, faces, flowers, gestures, fabrics, animals, beards, dragons and wings. In doing so I discovered all sorts of wonderful things: brush marks, makers' marks, and a surprising amount of both horror and humour – all the things that make stained glass so appealing on a human level.

I also basked in the wonderfully dynamic and ephemeral effects of this static art. I stopped worrying about interpretation and analysis, and instead began to observe the little pools of colour on the floor and stonework, noting the way the glass changed and bathing in the brilliance of it all. And this is how earlier generations of worshippers would have seen stained glass: without modern-day binoculars or telephoto lenses, the details of the great medieval windows, placed high up in churches and cathedrals, would have melded into abstraction.

I discovered that 'church crawling', as John Betjeman termed it, is a vastly enjoyable pastime. One of the great joys of looking at stained glass is that excellent windows can be found in the most unexpected places (cathedrals and grand churches do not always have the monopoly), where you might also find an interesting churchyard, a good cup of tea, and perhaps a slice of cake and somewhere to browse second-hand books. It's just as rewarding to set off with a plan as it is to drop into churches on the off-chance of finding something stunning or surprising, and my advice is to always take advantage of open church doors; you never know what might be inside: lovely flowers, foliage and faces, fabulous fabrics, fragments or funny little creatures, carefully printed lettering, a fine pair of shoes. Or the glass on offer may simply inspire in the viewer awe, wonder and a connection with generations of mortals who have stood and looked at the very same window in the very same spot.

My advice is to get out, have a good look, and enjoy our amazing stained-glass heritage.

NOTE: Throughout the book I give specific examples of church windows and have made efforts to cover as wide a geographical spread as possible. However, as I was living in the south-east of England while writing the book, there is perhaps a preponderance of windows in the more southern and central parts of the country. Happily, though, this book is just a starting point; with thousands of great stained-glass windows throughout England to choose from, it is highly likely that you will find equally fascinating examples of particular themes or motifs wherever you happen to be in the country.

# EXPLORING A CHURCH

If you're a new aficionado of stained glass, or have merely had a casual interest in it until now, you might like to find a way to make the most of future church visits. I have developed an approach which I find useful when trying to track down the best windows, and I hope you find it helpful too.

If I am travelling somewhere specific or have a particular area in mind, I identify potential churches and specific windows in advance. For this, I use Pevsner's Buildings of England guides and other sources such as Simon Jenkins' *England's Thousand Best Churches*, friends' recommendations and my own research (see the Further Reading section for publications which might be helpful in compiling your own list of possible and must-see churches). I use churches' own websites and www.achurchnearyou.com, run by the Church of England, for opening times and arrangements, although the latter is not always comprehensive and up to date. If in doubt, I phone or email a church directly to double-check details or make a request to visit. I have found the majority of vicars, church-wardens and volunteers extremely helpful and welcoming. I then create an itinerary accordingly, and include a few other local churches in case the ones I want turn out to be closed when I get there, as sometimes happens. I bring any background information I have with me so that I can refer to it *in situ*.

It is also good to take pot luck and walk into any church which happens to be open as you pass, on the off-chance that it will lead to serendipitous discoveries. I would recommend always going inside a church you particularly wish to see if you find it open. You don't know if it will be closed next time you're in the vicinity, or even if the church will still be functioning as a church.

When I arrive at a church, I sometimes familiarise myself with the layout by walking round the exterior – this can be particularly worthwhile when a church has *dalle de verre* windows – but mostly I just go straight in because I'm so keen to see what's inside. I avoid switching on any lights because electric light reflects off stained glass and makes it difficult to see the detail. Windows are always much better viewed with natural light coming through from behind, and even on dull, overcast days there is usually enough to make them come alive.

Churches are oriented so that the altar is at the east end and the porch or door through which a visitor enters is usually on the south side, although the entrance is sometimes on the west or north side. Even if the church is not exactly aligned in this way, its plan will adhere to traditional liturgical orientation. On arrival, it pays to work out which compass points relate to the different parts of the church. This will help you understand the official Corpus Vitrearum Medii Aevi (CVMA) format for numbering stained-glass windows, which is often used by official bodies and websites to describe the position of a window within a church. I have also found it useful to know the names of the different parts of the church where there tend to be windows: nave, aisle, baptistery, triforium, clerestory, chapel, transept, chancel, apse and ambulatory.

Once inside, I check to see if there is a church guide, but I don't read this before looking at the windows; I like to look with an open mind. Instead I go clockwise around the church from my starting point, assessing the windows, their content, quality and highlights. I then go round again, this time reading background information. If photography is permitted, I take photos. I am very aware that each visit to a different church may be the only one I make, so I make every effort to imprint the place and its windows on my mind while I am there.

When it comes to actually looking at a stained-glass window, it might be a good idea to decide in advance the approach you want to take. What usually works well for me is a relaxed attitude – sometimes I am delighted with what I see, sometimes amused, sometimes perplexed, but (I hope) always open-minded. I know that I am not going to find a stunning master-piece in every church. Nor do I expect all stained glass within a locally or nationally important building to be worthy of display there. On the other hand, I also know that I should never make assumptions about what I might find before going inside.

My approach is not to criticise poor glass – or any glass – just because it doesn't happen to fit in with my taste, my views on what constitutes good design and art, or my personal beliefs. Instead I let windows educate me. It is very easy to dismiss and denigrate poorer examples, but much harder – and far more rewarding – to look for good qualities and positives even in the most sentimental piece of Victorian glass purchased from a church furnisher's catalogue. Once I had settled on this perspective, I began to enjoy myself enormously with stained glass and see it for what it is: a decorative art, a popular art, an art which is meant to move, to touch, to teach, to enlighten and to beautify, and an art that is a vastly underrated part of English visual culture.

Finally, it is important to consider your vantage point and viewing angle. Don't take just one point of view; the more you look at a window from different distances and angles, the more you will be able to see and appreciate. I know it can be difficult to understand, decode and absorb an entire (and often overwhelming) window in one go, so I often find it far more effective to start with an appealing or eye-catching detail and work outwards – from the micro to the macro, so to speak. By moving out in ever-increasing circles from a chosen starting point I find that a whole picture gradually emerges. This is the approach I have taken in this book, which I hope will accompany you on many enjoyable and rewarding church visits.

# HOW A STAINED-GLASS WINDOW IS MADE

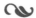

The process of making a stained-glass window is a blend of art and craft which has hardly changed since the twelfth century. It includes many of the same techniques, tools and materials that were used by medieval glaziers making windows for the great Gothic churches and cathedrals of Europe.

Once a commission is received, the first stage is a small-scale design on paper (e.g. half an inch to one foot), usually done in watercolour and ink.

When approval has been given, the design is scaled up into a full-size working drawing known as a cartoon, which is exactly the size of the window. The dimensions have to be correct, as the cartoon then becomes the working blueprint for the window and the ultimate point of reference for all subsequent actions. It may also contain all the details to be followed when painting.

In addition, a cutline will be made. This is the master plan for cutting, and later on leading, a tracing of the cartoon which shows the positions of the lead lines and forms the pattern from which the pieces of glass will be cut. Each section may be numbered and colour references noted to ensure the work proceeds in the correct order.

The glass is then chosen and cut using a steel wheel cutter and trimmed with grozing pliers. Each piece may be painted, stippled, scratched,

sandblasted, printed, acid-etched and/or stained, with separate firings after each application of paint. Traditionally, the pieces were fired just once, with paint on the internal side and silver stain on the external side. Often, the pieces of glass are mounted on a glass easel or screen while work takes place, to enable the artist to work with daylight behind the design.

Next, the pieces are leaded up. The cutline is placed on the studio bench with a frame to hold at least two sides in place as the glazier works. Following the cutline as the guide, the sections of glass are leaded with lead cames. These have an H-section into which the pieces of glass slot and by means of which they are held in place (they look like miniature girders). As the work progresses, horseshoe nails are lightly hammered into the board around the sections in progress to keep the pieces in place and to prevent any slipping or loosening.

Once the entire piece has been leaded, the joints of the lead cames are cleaned and covered with a flux, usually tallow, then soldered with an alloy of lead and tin. Following this, the piece is then cemented in order to weatherproof the window and hold the pieces of glass firmly in place. Cement made from a compound which includes whiting, plaster of Paris, linseed oil, turpentine and blacking is pushed under the leads on each side.

1. Details of medieval (left) and modern (right) stained-glass workshops
in A. K. Nicholson memorial window (1937), G. E. R. Smith with
A. K. Nicholson Studios. St Sepulchre, City of London.

As the cement mixture hardens, any excess is removed with a stick and a stiff brush.

Finally, the window is brushed and polished and, once any support ties made from copper wire have been attached, it is now ready to be installed, often with the additional support of horizontal iron saddle-bars to which it is tied.

# A–Z OF STAINED GLASS

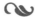

## ABSTRACT

Abstract stained glass in a church can be challenging. In a place where people are looking for meaning, it does not offer any immediate answers or guidance. And yet it can be powerful, subtle, persuasive and awe-inspiring, while its meaning, if any, remains open to interpretation by each and every viewer. This is what makes abstract windows in churches exciting, demanding and intriguing.

Although deliberately abstract windows became popular in the postwar era, abstraction goes back a long way. I suspect that much pictorial stained glass from medieval times onwards becomes abstract when seen through failing eyes or from a distant pew, and without aids such as spectacles, lenses and binoculars: all that is discerned is the play of colour and light, blocks and shapes, and black lines, while the details blur and

2. Detail of east window, by Keith New, 1966. All Saints, Branston.

become indistinct. And although it is sometimes claimed that the innovative, rule-breaking 1915 West Window in St Mary, Slough, designed by the post-impressionist artist Alfred Wolmark (1877–1961), is the sole forerunner of abstract glass, there are plenty of examples of simple shapes and abstraction in medieval, Victorian and Arts and Crafts windows. The latter often contain beautiful abstract sections of thick, streaky or slab glass and innovative, organic lines of leading. Indeed, much background glass in pictorial windows of all periods is made up of abstract designs and, if you focus and crop, so to speak, you can find all sorts of stunning, colourful and stimulating patterns in churches.

Wolmark's window did mark a turning point in stained-glass design, but the sea change towards abstraction as an artistic choice did not take place until after World War II. Abstract stained glass might have emerged much earlier if the post-World War I period had not been dominated by the manufacture of traditional, conventional memorial windows to the fallen. By 1945, though, the time was ripe for Modernist, abstract windows which were very much in tune with what was happening in fine art, galleries and, of course, art schools, where many young stained-glass makers were being taught and were experimenting with the medium. Out went war heroes dressed up in medieval suits of armour, and in came a very new type of window which reflected the church's changing role in postwar society, born out of its desire to become more modern and relevant. As a result, abstraction flourished alongside representations of ordinary people and everyday life, sometimes in the same window.

There is also the middle ground of semi-abstraction, in which highly stylised motifs, faces and body parts are half hidden in cleverly painted windows. Marc Chagall's renowned windows in All Saints, Tudeley, contain fluttering butterflies and small creatures amidst abstract swirls of colour and lines. In the superb series by Tony Hollaway in Manchester Cathedral (some of the best abstract/semi-abstract glass to be seen from the 1970s to the 1990s), letters, foliage and fragments of rooftops can be made out, and the closer you look in order to make out the details, the more you see of the qualities of the glass itself, with its bubbles and cherished imperfections.

The best known of all semi-abstract glass, though, is that in Coventry Cathedral (1962), designed and made by three of the biggest postwar names: Lawrence Lee, Keith New (1926–2012) and Geoffrey Clarke, who were directly inspired by Wolmark's window.

Soon after these windows were made, however, purely abstract glass gained greater acceptance, and if anyone needs confirmation of its magical and uplifting properties, I recommend standing in front of John Piper and Patrick Reyntiens' enormous and utterly beautiful baptistery window, also in Coventry, in which every one of the 195 panels is a miniature work of art. Piper understood that much of the effect of stained glass comes simply from the basic combination of colour, light, paint and lead lines, and that abstraction reduces a window to these essential qualities without losing its power to move and inspire awe. Abstract glass was also made from the 1950s onwards using thick glass and *dalle de verre* (see separate entry), particularly for new Roman Catholic churches and cathedrals. Outstanding examples include windows by Dom Charles Norris in Buckfast Abbey; by Gabriel Loire in St Richard RC, Chichester; by Henry Haig in Clifton RC Cathedral; and by Margaret Traherne, whose beautifully made, calm designs can be found in Coventry and Liverpool Metropolitan Cathedrals.

See also *DALLE DE VERRE*, LEAD, PINK, TEXTILES

# ACTS OF MERCY

With so much Victorian stained glass in English churches, there is sometimes no getting away from expressions of that period's piety in windows that can appear preachy, sententious and didactic to modern eyes. But it would be wrong to write off the more moralising examples completely; amongst them are numerous fine Acts of Mercy (or Corporal Works of Mercy) windows which illustrate examples of charity and sincerity. Despite some heavy-handedness – and frequently patronising attitudes – these windows are still as relevant as ever.

The Bible lists seven Acts of Mercy: to feed the hungry, give drink to the thirsty, clothe the naked, visit the sick, visit prisoners, shelter strangers and to bury the dead, although very often the last one is not illustrated (although there is an excellent 1857 example by Clayton & Bell in Holy Trinity, Blatherwycke). In addition to windows which include some or all of the acts, there are also plenty of illustrations of individual charitable acts and people, who may be biblical (e.g. the Good Samaritan), famous (e.g. Josephine Butler, Elizabeth Fry), saintly (e.g. St Elisabeth of Hungary), or simply ordinary and anonymous. With their collections of separate tableaux or vignettes, windows on the theme of mercy are easy to recognise and read. There is a great deal of pleasure to be had from examining how designers and artists have interpreted the

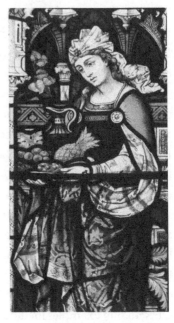

3. Detail from Acts of Mercy scenes, designed by T. W. Camm, made by Messrs R. W. Winfield, 1883. St Mary, Wirksworth.

different acts and reworked them for contemporary audiences, often with local references and modern touches. I particularly enjoy sickroom interiors and have spotted grand four-poster beds, rich drapes, piles of pillows, vases of flowers, potted plants, bedside tables with jugs of water and glasses and, at All Saints, Cambridge, an invalid with a bandaged head wearing a terribly smart emerald-green dressing gown with quilted satin collar and cuffs (Douglas Strachan, 1944).

Every period has outstanding examples of the genre, and it is a great pity that more early windows, like that in All Saints in North Street, York, have not survived, because they would have said a great deal about the way communities have looked after the sick, poor and needy. Made around 1410, it is a memorial to Nicholas Blackburn, merchant and mayor of York, who is perhaps the bearded, compassionate-looking man cheerfully doling out

bread buns from a huge wicker basket and releasing three men from the stocks as they wiggle their bare feet and toes. Equally rare and also very much of its time is Abraham van Linge's colourful painted-glass Acts of Mercy window (*c.*1630s) in All Saints, Messing, which is reminiscent of a Brueghel painting, full of action and crowds looking on with vivid gestures and expressions.

These examples feature men, but in fact Acts of Mercy windows are one of the few types in which women predominate and are notably active. They embody many Christian virtues, and even though their gendered ideals of piety may no longer be acceptable, these windows can be fascinating period pieces. At St Mary, Wirksworth, the gloriously sumptuous 1883 window designed by T. W. Camm of Smethwick is a detailed evocation of charity as performed by gracious, well-to-do ladies. The scenes, with many lovely domestic details (potted fern, wicker basket of blue grapes and vine leaves, ruby-and-white flashed-glass tumbler), must have been a long way from the stark reality of the local Derbyshire mill workers' and miners' lives, and very much exemplify and embody the Victorian social hierarchy of philanthropy. It also contains one fascinating piece of local history, in the shape of a pineapple on a platter of hothouse fruit carried by the woman who is feeding the hungry: Joseph Paxton's pineries at nearby Chatsworth House were some of the finest in Britain and the pineapples grown there were renowned in the nineteenth century. To give away a pineapple must have been the height of charity for the well-to-do of Wirksworth.

The best twentieth-century versions can be equally wonderful and revealing when updated to include the roles of the postwar welfare state and the National Health Service. Harry Harvey's 1967 Acts of Mercy window in Sheffield Cathedral contains vignettes through the ages. For example, a hungry boy, perhaps in an orphanage, waits like Oliver Twist for his slices of ham and bread, while this time the sickbed is moved to an NHS hospital ward, complete with standard-issue bedside locker, and the visitor, bunch of flowers in hand, wears a sensible coat, Mary Whitehouse-style hat and cat's-eye glasses.

See also BASKETS, FLOWERS

# ANGELS AND ARCHANGELS

## ANGELS

Angels are everywhere in stained glass. They are one of the mainstays of the art, so ubiquitous and obvious a subject that it is easy to take them for granted. But it pays to notice them – even if you are not an enthusiastic angelologist or believer in angels – because artists and designers often pull out all the stops to make them remarkable, dramatic, decorative, strange, sweet, sentimental, theatrical and camp. They reflect contemporary styles in art and design from medieval to modern, and are therefore an excellent subject for 'compare and contrast' exercises. Indeed, a newcomer to looking at stained glass would do well to begin with angels precisely because there *are* so many of them, they illustrate all aspects of designing and making, and they present a fabulous range of colours, patterns, faces, bodies, clothes, haloes and wings.

Fortunately, you can enjoy these windows without knowing the complex details of the various orders or choirs of angels. There are disputed versions of the hierarchy and no single agreed set of categories apart from the top-order archangels (see below), and even the attributes of two of the best-known types – seraphim and cherubim – often overlap and cannot be ascribed definitively. As a result, it may be more productive to focus less on identification of type and more on angels as a springboard for an artist's or designer's imagination.

The task of imagining what form a flying heavenly messenger might take has long exercised artists' creative powers, and it is of course their wings that set them apart from mortals, so these are worth looking at carefully. There is staggering variation in size, span, shape, colour and feathers. Some cover the body like a bird costume or a ballet dancer in Swan Lake; medieval versions of six-winged seraphim are particularly good, as are those done by Victorian firms and C. E. Kempe, although it can be disconcerting when they have no feet – almost as unnerving as the cherubs, which are made up of just a child-like face and a small pair of wings floating above a scene, or in the tracery.

Many artists in the Arts and Crafts period went wild with their angels' wings. Exaggeratedly large and extravagant versions can be found in windows by Edward Burne-Jones, Henry Holiday, Christopher Whall and Louis Davis, who used gorgeous colours (coral, magenta, sapphire, gunmetal blue, scarlet) to make them even more spectacular, while Karl Parsons goes one step further with his bright, multicoloured, almost neon-rainbow wings, and C. E. Kempe introduced peacock feathers into his. They were followed in the twentieth century by artists in the paler, more ascetic Sir Ninian Comper and Geoffrey Webb mode, who preferred smaller, less flamboyant green, gold, royal blue and purple wings to coordinate with angels' outfits. Douglas Strachan (1875–1950), though, counteracts this politeness and asexuality with his unique, Cubist/Vorticist/Art Deco-influenced, ultra-masculine, sci-fi warrior angels, which can be seen in places like the church of St Thomas and St Richard in Winchelsea (1929–33). Later, in the postwar period, many designers brought in a less lush, more modern, stylised aesthetic which echoes the textile and graphic designs of the period. The best are by Harry Stammers, Harry Harvey, Trena Cox and L. C. Evetts.

Angels often have typically angelic faces: childlike countenances with sweet expressions and clouds of golden hair. Some of the most appealing were made in the interwar years and look just like children's book characters such as Milly-Molly-Mandy and friends (look for young angels by Veronica Whall, M. E. A. Rope and Margaret Rope). But there are also many other types of faces: some are gentle and maternal, or youthful and handsome, just as you might expect.

In the twentieth century there is no getting away from the campness of angels. Sir Ninian Comper (1864–1960) and Hugh Easton (1906–65) in particular specialised in wonderfully kitsch angels whose beautiful faces, bare bodies, defined muscles, blonde hair, spectacular golden wings and sheer glamour cannot fail to attract attention. At St Wilfrid, Cantley, Comper created a fabulous window in 1918 illustrating nine orders of angels, three of each set out in a three-by-three grid like a box of chocolates, forcing you to choose your favourite, while Hugh Easton's best angels can be seen in

the 1947 Battle of Britain window in Westminster Abbey and in the Royal Air Force Chapel at Biggin Hill (1955).

The sheer theatricality of angels means that groups and choirs can look stunning, especially in *Te Deum* windows, where they are often choreographed in circles or rows, their faces upturned and bathed in light, their wings forming intricate and elaborate repeat patterns like a corps de ballet or a Busby Berkeley dance scene. There is a lovely version in St Mary the Virgin, Battle (Burlison & Grylls, 1906), where there are also whole orchestras of musical angels flitting about, often in the higher reaches of windows or in the tracery, playing the most enormous range of instruments, many of which are not easily identified these days. In the Beauchamp Chapel in the Collegiate Church of St Mary, Warwick, 22 different instruments are played by 32 medieval angels, and Edward Burne-Jones filled the tracery of his 1875 window in St Martin in the Bull Ring, Birmingham, with charming musical angels.

## ARCHANGELS

Archangels are regarded as the highest class of angels, the powerful guardians and messengers sent by God to perform specific roles, the closest thing to comic-book superheroes we are likely to find in windows and possibly the easiest angels for contemporary and/or non-religious viewers to understand and appreciate.

They are the subjects of some of the biggest set-piece designs and come with well-known narratives and symbols, so it is to the credit of numerous artists and designers that they have continually exploited the vast range of visual possibilities they provide and found new and expressive ways of depicting them in stained glass. An archangel may be old, grizzled and bearded or young, gentle and calm; he may be undeniably pretty, youthful and androgynous or strong-jawed, muscular and fierce; or he may even have the incongruous facial features of the fallen soldier whom he commemorates in a memorial window. As for clothes, wings, haloes and expressions, archangels are always rich sources of wonderful detail.

Although there are several archangels – the figure is often set at seven – English church windows usually contain just three (Michael, Gabriel and Raphael), sometimes four (add Uriel), and very occasionally five, as in the 1920 window by C. E. Kempe & Co. in Holy Trinity, Coventry, which includes Jophiel. They are historically represented with larger wings than other angels, but in the nineteenth and twentieth centuries these wings sometimes become immense while the drama surrounding them intensifies and they end up making the smaller-winged medieval archangels look terribly ordinary indeed. Even the huge medieval St Michael in St Mary, Fairford, with his pretty, multicoloured butterfly wings, appears to be rather gentle and non-judgemental when compared to the many terrifyingly powerful twentieth-century St Michaels.

As archangels vary greatly according to period and artist, it is useful to be able to identify the most frequently encountered by their attributes, although you might also find a helpful name under their feet, or in a banner or halo.

St Michael is undoubtedly the most visually exciting and dramatic archangel, and many a St Michael appears in a superhuman whirl and swirl of energy, the epitome of masculinity, in scenes that would not be out of place in a blockbuster movie. It is he who defeats evil/Satan in the guise of a dragon, serpent or devil, with a spear, sword or lance, and is often shown as a warrior-angel with shield, armour and helmet. St Michael's other role is to weigh souls on Judgement Day and thus he sometimes carries a set of scales (often holding suitably nasty baddies) or perhaps two books – the smaller for the Heaven list and the larger for the Hell list. When he is pictured with a dragon, St Michael should not to be confused with St George, who has no wings.

Gabriel is best known as the messenger to Mary and is often pictured raising his finger as he makes the announcement that she will have a child. He is associated with the lily: in Annunciation windows he usually carries or offers a stem, or there may be a lily growing in a pot nearby (he may also be known by a trumpet or lantern). His windows celebrate the happy news of the impending birth, and Gabriel is a reassuringly benevolent archangel.

Raphael is the archangel who deals with healing, and may be seen holding a bottle or flask, stirring the healing waters of the pool at Bethesda, holding a fish (the story is that he used parts of a fish to heal), walking with Tobias (as in the story of Tobias and the Angel) or carrying a staff in his role as guardian of pilgrims.

Finally, Uriel is associated with light and may hold in his palm fire, a flaming sword, or a sun or orb.

There are many superb archangels in English churches, including those by Alexander Gibbs in All Saints Margaret Street, London (1869), Mary Hutchinson's archangels in Hull Minster (1920), and those by James Powell & Sons in Holy Trinity, Sloane Square (late nineteenth century). The most theatrical line-up of all is by Hugh Easton in St Paulinus, Crayford (1953), which features four beautiful, mostly naked archangels in a blaze of light and coloured feathers, like a scene from a Derek Jarman film. Easton used the same design in 1954, in Grimsby Minster.

See also CROWNS, DRAGONS, HAIR, HALOES, LIGHT, PEACOCKS, SAINTS, TRACERY

## ANONYMOUS

Stained glass is a peculiarly anonymous art form, which means that the question of attribution can be particularly vexing, a problem which is compounded by the fact that a significant number of windows in English churches have been made by 'Anon' from the thirteenth century right up until the present day.

Much of this comes is due to the history of stained-glass production, which has been shaped partly by the medieval studios in which groups of anonymous, skilled, jobbing glaziers worked under the direction of a master glazier whose name may or may not have been recorded. John Thornton of Coventry (*fl.* 1405–33) is one of the very few whose names are known (his most famous work is the Great East Window in York Minster), but the names of many other medieval master glaziers and their teams were not recorded. It

is also partly because the making of stained glass is frequently a team effort, so even when a window is attributed to or claimed by an individual, one does not always know if the named artist had a hand in actually painting, staining, cutting, leading and firing the glass or whether these processes were carried out by assistants and teams. There is also a third reason: historically, the names of the artists and craftsmen who made church fittings and furnishings were rarely recorded, and the practice of naming only a master glazier, firm or studio has continued to the present day. Instead, the majority of those involved in production have simply allowed their work to speak for itself, for it to be a part of a larger scheme put together for the greater good of the church and the community. Stained glass is still, for the most part, the province of modest, self-effacing designers and makers, and England – unlike France and Germany – has very few celebrity or big-name artists in the field. It may be frustrating for those who like to identify and catalogue different windows – and there are many specialists and academics who devote great energy to doing this – but you have to accept that you will often not know whose work you are looking at.

The collaborative nature of often anonymous teams working to produce stained glass has been depicted in windows, most famously in the medieval 'trade windows' in Chartres Cathedral. Sadly, there is now no equivalent in England. There are, however, several tributes to stained-glass studios in twentieth-century windows, and these are fascinating because they reveal that little has changed over time. Christopher Webb's highly detailed Wren window (1959) in St Lawrence Jewry, City of London, shows the unnamed tradesmen and artisans involved in rebuilding the bombed church, and includes a man preparing a cartoon for a window. Not far away, in St Sepulchre on Holborn Viaduct, is a 1937 memorial window to the well-known stained-glass designer A. K. Nicholson, made by his own craftsmen; in one vignette the contemporary studio is illustrated together with the various activities, such as designing, making the cartoon, choosing glass and painting, while a second shows a medieval workshop in which monks are working at a glazing table in a scene which could just as easily be seen today, thus underlining the timelessness of the techniques used. Webb and

Nicholson always signed their work, but here they acknowledge the teams who supported them and did much of the hard work. Touchingly, in the corner of the Nicholson window is a neat set of initials denoting all those who worked on it. Although nearly everyone involved in making glass for the big Victorian firms had to accept that the company name would take precedence and that their own could be quickly forgotten or even never mentioned, the desire to be credited has increased since then, and some designers are generous with their acknowledgements. Lawrence Lee (1909–2011) acknowledges his assistants by name, as does John Hayward (1929–2007). Indeed, the closer we get to today's windows, the more signatures and signings we find, perhaps to ensure that names are not lost.

Nevertheless, it is surprising and shocking just how many gaps there are in church guides and how quickly designers' or makers' names can be erased or forgotten. Even windows made just a generation ago may apparently be by an anonymous person or company, according to church guides, often partly the result of original publicity material which covers every last detail of a new window yet omits the designer's name. All this anonymity has one interesting effect, though; when looking at stained glass by an unknown maker, we are forced to consider it on its own merit, making it a daunting, exciting and rewarding exercise.

See also EYES, MAKERS' MARKS, NOSES

# APPLES

It all begins with Adam and Eve and an apple. However, the tempting fruit which has a lot to answer for is not actually identified as an apple in the Bible, and it is only later in popular tradition that it is named as such. Nevertheless, apples appear in stained-glass windows of all periods, most frequently in the Garden of Eden but also in many other scenes, backgrounds and patterns.

Some are no more than a spherical fruit with a dimple and perhaps a leaf attached, while others are gold, yellow, red, orange or silvery-grey if

done in grisaille (see separate entry), which means that they could, arguably, just as easily be oranges, peaches, persimmons or tomatoes. They may be large and juicy-looking, small and firm like little russets, or similar to the super-shiny poisonous red apple eaten by Snow White. The important thing is that they are palm-sized fruits which can be picked, proffered, held or bitten into, and thus are easily recognised as the well-known symbol of temptation and sin. As for the trees, there are bushy, prolific, leafy versions, thin upright saplings with just a few fruits, while those in medieval windows tend to resemble rudimentary children's drawings. Quite a number of the apple trees have a thick, preternaturally long, evil-looking serpent, occasionally with a very unpleasant human face, winding its way round the trunk.

What is shown in apple scenes is also worth looking at carefully to see how the artist or designer and the commissioning church and society dealt with Adam and Eve and the morals of the story. The medieval makers are typically straightforward in their illustrations: Adam and Eve are very simple human figures who appear to have no shame or curves to their nakedness and they act out the expulsion in rather wooden tableaux. But by the time the painted glass of the seventeenth century was being installed (e.g. in the chapel of University College, Oxford), Adam and Eve's bodies had become a lot more curvaceous, fleshy and voluptuous, the serpent often remarkably phallic, and the images of temptation, apple-sharing and flight expressed with drama, like stills from a silent film. The Victorians later produced some very awkward designs which struggled to come to terms with the idea of nakedness in church windows while indulging their obsession with the female nude. They often covered flesh strategically with fig leaves, tunics or pelts, and maintained Eve's modesty by means of very Lady Godiva-esque hair, all of which can look a little prim and strange.

Since then, there have been many versions of Adam and Eve, the most interesting of which either challenge perceptions of what we expect to see or are lovely examples of contemporary stained-glass design. In Gloucester Cathedral the leading Arts and Crafts maker Christopher Whall surprises

by presenting Eve as what now looks like a 1950s Hollywood blonde bomb-
shell with waist-long hair and a scarlet dress split to the top of her thigh.
She should, perhaps, be paired with C. E. Kempe's Adam in Wakefield
Cathedral, who is extremely muscular, handsome and dashing, sports a
twirlable military moustache, and would not when fully dressed look out
of place in a painting by Tissot.

In the twentieth century, and the postwar period in particular, apples,
Adams and Eves are often stylised, simplified and far less sexualised. They
are more likely to be a vehicle which allows an artist's individual style and
aesthetic to shine through than a morality tale in glass. Adam and Eve look
freer and less harshly judged, with many an Eve clearly the product of
increased liberation, for example Harry Stammers' bold, strong, womanly
Eve in St Mary Redcliffe, Bristol, and John Hayward's sculptural, muscular
Eve, who is very much the equal of Adam, in St Michael Paternoster Royal,
City of London.

See also SPADES

# ARK

No wonder that the story of Noah and his ark is so frequently told in words
and pictures: it is an epic maritime undertaking, a narrative of beating the
odds and surviving. Today it could even be read as a timely warning about
global warming or a World Wildlife Fund campaign to save as many species
as possible from extinction. Add to this the background story of God's
anger and his decision to punish man for his descent into wickedness and
it becomes a blockbuster.

Noah, his ark and the Flood have been a popular subject in all periods
of stained-glass making. It has tremendous appeal, especially to children,
who have always been fascinated by the object itself and its cargo of animals,
and it is one of the best, clearest and easiest Bible stories to understand in
stained glass. Some medieval and Victorian makers do this by means of
a storyboard or series of pictures which move from ark-building to safe

landing; outstanding examples include the Noah window (late fifteenth/
early sixteenth century) in St Neots, Cornwall, and the window by Alfred
Gérente in Ely Cathedral, dating from 1850. Others focus just on a scene
or two, perhaps of building, embarkation, the rising waters, disembarka-
tion, the animals or simply Noah himself. Noah, the patriarch, is in charge,
and may sometimes be seen either holding a model of the finished ark or
holding a design for it while he supervises his sons or explains the work to
them. In other windows, he may work alongside his sons while his wife
and daughters-in-law are shown in the background.

The basic design of the ark itself is relatively consistent, unsurprising
as there are quite precise instructions in the Bible regarding the type of
wood and the size, number and placement of windows, doors and decks.
The fun here, though, is looking to see how it has been imagined by an
artist. It may be a simple, round-bottomed, one-colour, wooden affair, but
it may also look more like a rowing boat or even a gondola supporting a
shed with pillars and capitals (as in the early thirteenth-century window in
Lincoln Cathedral). The living quarters might consist of one, two or even
three storeys, a roof might be shingled or tiled, windows may be latticed
and doors may boast fancy ironwork, and there is often a little dormer
window through which Noah releases a dove. An ark may look as though
an architect has designed a des res, white clapboard, New England-style
houseboat (St Mary, Tissington), or it may look like a child's drawing, as
in the 1955 window by the highly influential Evie Hone in All Hallows,
Wellingborough.

The process of making the ark itself leads to some excellent woodwork-
ing and construction scenes (e.g. Clayton & Bell's 1886 window in St Mary
Redcliffe, Bristol), or even a full-scale waterside building site complete
with plans, ladders, ropes, rulers, hammers, nails, scaffolding, huge screw
tools and muscular workers (as in the nineteenth-century window in St
Martin, Dorking).

As for the animals, it is a joy to spot and identify them, to wonder at the
crude representations in old glass by painters who had never seen a camel
or a giraffe, to enjoy the Look and Learn- or Ladybird-style illustrations in

twentieth-century windows, to see which wildly exotic or familiar species have been included, and to recall the childish delight of observing them lined up in pairs, entering or leaving the ark, two by two.

Representations of the ark also extend to toy versions, and these are some of the most endearing of all. Wooden sets have an enduring popularity (they are said to be one of the few toys children of earlier generations were allowed to play with on Sundays), and the pleasure of pairing up and arranging the models never palls. Margaret Edith Aldrich (M. E. A.) Rope (1891–1988) includes a toy ark with various wooden animals in her Christmas scene window (1944) in All Saints, Hereford, and also in St Peter, Clippesby (1919), the latter with the ark safely arrived at the waterside and little elephants, giraffes and tigers leaving to go ashore.

Finally, it pays to look at the ways in which the floodwater is shown – and not just water in ark-themed windows, as there are a huge number of rivers, lakes, seas and bodies of water in stained glass. It is a very tricky subject to render convincingly in the medium of transparent glass (rather like smoke and incense) and not all painters succeed, with many seas looking more like solid green hills, plenty of strangely blue feet and innumerable static waves. Sometimes the most un-watery approach can in fact be the most effective: medieval and some neo-Gothic Victorian artists simply painted thick, dark, stripy bumps to indicate waves. The best artistic interpretation of water I have yet found is the stormy sea made up of irregular shapes cut from many types of high-quality glass, some streaky, in all sorts of colours including non-watery shades such as chartreuse and pink and yellow. The effect is gloriously brilliant, deep and swirling. It is by M. C. Farrar Bell (1963) and is in St Katharine Cree, City of London.

See also CARPENTRY, TOYS

# AVIATION

The theme of flight is an important one in stained glass. Angels fly across tracery, archangels bring messages from above, figures ascend to heaven and

birds hover, swoop and glide. But the subject of man-made flight is also prominent, particularly in the many war memorials and windows associated with the Royal Air Force (RAF) and the Battle of Britain. Once you start looking, you will find plenty of aircraft in full flight, air raids, dogfights, neat aerial formations and air bases, plus squadron badges and many airmen. These can be found all over the country in windows dedicated to airmen who died in both world wars, although there is a concentration of aircraft in the cathedrals and churches in towns and cities which suffered bomb damage or were local to RAF stations and US Army Air Force (USAAF) bases, and in rural churches in counties such as Norfolk, Suffolk, Kent, Cambridgeshire and Lincolnshire.

It is not just World War II planes that feature: church windows contain more than a century of aviation history, and there are some excellent examples of early planes which will delight those who are familiar with and use *Jane's Aircraft Recognition Guide* (first published 1909). Do not expect all of these planes to be big and obvious in a window, though. Instead they are often simply small background details, positioned high up in the air or pictured from a distance. Close scrutiny will reveal for example a Zeppelin airship in St Mary, Swaffham Prior, in the extraordinary World War I memorial windows made by T. F. Curtis which look like a Boy's Own guide to military campaigns, as well as a plane with propellers, fixed wheels and German markings, submarines and an early tank. More obvious are the planes in St Mary, Welton, Lincolnshire, where there is a marvellous view of Lincoln Cathedral and the surrounding area as seen from a cockpit, based on a photo provided by the RAF, in the 1921 memorial window by Burlison & Grylls. St Michael stands surrounded by little airborne planes such as Sopwith Camels, Blackburn Bombers and Avros, in what is now an important piece of contemporary historical art.

Moving on to World War II there is, as one would expect, a much greater proliferation of planes and, this time, the men who flew them. Again, the stained-glass designers' attention to detail is remarkable and many have created superb visual documents of events, machines and

pilots. Fine paintings of aircraft can be found in numerous places, such as Ely Cathedral, where a number of RAF Groups are commemorated, Salisbury Cathedral and St Denys, North Killingholme, where the plane can be identified as a Lancaster Bomber. USAAF men, bases and planes are also memorialised, marking the places where they operated during the war.

The image of the airman is a potent one, made familiar by Hollywood and English film studios. Although many designers such as Harry Stammers (1902–1969) and Christopher Webb (1886–1966) create straightforward, respectful, rather anonymous Everyman images of men in uniform, others emphasise chiselled jaws, striking good looks and physical presence, while Hugh Easton's impossibly good-looking pilots always resemble the stars of the silver screen. Some stand in corners of windows bathed in perpetual light (often with the line from the prayer 'let light perpetual shine upon them'), as in the 1989 memorial by Glen Carter in St Bartholomew, Gransden, to Canadian airmen who died, while others are seen among, on and above clouds, in bright light or just below a figure of Jesus, hands outstretched in greeting. Their clothing is captured beautifully too, and there are numerous bright-yellow Mae West vests, blue air force uniforms and brown leather gloves.

Although other means of flight such as helicopters and parachutes appear less frequently than planes, they have been recorded in church windows. Parachutes drop down in windows in St Vincent, Caythorpe, which has an excellent pair of modern windows (1994 by H. J. Hobbs, 2012 by Michael Stokes) dedicated to all the members of the Airborne Signals Unit who have died in combat since 1941. The more recent of the two includes many helicopters and a Chinook, but is just as interesting for the immediacy of its reportage style, with illustrations of operations in Kosovo and Afghanistan reminding the viewer of contemporary war artists' work. There is a distinct lack of glamour, formality and pose here and, once again, the theme of flight serves as a clear example of how artists and commissioners of windows continue to move with the times.

See also ANGELS, BOMBS, TRANSPORT

# BASKETS

In church windows as in life, baskets and bags are everywhere. Because they are so utterly commonplace they may go unnoticed, which is a shame, because once you include them in a list of things to look for, it becomes clear that they are there for a reason and play a vital role in many stories and scenes.

A basket or bag and its contents can be a helpful clue in recognising a figure or narrative in a window. Several important female saints can be identified this way, often in visually stunning, richly detailed windows which allude to their personal stories. The two I like best are St Dorothea (also known as Dorothy), who carries a basket of fruit and flowers, and St Elisabeth of Hungary, whose cloak falls back to reveal a miraculous basket of roses. There is a very plain but stunning 1962 St Dorothea by Harry Harvey (1922–2011) in St Edward the Confessor, York, which contrasts markedly with the elaborate 1920 depiction by C. E. Kempe & Co. in All Saints, Huntingdon. In St Michael, Kirby-le-Soken, the 1962 St Elisabeth by A. L. Wilkinson carries what could be a huge market trader's basket full of five-petalled dog roses. I also enjoy looking for baskets of bread as clues to St Martha's domesticity, and at those belonging to St Philip, patron saint of bakers. Beautifully detailed baskets of carpentry tools, pincers, hammers and nails can be seen in Joseph's workshop and also, more harrowingly, in windows which depict the Crucifixion, such as in St Mary, Sturminster Newton. Then there is the Feeding of the Five Thousand, which may involve a young boy standing by with a wicker basket of two fishes and five loaves about to be multiplied (e.g. in the 1929 window by M. E. A. Rope in St Andrew, Little Glemham), and the surprisingly rarely seen Old Testament story of Moses in the bulrushes in a woven baby basket made to a design still used today. There is a nice example in St Peter and St Paul, Weobley. Mary and Joseph's offering of two doves in a basket can be found in windows showing the Presentation of Jesus at the Temple (e.g. King's Lynn Minster), and the ever-popular sower of seeds carries a lovely variety of baskets and bags.

Baskets are also associated with charity. Acts of Mercy windows usually contain a basket of donations of food for the hungry; it may not be fancy or decorative but it does play an important symbolic role in the narrative. The outstretched hands of the abject poor and hungry figures in the excellent window by Heaton, Butler & Bayne (1862) in St Nicholas, Harpenden, almost grab the tiny basket and loaf from the charitable woman who appears strangely reluctant to share.

The making of bags and baskets is a basic, ancient skill, and stained glass shows that materials and designs have not changed enormously over the centuries. Most baskets are woven or plaited, handmade from willow, rushes, vines, reeds, ash or oak, and they reveal a whole history of basket-making with lovely weaving patterns (stripes, lattices and checks) and all sorts of traditional edges and handles. Some baskets are wide and flat for carrying figs, raisins and flowers, some are deep and capacious for carrying dozens of loaves, some sit like half-moons in the crook of the arm (see Harry Stammers' 1950s marketing basket in St Mary Redcliffe, Bristol, or Helen Whittaker's modern fruit-picking basket (2005–6) in St Peter, Stowmarket), while others are like bridesmaids' flower baskets, Amish shopping baskets or beautiful willow sculptures.

But it's not just all willow and weaving; there are also many useful bags made from fabric. Dick Whittington carries a classic red-and-white spotted knapsack – perhaps made from a handkerchief – in the excellent 1968 window by John Hayward in St Michael Paternoster Royal, City of London. Pilgrims and seekers of fortune throw their cotton bags over their shoulders, and some sowers in fields use cross-body canvas slings to hold their seed. More recently, utilitarian bags carried by official personnel, for instance gas-mask bags, have appeared in World War II memorial windows; the marvellous series by Arnold Robinson in Bristol Cathedral shows local civilian service personnel fully kitted out for emergencies. Fabric bags may also be decorative rather than practical, with the occasional sighting of small, embellished, prettily tasselled and stitched bags worn, Tudor- or Victorian-style, by well-to-do rather than working women (see for example St Catharine RC, Chipping Campden).

Women's bags feature prominently in the modern era. There is a collection of 'Sunday best' bags in windows by the group of makers who specialised in bringing ordinary people wearing everyday clothes into church windows. Harry Stammers, Harry Harvey, G. E. R Smith, A. E. Buss and George Cooper-Abbs often depicted churchgoing families in christening or wedding scenes which include a mother or wife wearing a neat outfit of hat, coat and court shoes and carrying a small, short-handled, brass-clasped handbag. Postwar women also carry shopping baskets (a leitmotif of the time of rationing). My favourite example is a 1959 window by the highly skilled F. W. Cole (1908–98) in Christ Church, Southwark, which wittily links contemporary London life and a Bible story with a woman waiting at dusk for a red London bus and carrying a bag which, when you look very closely, is seen to contain bread and fishes.

See also ACTS OF MERCY, CARPENTRY, SEEDS

# BEARDS

From being previously totally uninterested in beards, I am now quite fascinated by them – in stained glass, at least. I had no idea that facial hair could provide so much visual interest, and now realise that it is all too easy to assume that a beard is simply a beard until you make a study of them in church windows. With this revelation came the discovery that they contain enough beards to fill an entire beard reference album.

Beards are indicators of many things and are important in distinguishing different types of men. They may suggest age, venerability or status. Prophets nearly always have long, thick, luxuriant beards, often grey or white, to indicate seniority and wisdom. Kings and rulers have beards; real kings such as Henry VIII and Edward VII sport beards which are true to life and to their portraits and photographs. Young, virile, heroic saints such as St George and St Michael are usually clean-shaven, the better to show off their remarkably strong jawlines, but older saints, such as St James the Greater and St Peter, who have come through a long life or martyrdom,

are often depicted with unruly, unkempt beards, in keeping with a long pilgrimage or an earlier life as a fisherman. Jesus invariably fits in somewhere between the two, with a well-tended, shortish dark beard and droopy moustache, looking both young and experienced at the same time, while a clean-shaven Jesus or one with a blond beard may still be a subject of discussion and disagreement in some churches.

Then there are beards that reflect the era, artist and contemporary fashion. It is possible to identify the work of some of the better-known, great medieval glass painters from the way they painted beards. John Thornton of Coventry's beards are made up of neat, repeating waves, a little like those of Roman statues, while the prophets attributed to the 'Methuselah Master' (*fl.* late 1170s) in Canterbury Cathedral have long, thin, pointed beards. The Victorians painted beards which resemble those worn by prominent men of the time, such as members of the royal family or writers, industrialists and clergymen. Minutely detailed Pre-Raphaelite beards and lush, bushy Arts and Crafts beards which look more like sheep fleeces abound in late nineteenth-century glass, giving way to short, tidy, often goatee military beards at the beginning of the twentieth century. After World War I beards fall out of fashion, and appear only on biblical and historical figures, with the majority of male stained-glass figures now being notably fresh-faced and smooth-skinned, whether they are boyish-looking saints and angels or real-life soldiers and heroes.

Stained-glass beards may be droopy or pointed, enormous or modest, ringletted, curly or straight. Some are smooth and groomed while others fly out madly at all angles (see for example the wild corkscrew Victorian beards by W. F. Dixon in Sheffield Cathedral, which appear to have a life and character of their own). Even if you know nothing at all about their owners, beards in stained glass are a constant source of wonder, and sometimes amusement, to modern eyes. Fortunately, you do not have to look hard to find good examples, as even the most unexceptional windows can contain fine beards. Winchester Cathedral has a superb collection of nineteenth-century styles, including the marvellously luxuriant beards painted by Betton & Evans on the firm's Day-Glo prophets (1851 and 1853),

plus the highly realistic regal beard on George V in the eponymous window which also contains what looks today like a wizard's beard. Elsewhere, Canterbury Cathedral, Gloucester Cathedral, St Peter and St Paul in Lavenham, and the windows in the medieval churches in York such as St Denys, All Saints, North Street and the Minster are all excellent places to start a beard collection.

See also HAIR, LEAD, SAINTS

## BENEDICITE

For accessible, uncomplicated, celebratory stained glass, you cannot beat Benedicite windows. They provide an excellent entry point into an appreciation and enjoyment of the medium of glass which requires no previous knowledge and offers an element of secular appeal and plenty of good content. They contain an expansiveness and a lovely sense of joy and excitement about the natural world and everyday life, and their galleries of beautifully designed and painted images have a wide appeal so everyone, old and young, can join in the fun of looking.

Benedicite windows are based on the 'Song of Creation' canticle which calls on elements of creation and various figures and people to sing a hymn of praise to God. You will know when you are looking at one if you see the line, 'O all ye Works of the Lord, bless ye the Lord' ('*Benedicite, omnia opera Domini, Domino*'), or an extract which begins 'O all ye ...' and includes one of the many categories called upon, such as angels, heavens, waters, sun, moon, stars, lightning, rain, clouds, sun, fire, water, floods, seasons, frost, snow, cold, nights, days, mountains, hills, seas, floods, beasts, cattle, whales, children and people. These give makers and commissioners a wide range of subjects to choose from and, as there are no formal requirements, they are free to interpret them as they wish. As a result, a window may contain just a few references; M. C. Farrar Bell works with just two – 'green things' and 'fowls of the air' – in the delicately painted, picture-book illustrations of flowers, birds and other small wild creatures which make up his gentle

and charming 1988 window in St Mary the Virgin, Haddenham. Or it may contain many more: Christopher Webb uses as many as 12 or even 20 themes in his Benedicite windows (see later in this section).

Benedicite windows have been popular since the mid- to late nineteenth century, and the subject choices and illustrations reveal a good deal about contemporary concerns and interests. Victorian firms created some outstanding windows which tend to mirror their obsession with exploration, expeditions, discoveries and objects under or in glass (flowers, fish, taxidermy), or to convey powerful, evangelical Creation themes. Those worth seeing include the superbly illustrated, colourful 1871 example by Clayton & Bell in St Maurice in Ellingham, Northumberland, which packs in as many species of fishes and birds as possible; the dramatic, swirling example by James Powell & Sons in St Lawrence, Abbots Langley; and the two delightfully oddball windows designed by the local squire, Charles Allix, and made around 1920 by T. F. Curtis of Ward & Hughes for St Mary, Swaffham Prior. With detailed, small-scale Glen Baxter-style illustrations which include an exploding volcano, a *Jaws*-like shark, a glacier, a tiny Earth seen from outer space and a lake filled with water lilies, they look like pages from a child's natural science book.

Benedicite windows were also a safe subject choice for post-1945 memorials and windows which express collective thanksgiving, perhaps because they are ideal vehicles for the representation of the continuity, community, peace and sense of Englishness which had been fought for and defended. They also reflect the Church's increasing openness to the wider world, evidenced by the inclusion in them of more ordinary people, events and places in windows. Many of them contain what look like little snapshots of daily life and local landscapes which are idealised but nonetheless charming. H. T. Hincks painted two attractive, nostalgic scenes of peaceful, local village and rural life in the early twentieth century with church, lychgate, horse-drawn plough, thatched cottage, farmyard animals, blue skies and a multitude of flowers and fowl in St Helena, West Leake. This rosy glow also pervades the windows by Christopher Webb, a prolific designer whose distinctive

vignette style is ideally suited to the multiple-subject window. His are my favourite Benedicite windows, filled with 1950s optimism and bright colours: ice skating, cycling and cricket, apple-picking and haymaking, snowy scenes and Christmas trees, blazing fires and April showers, huge whales and tiny rabbits, and birds perched on telegraph wires. Happily, Webb made several versions, sometimes reusing scenes and details, and the best can be seen in St George in Toddington, St Mary in Wirksworth and St Mary in Welwyn.

See also BIRDS, FLOWERS, ICE

# BIRDS

Although quite a few types of birds are mentioned in the Bible, including doves, eagles, swallows, ravens and sparrows, it would take a seasoned birdwatcher to identify all the birds which perch, swoop, dive, flap and fly in stained glass. With a little scrutiny it becomes clear that some windows are, in fact, stained-glass aviaries; the birds they house may be symbolic, biblical, exotic, mythical, real, specific to a location or simply very ordinary.

There are innumerable sacrificial doves in baskets in windows which illustrate the Presentation of Jesus at the Temple, and plenty of doves of peace above Christ in large, celebratory *Te Deum* windows. Some are stiff and stuffed-looking, like taxidermists' specimens, but a good artist will do his or her best to give life, movement and energy to this powerful and important symbol.

Should you see a long-beaked bird feeding her chicks in a nest which is often cleverly positioned in an awkwardly shaped section of tracery, making it look as though a real bird has built a nest high up in a window, this is a 'Pelican in Her Piety'. In a pre-Christian story the pelican pecks at her own breast to draw blood to nourish her offspring, and in the Middle Ages this became an allegory of Christ's self-sacrifice and a heraldic device. The blood is not always obvious in more sensitive and/or recent versions. There is a remarkable and very unusual Pelican in Her Piety by C. E. Kempe

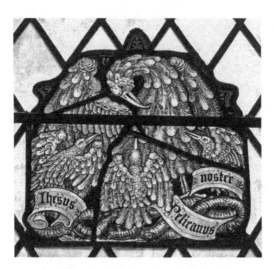

4. The Pelican in Her Piety, by C. E. Kempe, 1904.
St Michael and All Angels, Hathersage.

which mixes adorable fluffiness and strange peacock feathers in St Michael and All Angels, Hathersage.

As well as symbolic, heraldic and imagined birds, there are all sorts of very real birds: cheerful Christmas-card robins, watchful jackdaws, predatory hawks, elegant herons and birds you might find in the hedges, trees and gardens near the church in which they are shown. If painted well, they look as though they may take flight at any moment or, as in the case of John Piper and Patrick Reyntiens' beautiful owls (e.g. those in St Bartholomew, Nettlebed), they simply carry on sitting in wise, contemplative mode.

Artists in the twentieth century, perhaps aware of threats to endangered species, have been particularly keen to include and celebrate birds in windows and to give local meaning to stained glass, and birds are also popular subjects in millennium windows. Stylistically, there are all sorts of representations in this period, from field-guide accurate to characterful and creative. Like his mentor Christopher Webb, Francis Skeat (1909–2000) was particularly skilled at painting birds with superbly detailed feathers and markings. By contrast, Harry Stammers' many incidental birds are cleverly and carefully transformed by his artistic vision into storybook characters, woodcut prints

and delightful illustrations. Like many other artists, he also often included neatly built birds' nests, some with fledglings or eggs. In St Peter and St Paul, Stokenchurch, I came across the most delightful collection of nests with eggs perched on the intertwined twigs and branches, which make an oval frame around the religious scene in the 1947 war memorial window by G. E. R. Smith (1883–1959).

Serious bird-spotters should look for St Francis of Assisi windows, which frequently bring together various species. Usually this will be just a handful, but some St Francis windows are almost stuffed with birds, like a themed puzzle or jigsaw – they must be a lovely way for any bored, pew-bound, budding birdwatcher to learn how to identify different types. The St Francis window in St Mary, Woburn (designed by A. A. J. Houthuesen in 1938, in memory of the eleventh Duchess) is rather unsubtle and highly coloured but undeniably inclusive, and a useful guide to the birds of the Woburn Estate. The highest bird count, though, belongs to the three-light 1920 St Francis window dedicated to Gilbert White, author of *The Natural History of Selborne* (1789), in St Mary, Selborne, where he was curate. All the birds, shown with their carefully rendered distinguishing markings and colours, are mentioned in his diaries, and the window is a tour de force, with so many species included that it looks a little like a breadcrumb-feeding frenzy at a lake in a park.

Cockerels crow and hens cluck, too, in church windows. There are many stunning cockerels (roosters) with gorgeous plumage, bright-red combs and beady eyes in church windows of all periods (e.g. those which illustrate the denial of St Peter). They seem to encourage artistic flourishes and a showing-off of making and painting skills. See for example the spectacular use of stain and flashed glass by Bertram Lamplugh to produce a brilliant red and gold cockerel (1907) in St Mary the Virgin, Langley, Warwickshire, and the grand, colourful, painterly cockerel (1966) by John Piper and Patrick Reyntiens in St Peter, Babraham. By contrast, I am always delighted to find more modest, homely hens and chicks scratching around in rural and domestic scenes at the base of a window. I have found several plump brown mother hens keeping watch over fluffy, almost audibly chirping

yellow chicks, sometimes in Easter or Resurrection windows and therefore accompanied by lovely primroses, crocuses and daffodils, as in St Margaret of Antioch, Iver Heath (1955). I have also seen a delightfully simple and effective line drawing of a hen gathering her chicks in St Peter, Budleigh Salterton, by George Cooper Abbs (1901–66), a prolific stained-glass artist whose work often includes welcome, charming and pleasing little details of everyday contemporary life.

See also BASKETS, MILLENNIUM, PEACOCKS, QUARRIES, SAINTS

# BOMBS

If it hadn't been for bombs, the development of stained glass in the twentieth century would have taken a very different course. It is unlikely there would have been such a remarkable renaissance of what was becoming an overlooked and outmoded art, and churches would certainly not contain the marvellous postwar glass that was commissioned after World War II.

The wartime bombs highlighted the inescapable contradiction inherent in glass: it is long-lasting, durable, strong and weatherproof yet also incredibly fragile and can be easily broken and shattered. Although some valuable and medieval glass in cathedrals and city centre churches was removed for the duration of the war, stored in safe locations and later put back, huge amounts of glass, mostly Victorian, were lost in cities, towns and rural areas (although in some places the fragments were recycled into fine 'patchwork' windows). Every type of church location was affected, from the City of London to rural Norfolk and Lincolnshire, from industrial areas of the Midlands and across the north of England to the 'bomb alley' of Kent. As a result, postwar replacement windows can be seen in churches all over the country and, fittingly, many of these windows commemorate bombing campaigns, destruction, loss, service and death, sometimes even with bomb-related imagery.

However, the bombs had two positive outcomes. Firstly, by removing many older windows, they let light into churches which had been darkened

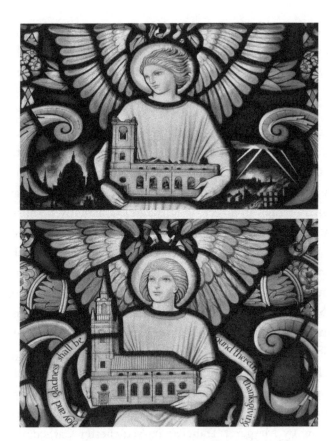

5. Details of St Paul window (with angel holding the bombed church) and St Catherine window (with angel holding the restored church), both by Christopher Webb, late 1950s. St Lawrence Jewry, City of London.

for decades by gloomy glass (although a large number of Victorian windows did survive, plenty of which are of superb quality). Some vicars and congregations decided they preferred lighter interiors and simpler, plainer glass; a few took this to new levels by commissioning non-coloured, beautifully leaded pale or white glass, as for example in the churches restored by architect and designer G. G. Pace.

Secondly, the empty openings made possible the creation of a new style of glass for a new era and many superb new replacements for lost windows.

By the 1930s, church stained glass was in the doldrums and largely stuck in the past. For a while it had seemed that World War I might be the catalyst for brave new work, but designers mostly fell back on safe and established prewar Arts and Crafts and medievalising styles, although a handful of bolder makers had begun to make more exciting, contemporary and relevant windows.

Then came the World War II bombs and blitzes, which are frequently depicted in postwar windows installed to commemorate restoration and rebuilding, or to give thanks for safekeeping. These often appear as backdrops or small scenes in larger designs and can actually be missed unless you know to look for searchlights, flames, night scenes and silhouettes of chimney pots. Sometimes a model of a church or cathedral which has been either damaged or protected is held by an angel or figure; there is a fine example in Exeter Cathedral by Christopher Webb which shows the city on fire at night (with great use of ruby flashed glass to create dramatic red and white flames) and another by Webb in St Lawrence Jewry, City of London.

Occasionally, bombs and bombing become the primary subject, as in the powerful red, gold and black semi-abstract flame- and spire-filled 1963 window by Harry Stammers in St Martin-le-Grand in York, a triumph of flashed, stained and abraded glass. Even more abstract is the magnificent Fire Window by Margaret Traherne in Manchester Cathedral, which is so intensely orange, fiery and hot it is as if the flames are raging behind a blown-out window. The original was made in 1966 to replace glass destroyed during the war, and remade by Traherne after it was removed by an IRA bomb in 1996.

Despite the cinematic vignettes of blitzes, it is rare to find a ruined, destroyed landscape depicted in a church window as the focus is far more on reconstruction, renewal and hope. So the post-bombing panorama of the East End of London designed in the early 1950s by Hugh Easton and painted by Hendra and Harper of Harpenden in St Dunstan and All Saints, Stepney, is highly unusual and worth a detour. The style is a mix of L. S. Lowry's cities and Paul Nash's World War I battlefields, and the blasted landscape is full of superb detail including burnt trees, wrecked homes,

distorted railings, skeleton gasometers, smoking chimneys and the church's melancholy churchyard. For what is now St George's Centre, Chatham, the same team of designers and makers also painted action-packed pictures of sea battles with battleships, explosions and flames, like Boy's Own illustrations in which you can almost hear the sound effects of whistlings and explosions.

Those involved with civil defence and dealing with bombings and raids are also commemorated in glass. We see people who fought in the war portrayed with dignity in their uniforms and badges – no need now to put them in medieval, historical or imaginary outfits – and these are good, often moving, historically accurate illustrations, as for example those by Arnold Robinson in Bristol Cathedral. At St James in Paddington the air raid warden raises the alarm, with a backdrop of the church at night illuminated by searchlights, like a still from an Ealing Studios or wartime propaganda film. In the Parish Church of All Saints with St Peter, Maldon, there is even a mobile tea canteen with a woman serving stretcher bearers and volunteers, which proves that bombs can even be the inspiration for a modern twist on the parable of the Good Samaritan.

See also BUILDINGS, FRAGMENTS, POSTWAR, VICTORIAN

## BUILDINGS

Architecture does not simply surround church glass, it finds its way into it, too. Buildings can be seen in backgrounds and foregrounds and, quite frequently, in the form of a small model of an entire building, such as a church, cathedral, temple or tower held in the hands or arms of a significant saint or figure. Interestingly for such a site-specific art – and this is something which is rarely discussed – there is not always an obvious (or even harmonious) relationship between the architecture in the windows and that which surrounds them. A single church may find itself with buildings in its windows which have no connection at all with the setting, and it should also be pointed out that some windows can appear shockingly insensitive or unsuited to the surroundings.

The range of building types to be found in stained glass is astounding and there is very little that does not make it into a window somewhere. (I'm still looking for a cinema, though.) It includes everything from towers, steeples, spires, churches, cathedrals, temples, ruins, castles, walled cities and Oxbridge colleges to suburban stucco houses with red-tiled roofs and dormer windows, thatched cottages, high-rise flats, colliery pitheads, factories, markets, town halls, power stations, warehouses, shops, sheds, barns, farmhouses and many more edifices. Buildings may be simple, hand-built, basic and plain, elaborate, exotic, extravagant and costly, grand and modest, imaginary or very real. They also cover a multitude of styles: Renaissance, Baroque, Brutalist, Classical, Neoclassical, Romanesque, Jacobean, Gothic, neo-Gothic, Georgian, Tudor, Modernist and Moorish. They range from the realistic and lifelike to the wildly imaginary, theatrical and cinematic, from the carefully detailed to the sketchily imprecise. They can be depicted from all angles, above or below, from near or far, as individual buildings or as a part of an evocative, sometimes recognisable skyline or roofscape. Windows also contain numerous artistic interpretations of shining hilltop New Jerusalems and Holy Land settlements which may resemble medieval English towns and castles, Disney-style princess towers and turrets, popular biblical illustrations or may, as in Christopher Whall's 1907 window in St John the Baptist, Burford, create a fantasy vision with a radiant mix of famous English and Italian landmarks and spires which should please any knowledgeable building-spotter.

One of the more intriguing sights in church windows is, as mentioned, that of an individual holding a small-scale building, rather like an architect's model. This is a convention in religious art whereby church founders, saints and prominent figures are shown with buildings such as the church, cathedral or abbey with which they are associated. It may be the church in which you are standing, or it could be another, so St Hugh of Lincoln often holds a model of Lincoln Cathedral but not always in churches in Lincoln itself, and St Chad, who founded Lichfield Cathedral, is also seen guarding the cathedral in various other churches. The holders may be church builders such as St Peter and St Paul, or they may be church founders such

as St Hilda of Whitby or St Etheldreda, who built a monastery in Ely in the seventh century and who is often shown holding Ely Cathedral (there is a fine St Etheldreda in St Nicholas, Blakeney). Buildings are also held, protected and looked after by angels, bishops, abbots, abbesses, sainted kings and queens, protectors and benefactors. Every time you find a building in someone's hands there will be a good story to go with it, as in St Lawrence Jewry, City of London, where an unhappy angel holds the bombed church against a dramatic backdrop of a burning, devastated London with St Paul's Cathedral silhouetted against the sky, while a much happier-looking angel holds the rebuilt church. More founders often seen holding their buildings include St Brigid, St Herbert, St Magnus, St Columba, St Aidan and St Cuthbert.

The process of building and rebuilding churches and cathedrals has also been commemorated in many church windows, occasionally in finely detailed, action-packed historical scenes. One of the clearest and best construction windows is the 1901 Kempe window depicting the rebuilding of Lichfield Cathedral in the 1660s: workers scramble up and down rope-lashed wooden scaffolding, stonemasons hammer and chisel, and bishop and architect discuss tiny but accurate plans and elevations while the enormous red cathedral grows behind them.

There is always an enjoyable jolt of recognition when you see the place in which you are standing shown in a window, rather like a Chinese puzzle ball but instead with a church telescoping into a church. Just as interesting is seeing the real, built environment which surrounds a church brought into the windows, as in Christ Church, Southwark, where many of the still-existing buildings which line the Thames – such as Bankside Power Station (now Tate Modern), warehouses, postwar flats and the Oxo Tower – can be clearly made out in the set of ten remarkable designs (F. W. Cole, 1961). Another favourite is the marvellous bird's-eye view of the Jewellery Quarter in St Paul, Birmingham, in Rachel Thomas' Millennium Window, which maps out every last detail of the built environment in what looks just like a town planner's model.

See also BOMBS, POSTWAR, SAINTS

## CANOPIES

A canopy is a projecting hood or cover above a statue set in a niche or recess, or over an altar or a figure in a tomb or monument. This architectural detail, borrowed and copied from those found in the church and furnishings, is widely used in stained glass to frame, surround and elevate a figure to greater eminence. Together with columns and pedestals, canopies are a way of housing or pinning down figures instead of having them apparently floating on the glass, and can also be useful theatrical devices, making figures appear to project forwards or to recede. Makers have clearly enjoyed using what effectively works as a proscenium arch to create illusions: see for example the masterly use of space and depth by George Hedgeland in his 1854 West Window in Norwich Cathedral.

Depending on the artist's style and chosen architectural references, which may or may not reflect the architectural style of the church which contains the windows, canopy work may be extensive or restrained, elaborate or simple, realistic or imagined. Most commonly it is Gothic, inspired by the medieval buildings which surrounded the early windows, although canopies have developed in many different directions over time and may mimic Baroque, Classical or Romanesque architecture.

Some of the most delightful and appropriate canopies are to be found in surviving medieval Gothic windows and in fragments preserved at the tops of windows which were too high to be smashed or removed during the Reformation. With their delicacy, appropriateness and range of detail (finials, pinnacles, crockets, ball flowers, tracery, cusps, foils, foliage), they illustrate just how well canopies can work in a window. Lovely examples can be seen in St Mary in Dennington, and in the Chapter House of Ely Cathedral, where there are tiny, gesturing figures of ordinary people in everyday dress. When Gothic came back into fashion in the mid-Victorian period, however, designers went into canopy overdrive. As the neo-Gothic movement progressed, they devoted more and more space to canopy work until many canopies dominated and overshadowed their contents, sometimes to quite an alarming extent. What was originally there to surmount and

surround an image ends up being used as mega-filler, an often stylistically incongruous framing device out of keeping with the image it contains, for instance when a naturalistic or realistic image is encased in extravagant canopy work, creating a jarring visual juxtaposition. Take for example the 1915 window by C. E. Kempe & Co. in St Peter, Binton, which illustrates Captain Scott's expedition to the South Pole in small, detailed scenes full of ice, snow, sledges and explorers which are almost lost in the overblown and out-of-scale canopies. Amazingly, this overuse of Gothic canopies continued right into the twentieth century, even when contemporary architects were moving on to the sleek lines of Art Deco and the austerity of Modernism.

Nevertheless, it is also possible to find beautifully detailed Victorian canopies which are simpler, smaller and less conspicuous but still play an important and well-integrated design role in a window. Lavers & Barraud (later Lavers, Barraud & Westlake) were particularly inventive and skilled in their canopy work, often flattening them into rich, decorative areas of colourful pattern surrounding a figure. Their windows can be found in many places, but there are especially good 1860s canopies to be seen in Worcester Cathedral and in the superb set of windows, also 1860s, in the deconsecrated church of St Mary Magdalene, Battlefield.

Once the Gothic convention had been questioned and played with, it was not long before canopies began to take on different forms and appearances. Christopher Whall is famous for his delicate, silvery, organic canopies inspired by natural forms such as vines and climbing, flowering, budding or fruiting plants and trees which bring a touch of the fairy-tale or storybook to a window (e.g. in Canterbury Cathedral). Karl Parsons, like other Arts and Crafts makers, adopted and adapted more humble structures for canopies: at St James the Less, Pangbourne, there is a very simple, arching bower with grapes and flowers over the lushly detailed Nativity-scene Mary, and at St Laurence, Ansley, a thatched structure on wooden uprights rather like a lychgate or market building acts as the canopy over another Nativity scene.

Many makers in the twentieth century have dispensed with canopies altogether, freeing the space, allowing a design more room to expand and creating a liberating effect on the eye, which is no longer guided by strict

verticals. Nevertheless, some postwar artists have used updated canopies to tremendous effect. Brian Thomas favoured Baroque-meets-Classical canopies with lots of flourishes of swishing curtains, swags and tails; his unique style includes all sorts of frames, borders and surrounds done in his rich, lively and beautifully tasteful way (e.g. St Vedast-alias-Foster and St Sepulchre, both City of London). Some of the canopies in Harry Stammers' windows could be made from Brutalist concrete rather than stone – albeit mixed with elements of a post-modern Baroque, as in Hull Minster and St Lawrence, Sandhurst.

See also BUILDINGS, TRACERY, VICTORIAN

# CARPENTRY

A lot of hard physical work goes on in stained glass. There are stonemasons, builders, farmers, reapers, bricklayers, blacksmiths, coopers and cooks, to name but a few of the occupations depicted in church windows. But because the Bible says that Jesus' father, Joseph, was a carpenter, that Jesus spent much time in his workroom, and that he, too, may also have been a carpenter, carpentry is the most commonly found skilled labour of all in stained-glass windows. And even though they are a perennially popular subject and have been illustrated many, many times, woodworkers, their workplaces and their tools are always fascinating to look at.

Today we can see that carpentry, a modest, practical, humble occupation which has barely changed over the centuries, forms a significant point of contact between the past and the present. It involves tools, benches and workplaces we can recognise, and has timeless qualities of usefulness, dignity and community that we can value. It is apparent that artist-designers who also work with their hands and materials connect with the idea of skilled, physical labour and are inspired to produce wonderfully rich portrayals of carpenters at work.

There is much to look at, and wood itself is a good place to start. It might be gopher wood, cedar or fir, with grains and knots adding texture,

colours and patterns. Then examine the workbenches and tables with their vices and planes: note the muscular forearms of the carpenter and the beautifully detailed coverings of fresh, curly or spiral wood shavings on the floor. Notice the different holders for tools – boxes, baskets, pouches and pockets – and count the many different tools which are still in use today, such as screwdrivers, saws, chisels, mallets, pincers, pliers, set squares, axes and, of course, the hammers and nails which prefigure the Instruments of Christ's Passion. Saws are extra-interesting because they present the challenge of effectively creating the illusion of shiny, reflective metal on glass – with some superb results (e.g. M. E. A. Rope's work in St Peter, Blaxhall). One of the most impressive collections of tools can be seen in a 1954 St Joseph window by the well-known cartoonist Thomas Derrick (1885–1954) in St Mary, Isleworth. Squeezed into a tall,

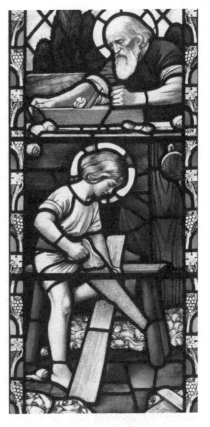

6. Detail of Childhood of Christ, by Ernest Board and Arnold Robinson (Joseph Bell & Son), 1925. Berkeley Chapel, Bristol Cathedral.

thin light and seen from an unusual perspective, as though from a stepladder, the many chisels and hammers and screwdrivers surround a modern carpenter in a radiating pattern, making an elaborate toolbox mandorla (see HALOES) and revealing the ingenuity of a clever stained-glass designer.

These traditional tools can frequently be found in stained-glass windows of the postwar period, when the subject of reconstruction was a pressing one and many churches were being repaired or rebuilt. Until then, most carpentry scenes featured a father and son(s) working together, side by

side: Noah is often seen directing or helping his sons as they build the ark, and Jesus frequently appears as a young boy or young man sawing and hammering alongside Joseph. But now non-biblical carpenters appear in windows, usually as part of a team of skilled workers, dressed in their contemporary work clothes, waistcoats, open-neck shirts, aprons, flat caps and sturdy shoes, unlike Jesus, who is frequently (and rather scarily) barefoot. It is always pleasing to find the workmen who contributed to the rebuilding of a church, cathedral, town or city recognised and included in this way. Three of the best postwar collections of skilled workers, including carpenters, can be found in London, where there was so much bomb damage to churches. They are in Christopher Webb's famous Wren window (1959) in St Lawrence Jewry, City of London, which contains many wonderfully detailed, miniature scenes of work, including a stained-glass studio; in F. W. Cole's marvellous 1960–1 series of local workers in Christ Church, Southwark, in which modern, automated woodworking tools are depicted; and in Lawrence Lee's lightly drawn and cleverly and amusingly placed plasterers and stonemasons in the Rider Memorial Window (1959) in Southwark Cathedral.

The theme continues in windows connected with individuals in the Bible who are associated with carpentry, such as the building, woodworking saints and apostles (e.g. St Joseph, St Jude and St Thomas), and who can be recognised by their attribute(s), often a carpenter's square or tools. In some recent windows the carpenters themselves may be dispensed with, leaving only the tools to represent the trade, the people and the stories, as in the lovely recent memorial window to a handyman churchwarden in Blythburgh, Suffolk, which shows his tools, bench, shed and shavings, perhaps just as he left them.

## CATHEDRALS

Given their stature and importance, you might automatically assume that cathedrals house the finest stained-glass windows in England. But I have

found that although they contain many superb windows, they are not necessarily always the best examples of periods, firms, designers and makers.

My visits to cathedrals have made me wonder if the most prestigious sites perhaps induce a degree of performance anxiety in an artist due to the importance of the commission coupled with a no doubt complex and sometimes restrictive commissioning process involving many interested parties. The results suggest this is true, as cathedrals tend to have more conventional, official-looking windows than those you might come across in smaller, less well-known churches, where a looser, more open and even daring brief allows a designer to give their vision and skills full expression.

So while English cathedrals offer outstanding and spectacular settings for looking at stained glass, not all of the windows are as tremendously exciting and groundbreaking as you might have been led to believe. (In addition, the soaring Gothic cathedrals are so tall that a great deal of the detail is difficult to make out with the naked eye.) On the other hand, cathedrals are stunning places to visit, and a number have lovely collections of glass which cover all periods and bring together many of the best makers. They are thus excellent places to look at and learn from. I have also found that although they may not have the most famous, the rarest or the oldest stained glass, the less starry, touristy and expensive cathedrals mostly have superb Victorian and twentieth-century glass in excellent condition, a scattering of good medieval glass and a happy mix of generally overlooked and underestimated styles and makers.

As a result, my list of suggestions for cathedrals to visit for stained glass departs somewhat from the usual top recommendations. I would much rather go to quieter cathedrals such as Salisbury, Bristol, Durham, Gloucester, Exeter, Lincoln, Norwich, Leicester, Lichfield, Newcastle, Wakefield and Chester to make my own discoveries than follow the crowds to look at the windows in often overcrowded places like Canterbury, York and Westminster Abbey. More favourite cathedrals include Ely for wonderful Victorian windows and Coventry's Stained Glass Museum for groundbreaking postwar glass, Manchester for semi-abstract and abstract modern glass by Tony Hollaway and Margaret Traherne, and Sheffield

for an extensive, colourful and entertaining mix. Lichfield has the stunning, imported sixteenth-century Herkenrode glass and wonderful early nineteenth-century prophets by Betton & Evans, and Christ Church, Oxford, has superb examples of glass by Abraham van Linge and Edward Burne-Jones, whose masterpieces can be seen in the small, elegant Birmingham Cathedral. Liverpool's Anglican and Roman Catholic cathedrals have very contrasting and brilliant examples of twentieth-century glass, and the two Bristol cathedrals have lovely postwar commemorative glass (Anglican) and extensive, colourful, 1970s abstract *dalle de verre* by Henry Haig (RC).

## CHRISTMAS

Although it might appear to be an obvious potential subject, Christmas is far less common in stained glass than you might imagine. The Church's focus is, of course, the Nativity, and there is an abundance of windows on this theme. But a little careful looking will uncover a few nice references in glass to domestic Christmas celebrations, and it is enjoyable to seek out cheery robins, snowy scenes, tinsel and brightly lit trees, wrapped-up presents and brand-new toys in order to see how stained-glass designers have dealt with the subject.

In fact, they and those who commission them are to be praised for avoiding commercialism and tackiness. Less is more in this case, and references to Christmas celebrations are usually oblique and relatively subtle in order not to divert attention from the more important messages. In any case, it does not take much to warm the cockles of the heart, as the two Margaret Ropes demonstrate. Both feature Christmas in wonderfully evocative, appealing and decidedly non-tacky windows. Margaret Agnes (M. A.) Rope (1882–1953) set discreetly small, glowing, candlelit Christmas trees in the border of one of her St Nicholas windows (made 1912–16), scattering wooden toys such as Noah's ark animals, a train and dolls around the children in St Peter and St Paul RC, Newport, Shropshire. Her cousin Margaret Edith Aldrich (M. E. A.) Rope created a cheerful 1940s Christmas scene with a tree, children

wearing their best clothes and a range of toys which any child would love. It can be viewed at close quarters from the balcony of the excellent café in All Saints, Hereford. Christopher Webb brings a light touch to festivities with little illustrations of Christmas trees decked with lights and baubles, which can be found in his Benedicite windows at St Margaret of Antioch in Isfield, St Mary in Wirksworth and St George in Toddington, the last with two children gazing up in delight at the angel-topped, decorated tree – a scene which itself would make a fine Christmas card.

This evocation of warmth, brilliance and joy against a backdrop of a cold, dark, winter night also characterises some of the most evocative and affecting Nativity windows. The Nativity is, of course, one of the most common and easily recognised subjects in stained glass and has been treated by artists and designers in a wide range of styles. Since certain elements are prescribed (baby, parents, stable, manger, kings, shepherds, farm animals, starry sky), it can be fascinating to see how a designer works with them and to consider why one window on the theme may be more memorable or moving than another.

Few medieval Nativity scenes survive, but where they do they are properly marvellous, without any affectation and with great, simplicity, sincerity and directness. They are uncrowded, sometimes just Mary and an old-looking, bearded Joseph leaning on his crook looking quite overcome, a benevolent cow, and perhaps a small crowd all gesturing in amazement with their hands; they focus instead on the miracle of birth as Jesus lies in an almost flashing, spiky golden mandorla. Lovely examples can be seen in St Peter and St Paul, East Harling (naive style, bright-red bull, fifteenth century), St Mary, Fairford (painterly, early sixteenth century), Great Malvern Priory (Jesus in eye-catching halo on a bed of straw, 1501), and All Saints, North Street, York (Mary in bed, wonderfully expressive faces, fourteenth century).

This early medieval style was much copied by the early Victorians: Nativity windows by William Wailes, William Warrington and Thomas Willement adhere closely to the earlier versions with humble details and a sense of affection and love. A little later, the large Victorian firms made

many a vibrant, energetic, theatrically lit and costumed Nativity, but the mid-Victorian period also produced innumerable sentimental, lifeless Nativities which resemble contemporary popular paintings and illustrations and, sometimes, waxwork tableaux. Nevertheless, even bad stained glass tells us something, and today it can be enjoyed as a piece of popular visual culture, for the richness of detail and for what would now be considered quite astounding sanctimoniousness.

Far better and more interesting are many of the Nativity windows made since the late nineteenth century. Although there were still plenty of conventional and generic treatments, this is the period when Nativity scenes turn into superb, unique examples of stained-glass art. In the hands of a good artist/designer who brings something of their personality and distinctive style to it, the subject can be reinterpreted and refreshed. As a result, Nativity windows make an excellent introduction to some of the best individual makers of stained glass since the late nineteenth century. These include Edward Burne-Jones at St Mary, Rye; Henry Holiday at St Michael and All Angels, Bootle, Cumbria; Louis Davis at St Martin, East Woodhay; Henry Payne at St Botolph, Carlton-in-Cleveland; Karl Parsons at St Matthew, Oxhey; J. E. Nuttgens at St Anne, Bath Road, Buxton; Harry Stammers at St Peter, Dumbleton; George Cooper-Abbs at St John the Baptist, Coventry; Lawrence Lee at St Mary the Virgin, Cuddington; and Trena Cox at St Oswald, Bidston.

See also ICE, TOYS

# CORNERS

In exactly the way that real corners collect and hold bits and pieces, odds and ends, so too do the corners of stained-glass windows. It is rare for a designer to overlook the usefulness of corners in a design, so they should always be investigated.

A well-used corner, seen at close quarters and thus as a cropped section of the whole, can look like a miniature stained-glass window in itself, a

repository of small motifs and objects relating to the central theme of the window which helps to balance out a design or make a scene fill the entire space. Some resemble flower paintings featuring small-scale flowers such as daisies, marigolds, lilies of the valley, snakeshead fritillaries and crocuses (e.g. Karl Parsons in St Alban, Hindhead), while others become corners of gardens with minutely detailed blades of grass and flowers, feet, shoes and toes treading lightly around chirruping birds, young rabbits and the occasional hedgehog. A corner may also be a detail of an indoor scene with a section of floor, patterned, tiled or laid with black and white marble, while the corner of a window which depicts children may have casually discarded toys, as in real life, such as a stuffed panda or a pair of giraffes from a Noah's ark (M. E. A. Rope, All Saints, Hereford). Some artists even manage to cram a tiny figure or two into the right angles of a light to create subtexts and commentaries within much bigger stories; in her stupendously good window in St Michael, Northchapel, Wilhelmina Geddes (1887–1955) fits in little angels and praying monks with glowing lanterns, which embellish and expand the main narrative. Others, like David Evans (1793–1861) in St Chad, Shrewsbury, create a clever *trompe l'oeil* effect with a gilded wooden frame which meets at the corners.

The lower corners are also often the personal part of a window, where the maker can leave their mark, full name, initials, address and even postcode for future reference and potential business. G. E. R. Smith, for example, left his 'calling card' in many churches. A maker may add a date, a message, a dedication, an explanation of who did what – the more generous and collaborative will acknowledge assistants by name or initial so that sometimes there can be a whole story of making in a corner (as in the 1964 window by Florence, Robert and Walter Camm in the Collegiate Church of St Mary, Warwick, which gives over one corner to a full explanation of who did what in tiny, neat lettering). Corners also hold dedications and perhaps details of the dedicatee, tiny potted histories of lives of service to church, family, community or country. The hand-painted lettering may be in Gothic script, simple capitals or beautifully formed italics. Occasionally,

a corner will contain an artist's signature: John Piper signed his windows with an extravagant flourish, and Marc Chagall always added his distinctive, wobbly signature made up of a mix of lower- and upper-case letters plus the date and place of making, as in his wonderful series of windows in All Saints, Tudeley.

See also FEET, FLOWERS, FRAGMENTS, MAKERS' MARKS, TYPOGRAPHY

## CROWNS

For every doodler who has added crowns to mugshots or sketched designs on exercise books and in margins, for anyone who wishes tiaras were everyday wear or has stood spellbound in front of the Crown Jewels or the jewellery collection in the Victoria and Albert Museum, stained glass is a treasure trove of sparkly, golden headwear. Circlets, diadems, coronets, crowns, tiaras, headbands and wreaths can be found on heads, in hands, on cushions, floating above a figure or as the main subject of roundels and quarries set in clear or patterned glass. A symbol of deity, immortality and martyrdom, a mark of royalty and authority, but also a piece of jewellery, an accessory, something pretty to encircle a youthful head, a crown is often worn by Christ ('King of Kings') and the Virgin Mary, as well as by many saints, prophets, kings and queens, princes and princesses, nobles, angels and maidens.

Crowns appear in innumerable windows, making one wonder if, sometimes, they are as much a solution to a design problem and the question of what to do with the top of a figure as a true necessity. This does not detract from the pleasure of searching for them, though, for crowns bring a touch of glamour and inventiveness to even the dullest, most conventional and uninspiring scene, and it does not take an enormous amount of glass and imagination to fashion a lovely crown.

Designs may be based on those in the traditional British hierarchy of crowns, which denote the wearer's rank from sovereign to baron, or on historical and European styles (e.g. Anglo-Saxon, Tudor, Victorian, Dutch,

Italian). They may be sturdy, unosten-
tatious (especially as worn by saints in
war memorial windows) and realistic.
Or they might be straight out of the
realm of fancy dress and doodling fan-
tasy: outsize, tall, sparkly and pointy,
like that worn by the Company of
Mercers' emblematic maiden in City
of London churches or those on the
heads of William and Mary in Max
Nauta's (1896–1957) superb 1954 win-
dows in the Dutch Church, Austin
Friars, City of London. There might
even be a collection and range of
crowns: Nativity windows showing
the Three Kings are a great opportu-
nity to include three variations, such
as the wonderfully theatrical 1940s

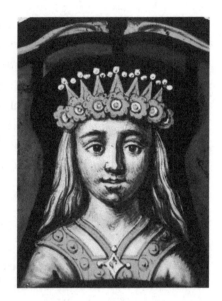

7. Detail of crown, maker unknown,
Netherlands, seventeenth century.
St Mary, Preston on Stour.

crowns created by J. E. Nuttgens' in Holy Trinity, Sissinghurst, while in
1955–6 John Piper managed to come up with nine different crowns for his
nine figures of Christ in Oundle School Chapel. Alternatively, a designer
can choose to be less showy, especially with angels and young girls, and
bestow a dainty, delicate, filigree tiara, a simple diadem or headband, per-
haps with a single, central gem and ribbons fluttering behind, or a pretty
circlet of pearls.

But a crown does not always have to be made of precious metal and
jewels. There are lots of short-lived, natural, floral crowns on small chil-
dren and young girls, little circlets of fresh daisies and delicate flowers.
Look at windows by Arts and Crafts designers such as Karl Parsons and
Christopher Whall, and windows by Victorian firms such as Heaton, Butler
& Bayne, whose star designer, Arthur Hassam, crowns the heads of wide-
eyed, long-haired young girls with pretty wreaths (e.g. St Mary, Putney).
Christ's crown of thorns, one of the Instruments of the Passion, is often

depicted in gruesomely realistic detail with juicily thick, entwined stems, nastily sharp thorns and sometimes drops of blood, although some artists turn the stem-and-thorn crown into a metallic golden version. And many ordinary people, onlookers and bit-part players wear what could be considered poor men's crowns made of rings of fabric twisted together; these may be everyday wear, but in the context of stained glass they take on the added meaning of blessedness, grace and humility.

See also DALLE DE VERRE, HAIR, HALOES, KEMPE

## DALLE DE VERRE

Although *dalle de verre* is not stained glass as such, it belongs in this book because there is so much of it in English postwar churches, and because the best is spectacular and will be of interest to anyone who enjoys church glass.

*Dalle de verre* is a French term which translates as 'slab of glass' and refers to windows made from thick (2–3 cm) pieces of glass set in concrete or epoxy resin, as opposed to 'stained glass', which uses thin pieces of glass held together by lead strips or cames/calmes. It is a relatively new technique; although some designers were experimenting with it in France from the late 1920s, it came to the fore in the postwar period when it was widely used in France and taken up in other countries, including Germany and England. Because the combination of thick glass and concrete or resin is solid and strong, it can be used to fill whole walls of churches, creating vast curtains of colour in the same way medieval makers did in the French Gothic cathedrals (e.g. Chartres, Bourges), but faster and more cheaply. An expanse of *dalle de verre* can be a lovely thing, especially when it reaches down to ground level and it is possible to get close enough to see the textures and the bubbles in the glass and to see (and feel) how the pieces have been deliberately hammered, chipped and faceted so that they create dynamic and dancing effects with the light.

*Dalle de verre* tends to appear in new churches built in the late 1950s and 1960s (its heyday) and into the 1970s, mostly in areas of new housing in urban

and suburban areas (e.g. Coventry, Sheffield, Manchester, Birmingham, Harlow). It is more common in Catholic churches built to new designs intended to reflect the liturgical changes made by the Second Vatican Council (informally known as Vatican II), some of which still look startlingly and excitingly ultra-modern and unusual. The designers of the best *dalle de verre* windows are often French, but not exclusively so. It is interesting that, unlike the anonymity associated with so much traditional stained glass, the designer's name really does count here and is generally mentioned in church websites and guides, almost as a matter of pride.

Some may regard *dalle de verre* as a clumsy, chunky, unsubtle type of window, but that is to underestimate the potential of the large-scale concrete-and-glass combination. A well-designed, abstract *dalle de verre* window is a stunning play of colour, pattern and light. In the right hands – and only a few makers have truly mastered the art – it is quite brilliant and breathtak-

ing, yet also surprisingly detailed and delicate. *Dalle de verre* may be out of fashion now, but it still has the capacity to create wonder and delight and surprise – which is exactly the purpose of stained glass.

*Dalle de verre* windows achieve superb large-scale effects. They may be fluid and swirling: see for example Margaret Traherne's huge 1963 window in Manchester Airport's Terminal 3 prayer room, which deliberately suggests the movement of parachutes through the air, or the enormous, stunning windows (1965–73) by Henry Haig in Clifton Cathedral which evoke vast skies and landscapes. They can also be abstract and dramatic, or abstract

8. Detail of angel in *dalle de verre*, by Gabriel Loire, 1962. St Richard RC, Chichester. The church houses the largest collection of Loire glass panels outside France.

and serene – John Piper/Patrick Reyntiens and Margaret Traherne respectively at Liverpool Metropolitan Cathedral. And there is nothing to stop them being pictorial, too: in some ways it is an even greater achievement to create expression and emotion with the simplest and chunkiest of materials.

Gabriel Loire manages this superbly at St Richard RC, Chichester (1962) in one of the finest displays of *dalle de verre* in the country. The major windows are filled with a mix of simplified graphic versions of traditional subjects and brilliant mosaic-like patterns, while the windows that run round the clerestory tell stories in often amusingly direct ways which are reminiscent of medieval windows in places like Canterbury Cathedral. Crude golden circles become angels' hair (it looks to me as though it's in rollers), long, thin, pale slivers of glass are fingers or hands pressed together, three or five pieces make a sky-blue or cerise bobble hat, and a pattern of camouflage-coloured slabs denotes a soldier's uniform. When you look at the windows from the outside, you see how the concrete and glass create a reverse pattern, and at night when the lights are on inside the church, it looks just like a magic lantern.

See also ABSTRACT, EUROPEAN, GLASS

# DICE

More used to associating dice with gambling tables, games of chance and rear-view mirrors, some viewers may be puzzled to find them in a church window; and even more baffled when they discover nearby other seemingly random objects resembling a stained-glass version of Monopoly pieces: a simple shirt, a handful of nails, a pair of pincers, a money bag, a ladder, bucket or lantern. There might also be a whip and a torch, sword, spear, rooster or pillar scattered about or collected together on a shield or series of shields. Many times they are not drawn to scale or in any order, so they look like surreal miscellany in a junk shop or toy box.

Those in the know, though, will recognise that these items are all, dice included, the Arma Christi, the arms of Christ's Passion or suffering in the

final period of his life before he was crucified. The group, also known as the Instruments of the Passion, has a long tradition in Christian iconography and in stained glass from medieval times to the present. Many of the objects' meanings can be worked out quite easily – the hammer for nailing Jesus to the cross, the pincers for removing the nails, the ladder for bringing him down – but others require a little more knowledge. So it may help to know that the dice represent those rolled by the soldiers who gambled for the seamless robe or shirt Jesus wore before the Crucifixion, which is why they can also sometimes be found on the shirt itself.

Even without deep, basic or any knowledge of the Bible, it is interesting to see how artists organise and handle the instruments, not all of which appear every time. As they are the 'arms of Jesus', they are often treated in a heraldic style. Each instrument may appear on its own shield, perhaps held by an angel, or you can find a number crammed in a semi-organised way into designs on a single shield (King's College Chapel, Cambridge, sixteenth century; All Saints Pavement, York, fourteenth century), or two arranged like a coat of arms with, for example, pincers crossing a hammer (there is a fine set in Leicester Cathedral). The instruments are also popular filler subjects for tracery, where the small openings have the effect of making them look less randomly scattered (e.g. St Mary the Virgin, Clumber Park), for borders where they make eye-catching patterns which also tell a story (e.g. St Sepulchre, City of London), and for clear, neatly arranged predellas (e.g. Winchester Cathedral).

More recently, some designers have chosen to make a set of chosen emblems the main subject of a window by presenting them in a series of medallions or vignettes and relying on their known meanings to create a direct visual shorthand. Leonard (L. C.) Evetts (1909–97), many of whose very fine windows can be seen in north-east England, made several beautiful and cleverly handled Passion windows in this way. His 1953 windows in St Andrew, Girton, and his 1958–9 ones in the Cathedral of St Nicholas, Newcastle, set a number of small instruments within windows made up primarily of dazzlingly clear glass and bold leading. His distinctive technique of mixing a modern, angular, silhouetted stencil style with pale tints and

washes, plus areas of stain and vivid colour, makes the instruments look like glowing miniature prints with enormous frames. He proves again that although dice in windows have a far from playful meaning, they can be handled with a light touch.

See also CORNERS, FRAGMENTS, TRACERY

# DOGS AND CATS

## DOGS

Even the most dog-averse person cannot fail to be intrigued and charmed by the enormous variety of dogs in church windows. I speak from experience, having found myself uncharacteristically drawn to sleek greyhounds, wiry terriers, faithful working dogs, mascots, and plenty of characterful and much-loved pets and companions. I have been impressed by the way that most designers and painters have avoided overtones of sentimentality and created dogs with appealing personalities, clear expressions and finely textured coats, in beautifully drawn and painted shapes and colours, which fit perfectly into the overall design like the last piece in a jigsaw. These dogs are part of the long-standing overlap in stained glass between the sacred (several Bible stories and saints involve dogs) and the secular (heraldic, hunting, domestic and working dogs) which runs all the way from medieval to contemporary windows and acts as an illustrated narrative of humans and their dogs through the ages.

The details are sometimes intricately drawn, with every last detail of fur and marking painted with a fine brush – this is particularly true of the many greyhounds, pointers and whippets in seventeenth-century glass and the portraits of faithful pets in many twentieth-century memorial windows. But there are many 'broad-brush' dogs too, although a less-than-sure hand can result in some dogs looking like sheep, large rats or hybrid animals, while others have very strange, cartoonish and un-doglike expressions. Successful medieval and modern examples can be some of the

most memorable stained-glass dogs because they have real character and immense likeability. In terms of breed, you will find just about every type of dog imaginable: Labradors, Scottish terriers, Pekineses, Welsh collies, dachshunds, beagles, spaniels, big shaggy pets, tiny 'handbag' dogs with their mistresses, plus all sorts of cross-breeds and mongrels.

Dogs are also a good subject to search out because they are nice and easy to find. Look for them in windows featuring saints whose stories include a dog, such as St Giles, who saved a deer from a hunting dog; St Bridget and St Francis of Assisi, who are both associated with kindness to animals; and St Frideswide, who flees an unwanted marriage to a prince and is chased by the King's dogs. In his stunning window in Christ Church, Oxford, Burne-Jones creates a pack of nasty, brutish hounds who strain at the leash as they search for St Frideswide while she cowers in a pigsty. Or look at heraldic glass, which contains large numbers of greyhounds – although spaniels, terriers and mastiffs may also be seen – often in traditional heraldic positions (rampant, couchant, etc.). Sleek creatures with obviously fine pedigrees appear in scenes depicting royalty and aristocracy, although there is the occasional enjoyable exception to the rule such as the tiny corgi rampant in Douglas Hogg's 2012 Queen's Jubilee window in the Queen's Chapel of the Savoy. Hunting and working dogs are most likely to be in churches in agricultural and rural areas; Yorkshire is particularly canine-rich, with lots of sheepdogs (Harry Harvey, who worked in York, was fond of dogs and created many with lots of personality, both in Yorkshire and further afield). And, finally, well-loved companions and playful pets, from scruffy to glossy, shaggy to tightly curled, tiny to huge, pop up in churches in children's windows and memorial windows; a very fluffy pet Pekinese called Bundle features in a 1961 memorial window by Francis Spear in St Bartholomew, Greens Norton.

## CATS

Cat lovers have to search harder than dog lovers as there are far fewer cats and kittens in stained glass. Mostly they are to be found in twentieth-century

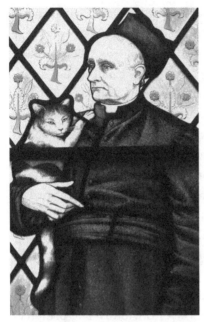

9. Detail of Arthur Henry Stanton with his cat, by Sir Ninian Comper, 1928. St Mary the Virgin, Wellingborough.

windows: wide-eyed, fluffy, tortoiseshell, white, tabby, ginger or black, sometimes sweet and very strokeable, sometimes immobile and inscrutable, and occasionally playful. John Hayward's Dick Whittington is accompanied by his famous cat in St Michael Paternoster Royal, City of London; a 1953 window by Trena Cox places a small but very appealing pure white kitten at the feet of St Francis in St Chad, Farndon, Cheshire, and Christopher Whall includes a homely, fur-licking, stripy cat and her big-eyed kittens in a 1909 sickbed scene in All Saints, Brockhampton. But my favourite, the one that makes me laugh because it completely 'owns' the window, is not at all adorable and appealing. The real-life Clergy House cat, Blobbs, has a scarily malevolent look, with narrowed eyes which warn and challenge the viewer as the cat places a proprietorial paw on the shoulder of Anglo-Catholic priest Arthur Stanton (1839–1913), who stares vacantly into the middle distance as if under a spell (by Sir Ninian Comper, 1928, in St Mary the Virgin, Wellingborough).

See also ARK

# DONORS

Stained glass has always been expensive, and churches often need financial assistance to fill openings with anything other than plain glass. Looking at windows in the light of who gave them is fascinating and rewarding; scanning them for donors, picture clues, dedications, names and dates, or

consulting a guide to discover who gave what, reveals them to be a rich source of material on local, social and family history.

In the world of stained glass, the most famous donors are the medieval benefactors who not only paid for the glazing of churches but also appeared in the windows. It was accepted that by giving the money you could expect to see yourself in the glass, perhaps with an inscription asking for people to pray for you, making the act of giving just as much about showing wealth and influence as piety and generosity. Sponsors were usually local lords, ladies, gentry, dignitaries and clerics, and they can be found kneeling and praying near the base or in the corners. They may be tiny in comparison to the sacred figures, as in the delicately painted and rather ghostly late fifteenth-century family group (mother, father, 19 children) at St Eata, Atcham. Or they may be larger, more naturalistic and integrated, or even the main subject of the window, as in the renowned series completed in 1494 in Holy Trinity, Long Melford. Here the generous local donors are depicted in their finery: patterned robes, ermine, jewels, tassels, lace, long fancy gloves and shining armour. Elevated to the position usually occupied by saints, they advertise both their power and their devotion.

The most endearing medieval donor windows are those in which groups or families kneel and face the same way (sons lined up behind the father and daughters behind the mother). St Neot in St Neot has several excellent examples of these medieval line-ups from the 1520s, set out like little toy figures. The Wives Window, given by the women of the parish, has five sets of five wives in coordinating dresses and headwear, all kneeling and praying, while the Borlase Window shows mother, father, four sons and eight daughters neatly arranged and memorialised together forever.

Individual donors also make the occasional appearance. York's medieval churches contain several good portraits, including one at St Denys with a very rare example of a donor holding a model of the window he has given (c.1340), although it is necessary to work hard to find the other modest benefactors. Some donors, though, are more than happy to take centre stage. Henry de Mamesfield, benefactor of Merton College, Oxford, is pictured

in pious pose no fewer than 24 times in the college chapel windows as he kneels on either side of each of the 12 apostles. Although the medieval donor-in-the-window tradition disappeared with the Reformation, it has on occasion been revived. At Ely Cathedral, Bishop Sparke is seen kneeling at the base of the window he donated in 1857, but my favourite is the 1937 West Window in St Mary, Rye, given by E. F. Benson of *Mapp and Lucia* fame in memory of his parents Archbishop and Mrs Benson. There in the corner is E. F. Benson himself in his mayoral robes, kneeling in true medieval fashion.

The question of who donates windows and why resurfaces with glass installed from the 1840s onwards, when windows more or less replaced stone monuments as memorials. Many donors are local families wishing to leave their mark on a church, and the happiest windows are those whose donors wish to celebrate a life or lives. I like the notification on the two 1863 windows in St George, Everton, which explains that they were donated in memory of their parents by their 11 surviving children. The saddest are the windows given by bereaved parents and families of those who died young or in war. World War I memorials are particularly upsetting, as donors often mark the loss of one or more young sons.

Congregations frequently club together to donate a window, for example in memory of a vicar, vicar's wife, rector or churchwarden, as thanksgiving for a church surviving a war, to celebrate a Sunday School or Mothers' Union, or to mark a significant anniversary or the millennium. In the past, the donors would have remained anonymous, but today many donors like to have their contribution recorded and some windows now come with a memorial book in which names are entered for all to see (e.g. the Laurie Lee memorial window in Holy Trinity, Slad). Churches have also always accepted windows paid for by local commercial donors as gestures of goodwill and support, or because a church is a company's parish church, or perhaps to promote their business. The medieval 'trade windows' in Chartres Cathedral in France are the best known, action-packed adverts for local businesses. On the occasion of its centenary in 1984, the Durham branch of Marks & Spencer made a gift to Durham Cathedral of a 'Daily

Bread' window (nice subliminal message) by Mark Angus. J. Sainsbury included a shopping trolley in the window they sponsored in 1984 in Christ Church, Southwark, and the logo of the local London Metropolitan Water Board appears in their 1962 window by A. E. Buss in St Mark, Clerkenwell. Guilds and livery companies also have paid to have their coats of arms in the windows of their parish church. Those in the City of London churches may at first glance appear predictably official and heraldic, but on second look turn out to include many fine details, trade-related tools, products and historical motifs. There is a lovely fruit-filled one in St Mary Abchurch for the Fruiterers' Company, and that of the Glovers' Company (motto: 'True Hearts and Warm Hands') in St Margaret Lothbury advertises its business interests with impressively large gloves and leather gauntlets. There are more outside London, too. The finest contemporary example is the Millennium Window by Rachel Thomas in St Paul's in Birmingham's Jewellery Quarter, the result of a competition run by the Birmingham Assay Office. It is a superb and clever design which incorporates many aspects of jewellery-making and local history and proves that corporate money can be used to make wonderful windows at a time when churches in England have to rely on the generosity of donors to keep the art and practice of ecclesiastical stained glass alive.

See also ERMINE, EUROPEAN, KNITWEAR AND KNITTING, MILLENNIUM

# DRAGONS

There is so much saintliness and sentimentality in stained glass that it can be quite bracing to come across a terrifyingly malevolent, snarling, reptilian creature with crocodile jaws, shark-like teeth, spiky webbed wings or a barbed tail, possibly breathing fire to add to its aura of nastiness.

Dragons have loomed large in popular fantasy culture for centuries, and stained-glass dragons are equally enduring. They overlap with myth, legend and horror, and are one of the few openly and overtly aggressive, blood-thirsty and truly scary creatures to be found in church windows. Although

there is a move today to meeker, friendlier, tamer and more cartoonish dragons which terrify nobody, there is nothing to beat a huge, roaring, sharp-clawed, serpentine dragon with a spear through its mouth for shock value and dramatic effect. Indeed, many an otherwise mild stained-glass designer pulls out all the stops with their dragons, revealing often surprising and unholy levels of aggression and violence. In ecclesiastical art, dragons are universally recognised as the embodiment of evil, untamed nature and the enemy, and are sometimes identified with the Devil. They appear with a saint or Jesus standing above or on their back to symbolise the taming of nature and destruction of evil, and are commonly associated with certain saints, such as the Archangel Michael, St George and St Philip, who are all successful dragon slayers. However, although a fighting or slain dragon often illustrates and celebrates a hero's masculinity, it is not just the men who tussle with dragons. St Margaret of Antioch displays equal strength and fearlessness when standing astride her defeated quarry. At St Mary, Fairford, she is pictured with a brilliantly strange goggle-eyed dragon which features spotted and chequered skin.

Designers do many wonderfully dramatic things with dragons, and there is no end to their inventiveness and imagination. They are often depicted as fantasy creatures par excellence, repellent and pulsating with evil intentions. Many are scaly, writhing and horribly contorted as they curl and wind their frighteningly powerful bodies round the legs of their attackers, almost crushing them in great curves and twists which add shape and movement to windows, although a few look utterly and occasionally laughably downtrodden, their half-open eyes rolled upwards in defeat. Claws, scales, teeth, tongues, warts, bumps, flared nostrils, flames, black eyes, pointy ears, huge webbed wings, spiky spines and remarkably clear expressions are all parts of the visual vocabulary mixed up in different ways to create a huge variety of individual dragons.

Dragons also reveal their makers' mastery in the choosing and handling of materials, and are often made using the best-quality flashed glass in order to increase the visual impact and to produce unearthly looking dragon skins. Makers paint, abrade and apply acid and stain on glass to achieve depth and

texture, which is why some dragons have shimmery, pearlescent, iridescent and multicoloured surfaces. Even single-coloured dragons can be spectacular and their colour or mix of colours – blue, red, purple, green, grey, brown, pink – the stuff of fantasy and horror.

As for the dragon slayers, there is undoubtedly an almost sadistic, determined aggression in the eyes of a few, while others appear to be winning the battle without too much exertion. Nearly all strike a pose, some in the superheroic act of killing, some like big-game hunters who have just killed, and many – often handsome young men in war memorial windows – in fierce martial stances. Chain mail, suits of armour, military uniforms and flowing robes are commonplace, usually making dragon windows dense with elaborate detail and incident, to the point where an enormous dragon, amazingly, can be almost camouflaged.

Christopher Whall created a number of very fine dragons in shades of blue and grey: royal blue, air-force blue, lead grey, pewter and silver. Both Margaret Ropes created some very scary blue dragons, while Florence Camm made wonderful iridescent dragons, as if the beasts are reacting to heat and cold. C. E. Kempe is particularly strong on multicoloured dragons with finely wrought details of markings and scales. One of his best is in Winchester Cathedral, a downcast red-and-gold snakeskin dragon with broken sword through its mouth and tied by St George to a balustrade like an obedient dog. As you might expect from somewhere with dragons on its coat of arms and dragon boundary markers, the City of London has a fine collection of mostly postwar stained-glass dragons, and cathedrals everywhere are good hunting grounds for dragons from every period.

See also GLASS, HORROR, KEMPE, SAINTS

# ERMINE

In Holy Trinity in Long Melford I was puzzled by the sight of what looked like sprouting seedlings or strange, furry insects on the robes of the donors

in the superb series of late fifteenth-century windows there. There was nothing in the guidebook to explain these funny little objects and, not being au fait with heraldry, I had no idea that these were in fact ermine spots, shown as black shapes arranged in patterns on a white background to represent the black-tipped tail of the stoat (aka ermine or short-tailed weasel) and its white winter coat. I now know that these markings have come in a variety of stylised, heraldic representations over the centuries. Some look to the layman remarkably like little black tadpoles, squashed centipedes or millipedes, small feathers or false eyelashes, commas, seedlings, sprouting beans, quavers and semiquavers, clubs on playing cards, and animal and bird footprints – which is how I still like to see and think of them. I also know, having spent more time searching, that there are an awful lot of them in stained glass to keep the eye entertained and that much of the fun of looking at ermine is seeing how it is shown and just how many versions there are.

10. Detail of ermine in donor window, maker unknown, late fifteenth century. Holy Trinity, Long Melford.

Since ermine, prized for its rarity and whiteness, is the traditional, ceremonial fur worn by kings and queens, peers and bishops, lords and ladies, local aristocrats and patrons, its spots can be found on the cloaks, copes, mantles, tippets, collars, trimmings, edgings and linings worn by high-status figures. Royalty, up to and including Elizabeth II, wear it, occasionally in full coronation robes, as do peers (whose rank is indicated by the number of rows of black spots or tail-tips). There is a lovely textured, strokeable tippet worn by a lord in the Queen Victoria Jubilee window

in St James, Paddington, a contrast to the flat, wriggly ermine in Comper's comically awful 1954 royal window in Canterbury Cathedral.

However, ermine is not just reserved for historical and living personages. It is also used on the garments of religious and biblical figures, thus conferring metaphorical nobility on them. Medieval angels wear ermine in York Minster, and fifteenth-century angels in All Saints, Bale, sport little ermine capes. Archangels also occasionally reveal ermine spots, perhaps with highlights of bright gold stain, and C. E. Kempe puts touches of ermine on seraphims' tippets in St John the Evangelist, Cowley, Oxford. Perhaps more surprisingly, given their modesty and self-sacrifice, saints, especially those with royal lineage, also occasionally wear ermine: the robe of M. E. A. Rope's St Etheldreda in St Mary Magdalene, Ickleton, has deep ermine cuffs while in St Cyprian, Clarence Gate, London, architect/designer Sir Ninian Comper depicts both St Mary Magdalene and St John with ermine-lined robes.

Several designers have a distinct penchant for ermine. William Peckitt (1731–95) drapes it over the shoulders of his sumptuously dressed and crowned prophets in New College Chapel, Oxford, and again in York Minster over the prophets Abraham and Solomon (the latter, incidentally, wears one of the best, most ornate and sparkly pieces of costume jewellery), thus effectively presenting them as kings. But the aforementioned Comper outdoes him – and most other makers – with his obvious passion for ermine, which embraces all the pomp and symbolism that goes with it. His windows are filled with people in ermine, which he often complements with his characteristic, regal palette of gold, white and purple. Fine examples include the windows in his masterpiece church, St Mary the Virgin in Wellingborough, and his Christ in Majesty in Southwark Cathedral.

Many representations of ermine can also be found in heraldic windows. One of the best concentrations is in Lincoln's Inn Chapel, and ermine can also be seen, appropriately, in the coat of arms of the Skinners' Company in City of London churches such as St Mary Aldermary.

See also CROWNS, HERALDRY, TEXTILES

## EUROPEAN

The phenomenal sixteenth-century Herkenrode windows in Lichfield Cathedral are the largest and finest examples of European glass in England, but there is plenty more of it to be found in churches up and down the country. In the early nineteenth century Grand Tourists, dealers and collectors on the Continent snapped up large quantities of glass which had come from abbeys, churches and private houses in north-east France, Germany and the Low Countries and installed it in their own homes and nearby churches (much of the excellent collection of European glass in the Victoria and Albert Museum was acquired this way). The local market in imported glass was brisk, and enthusiastic vicars bought from dealers such as

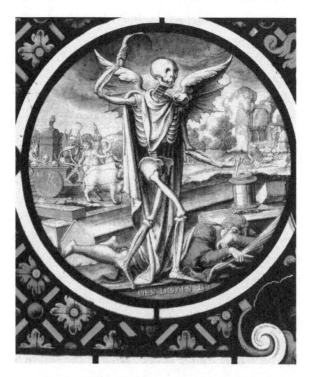

11. Painted roundel, maker unknown, probably Netherlands, seventeenth century. St Mary, Preston on Stour.

J. C. Hampp (1750–1825) in Norwich, a notable saver of glass who supplied several Norfolk churches with fine pieces of late-medieval Continental glass. Later collectors, too, acquired glass through sales and dealers, and Exeter Cathedral received remarkable sixteenth-century Franco-Flemish glass in 1918 from the private Jerningham Costessey collection. As a result, large numbers of even the most out-of-the-way English churches house some European glass.

Fortunately, it does not take long to discern the differences between English and Continental glass as the two frequently coexist, making them easy to compare in terms of scale, subject, colour and technique. A lot of the imported work dates from the seventeenth and eighteenth centuries, and there is a prevalence of small, minutely detailed, often exquisitely painted pieces and roundels. Subject-wise, European glass often contains what could pass for busy, action-packed, Bruegelesque genre scenes until you look more closely and find lots of gruesome, graphic details. It is more direct, down to earth and realistic (sometimes grotesquely so) than English glass; it is unsettling, brutal and even shocking at times, and often deals with a different range of subjects such as skeletons, figures of death, bears eating people and whales swallowing Jonah. Techniques focus above all on painted narratives often in miniature, similar to the style of painting on porcelain or Fabergé eggs, using the glass as a canvas. Leading is minimal and is used mostly for outlines.

Since glass brought from Europe was not made to measure, it has had to be adapted, reset and extended to suit the new locations, and it can be interesting to see how the glass fits in. Many pieces are set very simply in clear glass, but occasionally it is obvious that a real creative effort has been made to integrate imported glass into a bigger design with surrounds, borders and fillers made by local companies and glaziers. See for example the bright, boiled-sweet colours placed in c.1816–20 by S. C. Yarington round the palely naturalistic seventeenth-century Flemish roundels in St Peter, Nowton. To some the results may look garish and clumsy, to others they may offer an interesting resemblance to subversive paintings by Gilbert & George, who have frequently been inspired by stained glass.

When considering European glass, it is also worth looking at the ways in which foreign artists and designers have influenced domestic English glass. This may be very directly: in the sixteenth and seventeenth centuries, a period when English glass was barely surviving and many local skills had been lost, refugee Flemish glaziers who lived and worked in Southwark were responsible for the outstanding windows in King's College Chapel, Cambridge, and in St Mary, Fairford, while Abraham and Bernard van Linge received prestigious commissions for several Oxford colleges and Lincoln's Inn Chapel. Indirectly, too, they had an impact on the style of glass made pre-1840, after which the neo-Gothic revival and home-grown talent flourished. Look at the work of David Evans of Betton & Evans of Shrewsbury (e.g. Lichfield and Winchester Cathedrals and many Shropshire churches), which is now often considered lurid and in bad taste but which I love for its vibrant colour, splendour, experimental approach and obvious difference to so much of what followed. Interestingly, it did not stop there, as the late nineteenth- and early twentieth-century windows by Burlison & Grylls owe a great deal to European glass. Even today the Flemish genre style can be discerned in beautifully painted, characterful and down-to-earth work by the likes of Chris Fiddes with Nicholas Bechgaard at St Nicholas in Potterspury, St Mary in Hardwick and St Mary the Virgin in Mursley.

The European connection has continued to flourish, and several English churches and cathedrals contain windows designed by European artists, giving us a flavour of what has been happening on the Continent since World War II (a quite different direction and style to most postwar English glass). My must-sees in this category include the set of windows (1963–85) by Marc Chagall in All Saints, Tudeley, the ultra-modern 1990s windows by Johannes Schreiter in the deconsecrated church which now houses the Royal London Hospital Medical Library, and the densely coloured, jewel-like 1950s windows by Max Nauta in the rebuilt Dutch Church, Austin Friars, City of London.

See also DALLE DE VERRE, JEWELS, POSTWAR

## EYES

In a book about looking at stained glass, the subject of eyes in windows is apposite and interesting, because amidst the thousands of pairs of eyes looking out from windows there are many exceptional and unusual examples which catch our own eye and can reveal a great deal about the artist and period.

Many people consider the eyes in medieval glass to be some of the most beautiful representations of all. They are often oversized in order to indicate and underpin a narrative, and can be incredibly expressive. Love, tenderness, surprise, watchfulness, thoughtfulness, wisdom, horror and anger are indicated in the simplest of clear, firm painted lines applied with complete confidence and ease. Just look, for example, in Canterbury Cathedral at how Mary regards Jesus with maternal love, how prophets ponder, tell and warn, how the murderers and Thomas Becket convey their intentions and

12. Detail of the Wise and Foolish Virgins window (1872),
Heaton, Butler & Bayne. St Mary, Putney.

reactions. Most medieval glaziers remain anonymous, but John Thornton of Coventry is one of the few who are known by name, and his work can be identified by his close-set, bulging eyes (together with bulbous noses). Each individual pair is painted with great care and remarkable detail in the eyebrows, eyelids, whites, irises and wrinkles, which draw in and hold the viewer's attention. The best can be found in York Minster, but such was his influence that this style can be seen in many different places where medieval glass has survived.

Prominent eyes are something of a theme in stained glass, and they become even more noticeable in the eighteenth century. William Peckitt, for example, whose work can be seen in St Ann, Manchester, York Minster and New College Chapel, Oxford, filled windows with huge figures of prophets who all have unsettlingly large, protuberant eyes in deep sockets with a great deal of white underneath, which nowadays makes them look like an illustration for diagnosis of a medical condition – although this could have been more to do with the idea of beauty at the time. (The same eyes can also be seen in painted portraits of George I, II and III and even Queen Victoria.) William Price, his contemporary, who painted windows for New College as well as for Merton College Chapel, gave his figures watery, oyster-like eyes. The strangest of all are the early seventeenth-century eyes by Robert Rudland in Wadham College Chapel, Oxford, which are heavy-lidded, very close-set and, with moustaches and beards below, make their owners look like teddy bears and walruses.

Eyes come into focus again in the Victorian period, and although many less artistically interesting windows contain rather sentimental, Valentine's sweetheart eyes on men, women and children which match popular printed illustrations, the more arresting are huge, dark and actually far more effective in expressing emotion. Several of the big firms used designers whose work stands out amongst the acres of 'wallpaper' glass (chosen from a church furnishings catalogue) and whose signature style includes this treatment of eyes. So when you come across flashing, dramatic, theatrical eyes and eyebrows they are probably by Frederick Preedy, while huge, fine, often mournful, quizzical eyes are likely to be the work of Alexander Gibbs.

These, plus the enormous, hooded, soulful, Dante Gabriel Rossetti/Jane Morris-type black eyes by Arthur Hassam for Heaton, Butler & Bayne are the ones I seek out. By contrast, with Arts and Crafts makers eyes are reduced in size and become more painterly and realistic, although there are exceptions to the rule. There is a proliferation of children with sweet little black button eyes in round or heart-shaped faces which resemble those in illustrations by Mabel Lucie Attwell and Joyce Lankester Brisley, as for example the windows by Veronica Whall in the Lady Chapel in Gloucester Cathedral. Paul Woodroffe's work can be identified at a glance by his heavy-lidded, often half-closed or downward-looking languid eyes with the most luxuriant, unfeasibly long eyelashes, which look as though they have been painted on with mascara or felt-tip pen and is found, for example, in St Catharine RC, Chipping Campden.

For twentieth-century artists who deliberately developed an individual style rather than making conventional windows, eyes can act as a maker's mark or signature. No one would ever mistake a window by Harry Clarke (1889–1931), whose work is found mainly in Ireland, although there are a few of his windows in England (e.g. St Mary, Sturminster Newton). His subjects' eyes are beautiful in an overstatedly wide, smoky, kohl-rimmed Biba style, with fine, arched eyebrows and sometimes shadows under the eyes, which have the effect of making the face appear sad and entreating, although they can stray on occasion into Margaret Keane's winsome 'Big Eyes' territory when they are a little too dolorous. Just as memorable and unmistakable are the eyes by Ervin Bossányi (1891–1975) as seen in York Cathedral, Canterbury Cathedral, Christ Church in Port Sunlight and the chapels of St John's College and St Peter's College, both in Oxford. His eyes are what we now think of as pure Disney: deep black, almond-shaped, dreamy or full of wonder, and cartoonishly large, not just on females but on all his people and animals.

Expressive eyes are not just the prerogative of humans in stained glass: devils, demons and dragons get some of the very best eyes of all. These can be fantastically expressive, truly malevolent and evil, or amusingly – perhaps unintentionally – pantomimic, as illustrated by the superb selection

of medieval demons in St Mary, Fairford. They set up a nice contrast with the many soft, gentle-eyed, long-lashed donkeys, cows and rabbits that can be seen in churches, although some artists clearly cannot resist the temptation to anthropomorphise animals and to make their eyes perhaps more expressive than necessary for effect.

See also ANGELS, MAKERS' MARKS, NOSES

# FEET

Maybe it's because they are mostly in the lower parts of windows that it is so easy to take notice of the many feet in stained glass. In fact, looking at feet became one of the highlights of researching this book because they manage to be so much more than simply body parts. Bare feet – and there is an inordinate number of unshod feet – suggest humility and saintliness and a more complete nakedness when standing before the Lord. But a large number also convey a wide range of attitudes on the part of the maker and communicate something of their owners' feelings and personalities. This might appear far-fetched, but I can guarantee that you will find plenty of feet that will make a big impression.

Look for example at brilliantly characterful medieval feet with large, fanned-out, wiggly toes happily feeling the fresh air – the antithesis of elegantly dainty, idealised specimens. St Mary Redcliffe, Bristol, has a pair of delightfully expansive, widely splayed feet which look as though they have never been tortured by uncomfortable shoes, and some of my very favourite wriggling medieval feet are forever trapped in stocks in All Saints, North Street in York. Although, like so much medieval glass, these have been restored in the nineteenth century, later painters have not altered the original artists' clear, childlike directness and apparent affection for these body parts.

Also quite remarkably unvarnished and genuine in everything except their size are the feet of prophets in painted glass in seventeenth-, eighteenth- and early nineteenth-century windows. These tremendous figures

often have feet which strike the viewer looking at them at ground level as gigantic. With phenomenally large big toes and highly defined nails which are all clearly visible even when in sandals, they are firmly planted on their pedestals and clearly underpin the prophets' earthly significance. Look at the seventeenth-century windows by the van Linge brothers, Abraham and Bernard (e.g. Wadham College Chapel and Lincoln College Chapel in Oxford, Lincoln's Inn Chapel in London), and, later, work by William Peckitt (e.g. York Minster). Like those of the designer David Evans of Shrewsbury, another master of overstatement, they recall the feet of Roman and Renaissance male statues (e.g. Wadham College Chapel in Oxford, Lichfield Cathedral and St Mary, Oldham). Just as solid and sturdy but hinting at hard skin and calluses are the bare feet of pilgrims such as St James the Greater, which have walked so many miles and performed such good service. There are good examples which span the centuries and range from

c.1330–40 in St Mary, Castlegate, York, to Moira Forsyth's 1953 windows in St Mary the Virgin, Friston. It is interesting to compare the feet discussed above with the feet of angels, which have no need for shoes and are thus far more likely to be slender and elegant, maybe pointing downwards in a balletic posture and ready for lift-off and ascent. The feet of Hugh Easton's male angels are beautifully observed and skilfully painted as though in a study from a life class by the artists in the Hendra & Harper studio who painted all of Easton's windows from the late 1930s onwards (e.g. the RAF Chapel, Biggin Hill, and the Battle of Britain window in Westminster

13. Detail of Corporeal Acts of Mercy window, maker unknown, early fifteenth century. All Saints, North Street, York.

Abbey). Just as untouched by shoes and hard lives are the narrow, pretty, graceful Pre-Raphaelite feet on so many of Edward Burne-Jones' women (e.g. Birmingham Cathedral). His men's feet are suitably and contrastingly broad, flat and sinewy.

It is difficult not to coo over the adorably chubby feet on babies and children that are often seen in Victorian glass and windows up to World War II. These can be quite delightful, and although some depictions may now appear a little too sentimentally sweet, the majority are touchingly unaffected. Arnold Robinson (1888–1955) of Joseph Bell & Son included many very natural-looking children's feet in his windows in Bristol Cathedral and churches in the Bristol area such as St Alban, Westbury Park, although he is only one of many makers and firms whose young feet are sweetly realistic. Equally affecting are the vulnerable bare feet of people, young and old, seen from behind as they kneel to worship. This pose, with its exposure of slightly curved soft soles and toes, is frequently painted in a very tender way by artists in the Victorian era, as in St Mary Redcliffe, Bristol. John Piper, too, uses it in his Britten window in St Peter and St Paul in Aldeburgh, where his view of the exposed heels, soles and little button-like toes emerging from under a long robe moves the viewer and evokes compassion.

By contrast, there are also some wickedly horrible feet in stained glass belonging to devils and strange semi-human creatures. The feet of the colourful, laughing, taunting demons in W. T. Carter Shapland's marvellous 1958 window in Peterborough Cathedral may have the same foot shape and soft undersides as children and people at prayer, but their nastiness is made very clear by their abnormally long, sharp toenails.

See also PASSEMENTERIE, SAINTS, SHOES, TEXTILES, WALKERS

# FIRE

Fires are one of the most visually dynamic and colourful subjects in windows. From the fires of hell to Scout campfires, from scenes of martyrdom

to hand-warming braziers, they range all the way from the terrible to the cosy. They rage, blaze, smoulder, consume and destroy, but also glow, heat and illuminate in churches up and down the country and are seldom boring or pedestrian. And from an artistic point of view, fire offers all sorts of exciting possibilities to designers, many of whom respond with vigour to evocations of judgement, hell, purgatory, suffering and people being burned alive.

The most dramatic and alarming are the large-scale, apocalyptic fires which accompany the traditional, no-holds-barred scenes of the Last Judgement in whose lower right-hand corners the damned are consigned to the flames of hell, taunted and helped on their way by horrible, horned, jeering demons and devils. Red flames engulf them, licking their way up the window, suffusing it with horror and often almost palpable heat. One of the very best fiery scenes, which must have been terrifying in its time (it is now more a stunning period piece with the types of scary creatures we are more used to seeing in sci-fi books and horror films), is to be found in the original early sixteenth-century lower register of the west window in St Mary, Fairford. In a truly hellzapoppin' scene, a devil wheels a soul towards hell in a handcart while bodies tumble and spiral downwards into the flames, sucked into the gaping jaws of hell represented by a wonderfully odd, bug-eyed Satan. Huge jaws and people-consuming fires appear again and again: see for instance the claustrophobic, crowded window (*c.*1655) by Abraham van Linge in the Queen's College, Oxford, and the brilliantly strange late nineteenth-century Judgement window by Lavers, Barraud & Westlake in St John the Baptist in Sampford Peverell, which has the two longest crocodile-style jaws of hell imaginable, placed at right angles in the corner up the side and along the edge, ready to catch and devour the hapless sinners. Interestingly, very few stained-glass dragons breathe fire and are instead more likely to scare with forked tongues and terrible teeth, although there is an excellent fire-belching example in the 1918 war memorial window in St Laurence in Meriden by the supremely talented Florence Camm. Terrifying Judgement windows continue into the nineteenth century, but from the twentieth century onwards they become far less fearsome, fiery

and condemnatory, and concentrate more on the figure of St Michael and his scales. Instead of being evocations of a biblical hell, fires in stained glass now mostly become representations of the very real, destructive flames of bombings and blitzes in postwar windows installed to commemorate wartime events and the subsequent rebuilding and restoration.

Fires are also associated with manifestations of God in order to test, temper and purify. Moses and his encounter with God in the form of the burning bush is a popular subject, usually with highly stylised pink, orange or yellow flames leaping out of a green shrub like pieces of tissue paper, or perhaps a bright, blood-red and yellow-stained fire above emerald-green foliage (e.g. by Ford Madox Brown in Jesus College Chapel, Cambridge), and occasionally with the rather surreal sight of God sitting in the bush as it burns (e.g. St Mary, Fairford, and St Etheldreda in Ely Place, London). There is an intriguing contemporary version by Thomas Denny in his typical densely layered and scratchy style in the 2010 Transfiguration window in Durham Cathedral in which the whole scene, suffused with warm amber and pale citrine, appears to be alight and burning, with Moses himself almost aglow, too.

Various stories of saints, sacrifice and suffering include fires and flames. St Lawrence's grisly martyrdom involves him being roasted alive on a grid-iron, and although many designers depict him holding his instrument of torture, plenty more show him actually on the fire. A graphic and rather sadistic medieval version is in St Laurence, Ludlow. There are lighter notes, too, however. St Dunstan, the blacksmith monk, is tested by the Devil, who gets his comeuppance when the saint takes his red-hot tongs out of his blazing workshop fire and either pulls him along by the nose or tweaks his tongue with them, and it's always pleasing to find one of these fine and funny glowing-red, hopping-mad devils in a window (e.g. by A. K. Nicholson Studios in St Dunstan-in-the-West, Fleet Street, London).

Not all fires and flames are painful and destructive, though: there are plenty which are homely and companionable, and some even stray into Christmas-card territory. Campfires glow in Boy Scout windows, Martha and Mary cook over crackling kitchen fires, cheerful hearths are a welcome

antidote to the cold outside and, in a lovely wintry picture by Christopher Webb in St George, Toddington, children warm their hands on a brazier while ice-skating.

Interestingly, cool, stable glass has proved to be an ideal medium for evoking heat and movement, and designers use all the techniques at their disposal to create wonderfully convincing flames. Streaky glass with colours moving through it can work hard to suggest fire, while flashed red-and-white glass can be acided, abraded and stained to great effect to create a mix of white, scarlet, ruby, pale yellow and dark gold all in the same piece of glass as, for example, Harry Harvey's 1960 window in the Guildhall, York.

See also BOMBS, DRAGONS, HORROR, SAINTS

## FLOWERS

If you are unsure where to begin, flowers are arguably a good starting point. They offer some of the most straightforward and uncomplicated pleasures of looking, and it is rare to find an English church without flowers in its stained-glass windows. Flowers have been used in every period from medieval to modern and because they are found mostly in the lower parts of windows, they are accessible and can be examined at close quarters. Even if you only ever looked at flowers in windows, you would still acquire a fine education in stained glass. Unfortunately, as flowers are so profuse and varied, a single entry in this book cannot do justice to their range

14. Detail of lily crucifix in Annunciation window, by Hugh Easton, 1954. St Paulinus, Crayford.

and treatment. Instead, this brief overview is a starting point: where to find them, different styles of representation, some of the varieties you might come across and the meanings of these, and a few outstanding examples.

Style-wise, flowers tend to reflect what was happening with contemporary painting, illustration and crafts, and even trends in interior design and gardening. So it is possible to find examples influenced by millefleur tapestries, medieval herbals, illuminated manuscripts, botanical illustrations, wood cuts and linocuts, Victorian needlepoint, Pre-Raphaelite art, Arts and Crafts work, William Morris wallpaper and fabric designs, Festival of Britain textiles, the Aesthetic Movement, and Pugin's Gothic Revival, to name but a few sources of inspiration. Some are reproduced with the accuracy of a field guide or botanical illustration, while others are more painterly or creative interpretations of form and colour. They may be flattened and formal, blowsy and billowing, scratchy and spiky, delicate or sturdy.

Many, but not all, flowers are recognisable. Some windows are crowded with stylised rather than literal representations as well as with many purely invented flowers which owe more to doodling, pattern-making and creative imagination than to nature. Many windows, though, contain lovely and familiar flowers which grow in meadows and hedgerows, cottage gardens, herbaceous borders, greenhouses, hothouses, and pots in country houses. Even here, liberties may be taken, and bright-blue daffodils and mixes of flowers from different seasons have to be accepted as part of a scheme (e.g. St Alban, Hindhead).

Of the identifiable varieties, most common are lilies. Mostly it is the spring-flowering, tall, elegant, Madonna lily (*Lilium candidum*, also known as the Lent lily), which is to be found, held or offered to Mary by Gabriel in Annunciation scenes. You might also find exotic white calla lilies, or the occasional spotted vermilion Turk's cap lily (*Lilium martagon*) mixed in with Madonna lilies, a lovely flower which appealed to Arts and Crafts artists such as Louis Davis (see All Saints, Longstanton, Cambridgeshire).

A far rarer sight is that of a lily crucifix, with Jesus pictured on a lily 'cross', something which is peculiar to Anglican churches and based on the

medieval belief that the Annunciation and the Passion (i.e. the Crucifixion) occurred on the same day of the year. Only a handful of small and rather worn fifteenth-century lily crucifixes survive in glass (e.g. Holy Trinity, Long Melford, and St Michael at the North Gate, Oxford), and it is admittedly rather unsettling to come across a body in a lily (even though we are used to seeing illustrations of fairies in flowers). It is even more surreal when a lily crucifix is painted in hyperreal, Technicolor detail: Hugh Easton's aestheticised, eroticised versions in St Paulinus in Crayford, St Mary in Burwell and St Matthew, Skegness, are part of what makes stained glass so very surprising at times.

Beyond lilies, the range of flowers in windows would make a fabulous plant list for a gardener. All habits and heights, colours and shapes, are covered, and as well as the to-be-expected roses, lilies of the valley, marguerites, daisies and bluebells, plus spring bulbs such as tulips, crocuses, hyacinths and daffodils, there are cowslips, dandelions, anemones, poppies, snowdrops, delphiniums, pansies, lupins, fritillaries, foxgloves, hollyhocks, passion flowers, blossom, sunflowers, violets, marigolds and morning glories.

Medieval windows are not especially floral, but when flowers are included medieval artists depict them with such great economy and simplicity of form and line that, with the exception of lilies, they are difficult to identify. They spring up in lightly sketched, flattened sprigs and in arcs and hummocks and closely resemble the illustrations in medieval herbals. By the seventeenth century, flowers have become far more painterly and clearly identifiable, but are still incidental and secondary to larger areas of foliage as, for example, in Bernard van Linge's large window (1631) in Lincoln College Chapel, Oxford. In the eighteenth century, glass painters emulated easel artists or even copied oil paintings and included their soft, blowsy, but botanically accurate flowers. In St Helen in Denton, Yorkshire, William Peckitt used enamels in 1776 to paint delicate swags of lilies, pinks, roses and camellias which look like enlarged versions of those found on fine porcelain, while the single elegant, silvery thistle in the corner of the 1794 window by Francis Eginton in St Alkmund, Shrewsbury, is a beautiful plant portrait worthy of a frame of its own.

From the 1840s onwards, stunning stained-glass flowers abound in windows, and lovely examples can be found in any good piece of Victorian stained glass made by the major firms. These may be painted in a lush, botanically correct style which we associate with Pre-Raphaelite art. However, many of the most effective and attractive imitate the flattened, stylised medieval flowers painted economically in dark lines on coloured glass as, for example, in the 1866 Heaton, Butler & Bayne window in St Mary, Kempsford. Some firms, such as Lavers & Barraud, also created a contemporary version with a little more realism and depth and lots of bright colour, for example the stunning passion flowers and roses (*c*.1864) in St John the Baptist, Cookham Dean.

Later, William Morris and Edward Burne-Jones filled areas of windows with their hallmark repeating flower and foliage patterns. Fine examples can be seen in Winchester Cathedral and especially Jesus College Chapel, Cambridge. Their Arts and Crafts successors, led by Christopher Whall, created outstandingly gorgeous flowers, as for example in the 1920 window in St Mary, Iwerne Minster. Karl Parsons deserves a special mention: the fresh anemones, primroses, violets and Van Gogh-style irises in his window in St James the Less, Pangbourne, are exquisite. The work of the Birmingham school of artists influenced by Henry Payne, such as Florence Camm and Mary Newill (1860–1947), and of the Bromsgrove Guild designers such as A. J. Davies, is always worth seeking out. They often used a limited but brilliant palette – emerald green, kingfisher blue, violet, silver – and a dense profusion of real and invented flowers, as can be seen, respectively, in St Mary in Muker, St Peter in Wrockwardine and in St Thomas, Normanton and St Matthew, Surbiton.

Mid-twentieth-century and postwar glass contains a wide range of flowers, and these are included in several fascinating windows which illustrate the local flower-growing trade. Caroline Townshend and Joan Howson depict daffodil-picking in Cornwall in their 1940 window in St Credan, Sancreed, and Harry Harvey celebrates Lincolnshire bulbs and tulips in his brilliant 1966 window in St Mary and St Nicolas in Spalding, which also contains scenes of potato sorting and packing. My personal pick from

the period would include flowers by Harry Stammers, Harry Harvey and L. C. Evetts (St Wulfram in Grantham, St Oswin in Wylam and St Mary the Virgin, Ovingham), who all manage to make their flowers both utterly modern and timelessly lovely.

Finally, if you would like to enjoy a mass of stained-glass flowers while you have a beer or glass of wine, I recommend a visit to the Angel in the Fields pub on Marylebone High Street, London. Beautifully designed and deeply coloured flowers of every type – wild, garden and climbing – fill every window. These were made in 1997 by Ann Sotheran, whose flowers can also be seen in her church windows, as for example in St George, Thriplow.

See also CORNERS, FEET, FOLIAGE, PAINTING, QUARRIES, SEEDS, SPADES, SUNFLOWERS

# FOLIAGE

Leaves make perfect filler, foil, decorative and background subjects. They offer a huge range of real and imagined, naturalistic or stylised shapes which can be scattered about or used in patterns and repeats, applied on a large or small scale, individually or en masse, *en grisaille* or in quarries, and of course they bring plenty of opportunities to introduce spots or whole canopies of colour. It is always possible to squeeze foliage into borders, onto textiles and into awkward spaces and small tracery openings (e.g. the medieval leaves in Dewsbury Minster), and as a result much stained glass is beautifully leafy.

The leaves one finds in church windows are not just those on trees, but also those on plants – as distinct from flowers – and on the tufts, thistles and weeds which have filled in gaps and provided ground cover for centuries. They may be real plants, the product of an artist's fertile imagination, or a mix; one of the pleasures of looking is to try to identify plant sources and to see how an artist has used and adapted them. Inspect the bases of windows and sections around feet in medieval windows to find very simple,

freehand, almost doodled foliage like that in St Mary, Fairford, in which outlines and shapes have been lifted or scratched off dark paint which was applied to coloured glass before firing.

The Victorians, too, filled lower areas with wonderfully creative plants which sometimes resemble the stiff leaf carvings on capitals, often in delightfully eye-catching non-naturalistic colours (examples abound, but especially good ones are found in windows by Clayton & Bell, Lavers & Barraud, and Heaton, Butler & Bayne). But the high point of plant foliage comes, arguably, with the Arts and Crafts makers of the early twentieth century, whose windows look like beautiful tapestries or pages of pressed leaves with rich mixes of shapes and colours. Look for example at Henry Payne's 1925 window in St James, Chipping Campden, where you will also find two lights with excellent espaliered fruit trees, and at the outstandingly beautiful 1906 window by Mary Newill in St Peter, Wrockwardine. In contrast to this loose, organic density, postwar leaves become flat, spiky, airy and linear, often shown in silhouette or outline only. This is in keeping with the contemporary mid-century modern aesthetic which is now popular again, making 1950s and 1960s windows extremely appealing.

Leaves on trees can be seen higher up in windows, not as easily examinable as ground-level foliage, and are more likely to be used for large-scale patterns and colour coverage. Once you begin to notice them, it becomes apparent that trees are one of the staples of stained glass, adding strong verticals, architectural structure, height and textured surfaces, with many painstakingly painted canopies of tiny leaves which can resemble theatre scenery. C. E. Kempe uses this type of foliage extensively, creating remarkably fresh, vibrant and minutely detailed leafscapes, as in Ely and Wakefield Cathedrals. Deciduous trees such as these and many more typically English varieties contrast markedly with olive trees, tall figs and exotic palm trees which denote geographical location as much as anything, just as oak leaves and acorns are often shorthand for England and a traditional concept of Englishness.

Designers exploit many different leaf shapes, both naturalistic and stylised. The distinctive foliage of native trees abounds: think oak, holly,

PLATE I

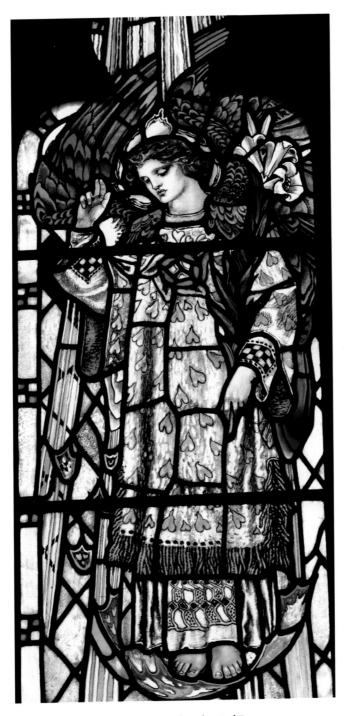

Detail of Annunciation window, by Karl Parsons, 1912.
PCC of St Alban's Church, Hindhead.

PLATE 2

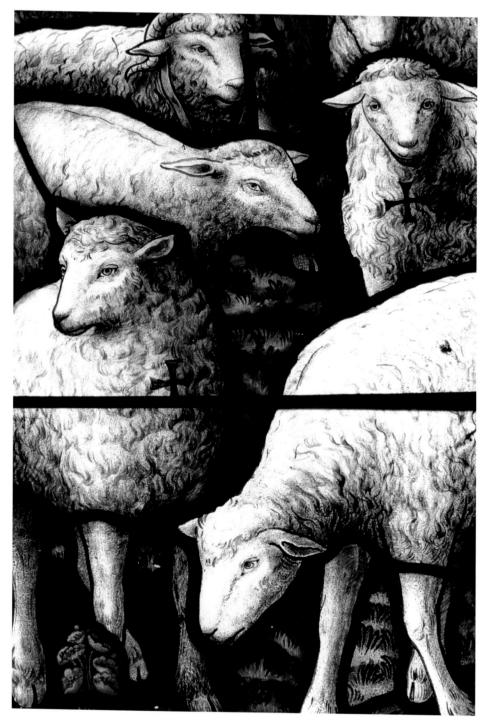

Detail of Good Shepherd window, possibly by W. F. Dixon, *c.*1884. St Mary the Virgin, Bruton.

PLATE 3

(*Top left*) Detail of quarries, possibly by Lavers & Barraud, second half of nineteenth century. St Peter and St Paul, Lavenham. (*Top right*) Detail of foliage in Suffer Little Children window, by Henry Holiday, 1891. Salisbury Cathedral. (*Bottom left*) Detail of medieval grisaille, maker unknown, *c.*1225–58. Salisbury Cathedral. (*Bottom right*) Detail of 'Prior's Early English' glass, designed by E. S. Prior, made by James Powell & Sons, late 1880s. St Mary and St Peter, Kelsale.

PLATE 4

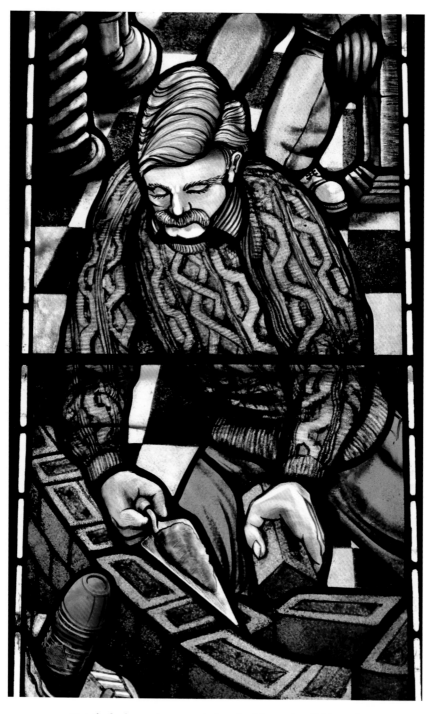

Detail of ruby anniversary window, by Christopher Fiddes and
Nicholas Bechgaard, 1997. St Nicholas, Potterspury.

PLATE 5

*(Top left)* Detail of memorial window, by C. E. Moore, early 1920s. St Nicholas, Potterspury. *(Top right)* Detail of Creation window, by Clayton & Bell, part of a scheme conceived in 1882 and completed in 1925. St Edmundsbury Cathedral, Bury St Edmunds. *(Bottom left)* Detail of fifteenth- and sixteenth-century fragments, maker unknown, reset 1798–1800. St John the Baptist, Cirencester. *(Bottom right)* Detail of dragon with St George, by C. E. Kempe, 1904.

PLATE 6

Detail of window depicting repair of the cathedral in the
1660s, by C. E. Kempe, 1901. Lichfield Cathedral.

PLATE 7

*(Top left)* Detail of Jonah and the Whale, by Abraham van Linge, 1641. University College Chapel, Oxford. *(Top right)* Detail of north-west window in cloisters, designed by J. H. Dearle, made by Morris & Co., 1924. Gloucester Cathedral. *(Bottom left)* Detail of window depicting repair of the cathedral in the 1660s, C. E. Kempe, 1901. Lichfield Cathedral. *(Bottom right)* Detail of nave window, by Constantine Woolnough of Framlingham, 1858. St Mary, Dennington.

PLATE 8

*(Top left)* Detail of Annunciation window, by James Powell & Sons, 1955. St Mary, Wargrave. *(Top right)* Detail of Lady Chapel window, by Harry Stammers, 1961. St Mary Redcliffe, Bristol. *(Bottom left)* Detail of antechapel window, by David Evans of Shrewsbury, 1837–40. Wadham College Chapel, Oxford. *(Bottom right)* Detail of memorial window, by Mayer & Co, 1871. St Giles, Stoke Poges.

PLATE 9

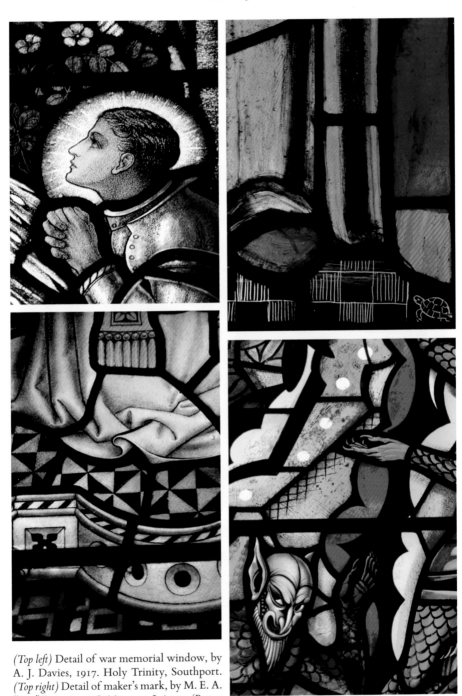

*(Top left)* Detail of war memorial window, by A. J. Davies, 1917. Holy Trinity, Southport. *(Top right)* Detail of maker's mark, by M. E. A. ('Tor') Rope, 1959. St Margaret, Leiston. *(Bottom left)* Detail of nave window, by Clayton & Bell, between 1883 and 1919. St John the Baptist, Peterborough. *(Bottom right)* Detail of window in St Benedict Chapel, by W. T. Carter Shapland, 1959. Peterborough Cathedral.

PLATE 10

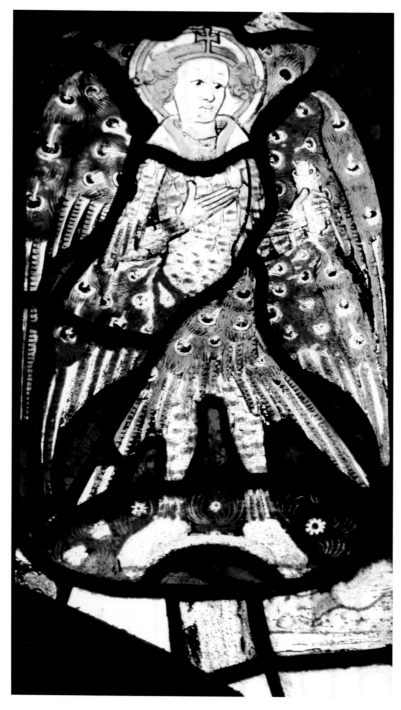

Detail of angel with peacock-feather wings in tracery, maker unknown, fifteenth century. St John the Baptist, Cirencester.

PLATE II

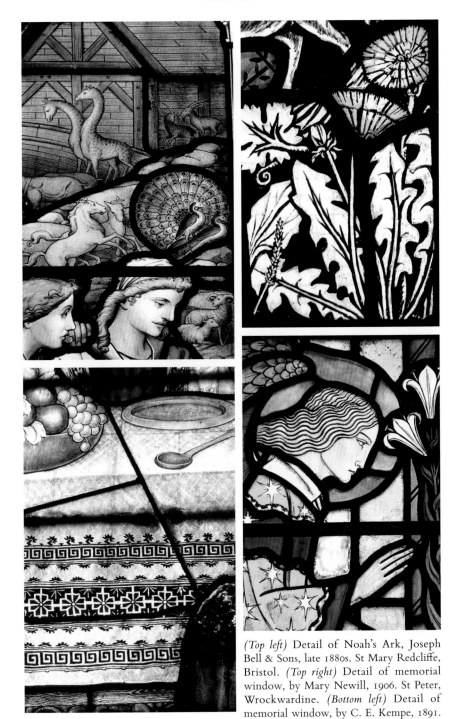

*(Top left)* Detail of Noah's Ark, Joseph Bell & Sons, late 1880s. St Mary Redcliffe, Bristol. *(Top right)* Detail of memorial window, by Mary Newill, 1906. St Peter, Wrockwardine. *(Bottom left)* Detail of memorial window, by C. E. Kempe, 1891. Wakefield Cathedral. *(Bottom right)* Detail of Annunciation window, by J. E. Nuttgens, 1935. St John the Baptist, Windsor.

PLATE 12

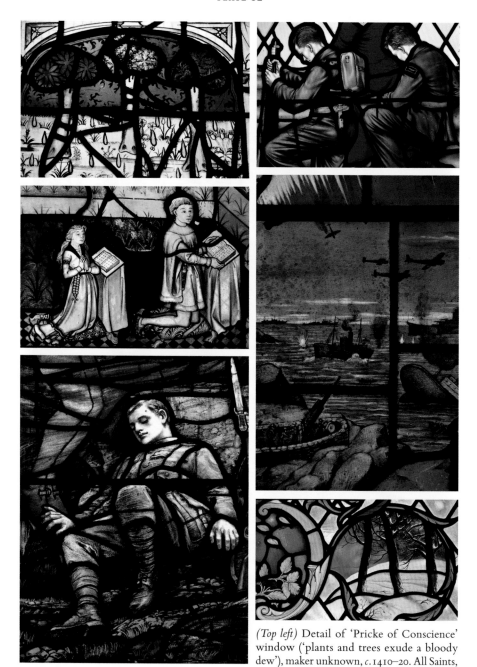

*(Top left)* Detail of 'Pricke of Conscience' window ('plants and trees exude a bloody dew'), maker unknown, *c.* 1410–20. All Saints, North Street, York. *(Top right)* Detail of servicemen, by Hugh Easton, 1947. St Mary the Virgin, Willingdon. *(Middle left)* Detail of donors, maker unknown, first half of fifteenth century. St Laurence, Ludlow. *(Middle right)* Detail of World War II battle, G. E. R. Smith for A. K. Nicholson Studios, 1940s. St John the Baptist, Little Missenden. *(Bottom left)* Detail of World War I memorial window, a copy of James Clark's *The Great Sacrifice*, by Wm. Pearce & E. Cutler, 1920. St Mary, Maldon. *(Bottom right)* Detail of Benedicite window, by Christopher Webb, 1958. St Mary, Wirksworth.

PLATE 13

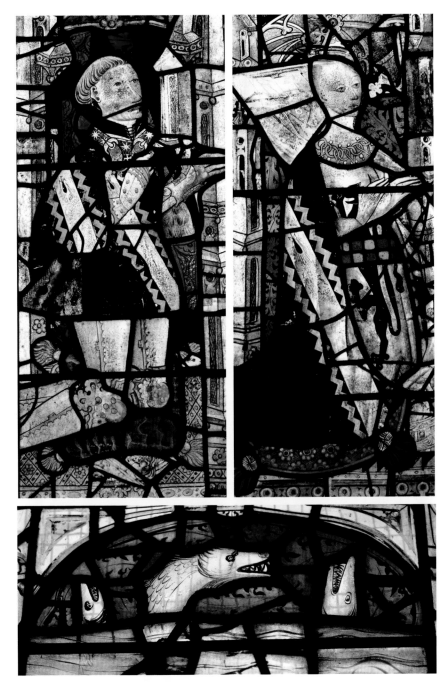

*(Top left)* Detail of donor, maker unknown, late fifteenth century. Holy Trinity, Long Melford. *(Top right)* Detail of donor, maker unknown, late fifteenth century. Holy Trinity, Long Melford. *(Bottom)* Detail of 'Pricke of Conscience' window ('the fish make a roaring noise'), maker unknown, *c.*1410–20. All Saints, North Street, York.

PLATE 14

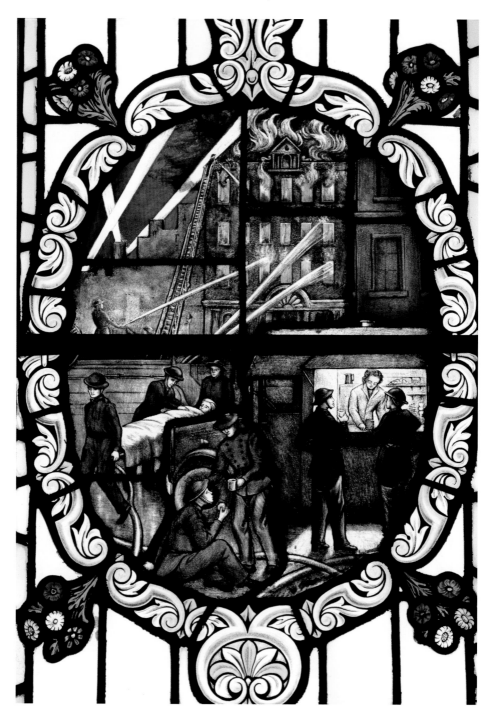

Detail of memorial window, by G. E. R. Smith, 1950.
Parish Church of All Saints with St Peter, Maldon.

PLATE 15

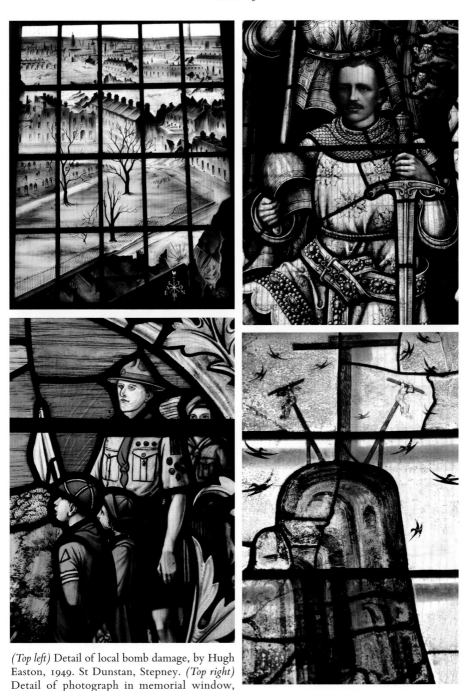

*(Top left)* Detail of local bomb damage, by Hugh Easton, 1949. St Dunstan, Stepney. *(Top right)* Detail of photograph in memorial window, designed by Canon Edward Pountney Gough, vicar of Spalding (1913–20), *c.*1918. St Mary and St Nicolas, Spalding. *(Bottom left)* Detail of Robert Baden-Powell in west window, by A. E. Buss, post-1945. St James, Paddington. *(Bottom right)* Detail of Golgotha, maker unknown, *c.*1500–15. St Mary, Fairford.

PLATE 16

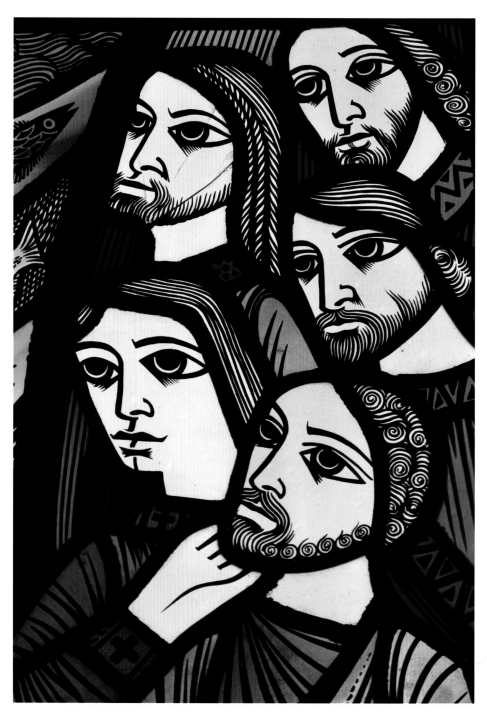

Detail of 'It is the Lord' window, designed by Joseph Ledger, made by
Lowndes & Drury, 1952. St John the Evangelist, St Leonard's-on-Sea.

horse chestnut, briar rose and sycamore, which can all be seen in the glorious Victorian windows in St Mary, Banbury. Consider, too, William Morris' use of acanthus leaves in his signature scrolls and repeat patterns, his pomegranate-leaf backdrops, and the way he scatters willow leaves on women's dresses or fills entire windows with cherry leaves, blossoms and clusters of fruit. Morris was not afraid to reuse his foliage designs which often form the background to Edward-Burne Jones' distinctive figures, also frequently adapted and recycled for different locations. As a result, their instantly recognisable windows can be seen in many English churches and cathedrals, some of which were executed after their deaths. This reuse of designs is quite common in stained glass and can lead to a jolt of recognition when visiting a church for the first time. Quite whether the congregation and patrons always knew that they would be getting virtually the same window as another church is another matter altogether.

See also FLOWERS, GRISAILLE, LEAD, QUARRIES

## FRAGMENTS

Stained glass is terribly fragile yet at the same time incredibly durable. So when it does get broken, as it was during the Reformation and by World War II bombs, the pieces can be rescued, dug up from ditches, gathered together and reused to make windows, sections or borders which look like colourful, crazy patchworks full of details, motifs and letters juxtaposed in creative, bizarre and often surprising ways. These 'patchwork' or 'fragment' windows (there is no technical term) are utterly fascinating, like samplers of glass and techniques, and are to be found in many places, particularly in cathedrals and large parish churches which were once filled with medieval stained glass and in locations which suffered bomb damage.

In the act of mending and putting back together after shocking upheavals, wonderful things have been done – and continue to be done – with fragments, and they are some of the most entertaining windows of all. Although they are the product of violence, these windows are rarely

sorrowful. Instead, they contain a real sense of optimism and resilience, and a determination to create beauty from destruction. Perhaps the most famous example of 'crazy patchwork' glass is the vast Great West Window of Winchester Cathedral, which, with its Modernist or deconstructed Mondrian style, looks as though it was made in the twentieth century but in fact dates back to the 1660s, when fragments of glass from the cathedral's windows which were broken after the start of the Civil War in 1642 were collected and used to make this remarkable window. To the naked eye it is a mass of colour and lines, but if you have binoculars or a good camera lens you can discover a whole galaxy of medieval motifs, faces and patterns within it.

Some fragment windows are neat and orderly, with the pieces carefully fitted into defined borders, strips or sections. St John's Chapel of St Mary Redcliffe in Bristol, for example, has stunning patchwork windows made with precious medieval glass laid out in a relatively regular arrangement: various circular motifs are set in rows of horizontal bands, making them look like patterned plates displayed on the shelves of a tall Welsh dresser. Others, like the charming Godiva window in Holy Trinity, Coventry, are simply filled with a wild assortment of shapes and sizes. Both types usually reveal a fine, eccentric sense of humour on the part of the maker or makers, who have clearly enjoyed putting together strange combinations of body parts, beards, eyes, pieces of animals, bits of devils and scraps of letters and patterns, giving some fantastically surreal results, like a game of picture consequences. Look at the Great East Window in the Lady Chapel of Gloucester Cathedral, which was created in the 1800s with glass from other parts of the cathedral and contains a dense, fascinating jumble of medieval glass (e.g. ears and hair where faces should be), and in York, where the Minster and the churches of St Denys, Holy Trinity, Goodramgate, and St Michael, Spurriergate, all have wonderfully inventive and richly detailed examples with some very funny arrangements (e.g. a crowned royal head perched on cockerel feet).

Fragments may also be used to create beautiful borders. My favourites are in St Marylebone Parish Church in central London, where fragments of Victorian windows blown out by bombs were pieced together in 1949 by

the firm William Morris of Westminster and reinstated as borders around plain, frosted glass. Rather than trying to make any sort of sense of them, the pieces have just been fitted in in the best way possible, which means they are full of irregular, richly coloured painted glass and chance details of architectural decoration, faces, arms and profiles (not always the right way up). The results give a postwar modern touch to the grand, elegant 1817 church, a dash of whimsy amongst the seriousness, and an appealing suggestion of an illustrated storybook which has been torn up and randomly reassembled. Similar borders with lovely, colourful fragments of foliage, floating bald heads, armless hands and single eyes can also be found in Christ Church Cathedral, Oxford.

Depending on the age and history of the church, one may also find mixtures of medieval, Victorian and contemporary glass in fragment windows. In the south transept of Blackburn Cathedral John Hayward combined 1970s and Victorian glass to great effect in his large 'Tree of Life' window.

Finally, the work of one maker stands out in the field of fragment windows. Joan Howson (1885–1964) made a speciality of this type of work and was responsible for the postwar restoration of the Westminster Abbey Chapter House windows as well as many other rearrangement projects with medieval glass (e.g. her 1957 work in St Mary Magdalene, Newark).

See also BOMBS, GLASS, QUARRIES, TRACERY

# GLASS

A church visitor could quite easily spend a great deal of time simply looking at glass itself and deriving much enjoyment from an appreciation of the material quite apart from the designs and contents of the windows. Just as the glass in vases, ornaments and paperweights draws and holds attention, so too does the quality of glass in church windows, especially when examined closely. For this is when it can reveal a multitude of variations, thicknesses, textures, abrasions, trapped bubbles, streaks, whirls and ripples, not to mention the many intriguing effects of ageing.

Most stained-glass makers use pot-metal glass (glass which has been coloured using metallic oxides while in the pot in the furnace), just as medieval makers did. Since the mid-nineteenth century, however, there has been a much wider range of glass available for church windows. A glass supplier's list will reveal many types of glass such as 'antique' and 'cathedral', 'seedy' and 'streaky' (many of which terms have no official meaning), plus specialist glass such as mouthblown slab glass and *dalle de verre*.

Many makers are very particular about their glass, and some insist on using only the very best, or glass which has been made specially for them. These are the people whose windows are worth looking at as collections of glassmakers' art. E. S. Prior (1852–1932) developed his own 'Prior's Early English' glass, a thick, reamy, uneven, light-holding slab glass, often in lovely colours – pale green, citrine, amber, ruby – which create glorious effects

in his churches (e.g. St Michael in Framlingham, and St Mary and St Peter in Kelsale). J. Silvester Sparrow (1862–1929), who styled himself as the 'Wagner of stained glass', created suitably dramatic effects by choosing and mixing richly coloured and textured glass and by using two or more layers of glass in a section of a window, as in his outstanding execution of Frank Brangwyn's design in St Mary the Virgin, Bucklebury, and his own window in Hull Minster. (This plating technique has been and is used by several makers, but there is a question mark over its purity – medieval glaziers never plated their glass – and its longevity.) Anyone who wants to see how

15. Detail of 'Prior's Early English' glass patented by E. S. Prior, 1888–9. St Michael, Framlingham.

well wonderful glass can work when chosen by a supremely fussy and demanding artist should look at the windows by Wilhelmina Geddes in St Michael in Northchapel, in St Luke in Wallsend, in All Saints in Laleham, and in Holy Trinity in Southport.

There is also one stained-glass designer whose windows are virtually all about the glass, and this is Leonard Walker (1879–1965), who made extensive use of slab glass (made by blowing semi-molten glass into a rectangular bottle mould and later cutting it). Each piece of handmade slab glass is unique, with its own set of subtle variations. These are exactly what he exploited in his windows, which are closer to almost abstract collages of beautiful glass than traditional stained glass. His work is rich with organic swirls and streaks of colour and movement (often with rather strange faces which struggle to stand out from the glass) and is quite unlike that of any other English maker. His windows can be seen mostly in southern counties, with the occasional example further north, as in Holy Trinity, Hartshill (1936), and St Chad, Bensham (1916), and also in the Royal Academy of Music (1945) in London.

See also DALLE DE VERRE, HOW A STAINED-GLASS WINDOW IS MADE, LEAD, LIGHT

# GRAPES

To love stained glass is to love its oddness, its strange juxtapositions, its jumble of subjects and mix of scales and perspectives. This is nowhere more apparent than in windows in which two men carry a *huge* bunch of grapes, almost as tall as themselves, which is so large it has to be attached to a pole resting on their shoulders. The cluster looks like one of the old trade signs, such as enormous keys, teeth, padlocks, boots, gloves or spectacles, which used to hang outside shops and businesses, but in this case it draws attention to a specific story. The men are spies returning from Canaan, where they have been sent by Moses to investigate the Promised Land, and are bringing back the outsize bunch of grapes they have collected from the

valley of Eshcol. It is an image which recurs in windows in all periods up to
and including the nineteenth century but rarely in the twentieth century;
there is a bright-green cluster in Ely Cathedral by William Wailes (1850),
who also produced the deep purple grapes (1858) in Doncaster Minster, but
both are dwarfed by the weathered but still impressive thirteenth-century
French bunch of flaming red grapes in St James, Twycross.

However, the twentieth century has its fair share of pantomimically
large vines and bunches of grapes elsewhere in 'Tree of Jesse' windows,
which illustrate the descent of Christ from Jesse. In these, the vine becomes
a family tree with spreading branches on which perch Christ's ancestors
while Jesse reclines at the base as the vine or tree emerges from his loins,
back or chest and climbs up the window to reach Jesus, perhaps with Mary,
at the top. Huge clusters of violet, scarlet or gold grapes, lushly oversized
leaves and corkscrew tendrils sprout from thick, strong stems which curl
and wind their way around the ancestors. Jesse windows have been popu-
lar in every era, although few medieval versions survive. An exception is
the marvellous window in St Margaret, Margaretting (*c.*1460). Several late

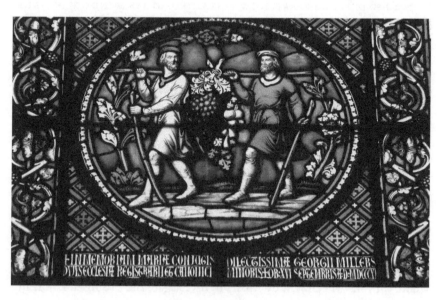

16. Detail of Grapes of Eshcol, by William Wailes, 1850. Ely Cathedral.

nineteenth-century and twentieth-century makers such as C. E. Kempe, Sir Ninian Comper and Francis Skeat (who are, incidentally, all part of the same branch of the stained-glass family tree) have used vines as a structure for impressively large, set-piece windows. It is worth mentioning that Burlison & Grylls' 1890s Tree of Jesse window in St Mary, West Lutton, is exceptionally well hung with grapes.

Pattern-makers have also long cherished grapes, tendrils and vine leaves for their distinctive shapes and colour possibilities, and for the many different ways in which the vines themselves can be trained, just as they are in vineyards. This leads to exquisite repeat patterns which can fill large areas of glass without any risk of monotony. Edward Burne-Jones shows how it can be done in his 1881 window in St Peter, Vere Street, London, with gorgeous golden clusters surrounded by delicate, silvery leaves and tendrils spiralling everywhere in between. In St Chad's Head Chapel in Lichfield Cathedral and elsewhere, C. E. Kempe fills squares with single vine leaves and uses them like tiles to build up bases and borders, and in St Mary the Virgin, Great Dunmow, Lewis F. Day fills the entire background of his early twentieth-century True Vine window with a dense, deeply coloured vine canopy, like wild Arts and Crafts wallpaper. Grapes and leaves are perfect for smaller spaces, too, and can be easily adapted and fitted cleverly into borders and corners, or tracery as in the 1862 window by Arthur O'Connor in St Mary the Virgin, Aylesbury.

See also CORNERS, FOLIAGE, KEMPE, TRACERY, VICTORIAN

# GRISAILLE

It is quite amazing what can be done with grey paint. Far from being dreary and dull, the practice of painting *en grisaille* (from the French *gris* for grey) has produced some of the most delicately stunning and impressive windows to be found in churches and cathedrals. When applied to stained glass, grisaille refers to both the painting technique and the type of window, which is made mostly of monochrome glass (it may be clear or a very pale grey or

green) and has painted surface decoration in varying depths and tones of grey or brownish-grey paint. Many of these windows often use complex leading patterns to crate intricate, ornamental effects, and grisaille glass may also contain a small portion of silver stain and coloured glass in its design. The technique has been used for entire windows or smaller panels since the thirteenth century for reasons of economy, practicality (it lets in lots of light) or religious preference (e.g. by Cistercian orders). In later periods, grisaille painting has also been a specific artistic choice, a way to create clever illusions, *trompe l'oeil* effects, and a means of imitating sculpture and architecture. Since the twentieth century, grisaille has also been a popular and very effective means of painting flesh and faces, and the fine, skilfully painted monochrome or almost-monochrome effects can be breathtakingly impressive.

When seen on a grand scale and from a distance, medieval decorative grisaille windows may give the appearance of having uniform, repeat patterns, like pale woven carpets. Look closely, though, and you will see

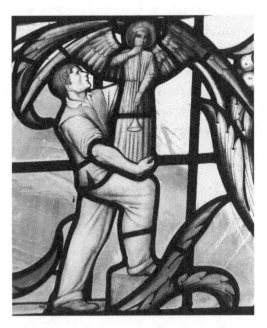

17. Detail of the Wren window, by Christopher Webb, 1959.
St Lawrence Jewry, City of London.

that each small section is unique and that the windows are in fact a gorgeous mass of interconnecting sequences with swirls, circles, quatrefoils and foliage (all of which prefigure the designs of William Morris). The greys too vary enormously, ranging from pale silver to deep pewter, and are enlivened with subtle eau-de-Nil greens and robin's-egg blues, small areas of saffron- and lemon-yellow stain, and jewel-like inclusions of ruby, garnet, sapphire and emerald. The thirteenth-century grisaille windows in Salisbury Cathedral are, I think, the best medieval examples in England. (Many rave about the Five Sisters window in York Minster, which dates from around 1260, but unfortunately it is not in great condition and lacks the clarity and brightness of those in Salisbury.) When you have marvelled at their intricacy and inventiveness, you can look elsewhere in the cathedral to see how later stained-glass makers such as Henry Holiday and Ward & Hughes reprised this grisaille style and used it in their borders, bases and backgrounds. In the nave, there is also a 1950 window by Harry Stammers, who was a true genius with with grisaille. It contains superb examples of the sculpture, stonework, plasterwork, monuments and architectural detail he represented *en grisaille* with such delicacy and lightness of touch. He also often used pale pink, blue and green paint instead of grey.

Grisaille, as Stammers' windows show, is also a traditional method for painting faces, flesh and fur in stained glass in the same way that it has been used by artists since the Renaissance. Interestingly, it made a comeback in the twentieth century, making a connection with black-and-white photography, and has often been used for realistic, photographic-style portraiture in church windows (e.g. G. E. R. Smith in St Margaret of Antioch, Iver Heath). However, it is more commonly seen in highly finished, ultra-smooth, marble-like skin and features, and for several twentieth-century designers it is a significant part of their style. Look, for example, at windows by Francis Skeat (who also demonstrates great mastery of birds and animals *en grisaille*, e.g. in St Mary and All Saints, Chesterfield) and his mentor, the prolific Christopher Webb, and by the little-known but marvellous Edward Woore (e.g. Salisbury Cathedral and St Katharine, Irchester). Remember, though, that it is unlikely that the more prolific

designers actually executed this remarkably refined style of painting the glass themselves, and that it is more likely the work of unnamed, highly skilled studio artists (see ANONYMOUS).

In more experimental hands, a modern, graphic style can make grisaille painting look very fresh and dynamic. The grisaille sections in Harry Harvey's windows often resemble quick pen-and-ink sketches, rather like newspaper strips. With firm, direct lines and the economy of a cartoonist, he painted a wonderful contemporary male voice choir in full song with frilly white ruffs, a variety of 1967 haircuts and individual expressions which range from the angelic to the deeply bored (St Mary, Bolsterstone).

Because of its ability to deceive the eye, grisaille has also had a playful side, as the artist Rex Whistler knew and demonstrated so well. In his Wren window in St Lawrence Jewry, City of London, Christopher Webb includes many grisaille cameos of the workmen who rebuilt the church after World War II. The nicely witty touches here include a grisaille stonemason carrying a grisaille sculpture, and a grisaille stained-glass designer working on what may very well be a window *en grisaille*.

See also PAINTING, PHOTOGRAPHY, YELLOW

# HAIR

It isn't just the myriad ways it is painted, stained, styled, parted, plaited and curled, but also the many colours, types, textures, lengths and implications that make hair in church windows such a captivating and absorbing subject. Hair goes all the way from unremarkable to the suggestive and even controversial, from the ordinary and realistic to the wig-like or something you might find on a stone statue, from the modestly mousy to the extravagantly blonde, and covers all styles: waves, flicks, updos, coils, crimps, ringlets, fringes, flicks, tonsures, waist-length tresses and regulation military cuts. In fact, stained glass is like a hairdresser's mirror showing the front, back and sides of the hair of an era.

*Hair*

To look at hair is to receive a tutorial in the techniques of stained-glass painting. Artists may use a very fine brush to paint strands and build up sections, or thicker brushes and strokes for outlines, shapes and directions of growth and curl. They can add texture and shading with stippling, badgering and matting, remove paint with sharp sticks to leave contrasting clear areas, and add gold or yellow highlights with silver stain. Hair can be made to look as though it has been painted with oils or created by means of one of many different artistic media: woodcuts, linocuts, charcoal drawings, pen-and-ink drawings, pastel portraits, book illustrations, posters and children's storybooks. It can be a simple area of colour with a few lines and curls painted with firm and confident brushstrokes, as in medieval glass. It may be meticulously naturalistic, unruly and flyaway as in seventeenth-century painted glass (e.g. Lincoln College Chapel, Oxford), or perhaps flatteringly thick and long, as in the eighteenth-century glass by artists such as William Peckitt (e.g. York Minster and St Mary Magdalene, Yarm), in which Old Testament figures and prophets have enviably luxuriant locks, often grey to denote age-associated wisdom. In this period, women's hair, when not covered, is delicately painted with beautiful naturalness and movement. The best examples can be found in New College Chapel, Oxford, in the 1777 window by Thomas Jervais, based on designs by Joshua Reynolds, which features the Seven Virtues.

This abundance of head hair continues to increase over time, with the exaggeration of growth reaching a peak with the Victorians, on whose imagination hair exerted a particular power. On women, this excess of hair can sometimes tip over into the suggestive, as for example in windows by Arthur Hassam for Heaton, Butler & Bayne (1842–69), in which young, virginal girls with inordinately long dark, gold, auburn and brown hair reaching down beyond their hips (and perhaps wearing nightdresses in Wise and Foolish Virgins scenes) look like a cross between huge-eyed Victorian wax dolls and Pre-Raphaelite 'stunners'. Extremely long hair is also associated with Mary Magdalene, who washed Christ's feet and dried them with her hair; when shown in a simple illustrative style, it is the gesture that is emphasised, but when Mary has luxuriant and loose hair as

she does in so many Victorian windows, the effect on the viewer takes on a new dimension.

Potentially controversial and problematic hair does not stop there. There have been objections when Jesus is shown as a beardless figure with thick wavy blonde hair. Judas is occasionally shown in Last Supper scenes with red hair (or sometimes very dark hair), and Eve may resort to using her hair to hide her shameful nakedness like a biblical Lady Godiva (see for example the window in University College Chapel, Oxford) – or she may let it flow freely around her, with the opposite effect of proclaiming and celebrating it (see C. E. Kempe's Eve in Wakefield Cathedral). Ideas of masculinity and androgyny are also often communicated by hair. In the twentieth century, C. E. Kempe, Sir Ninian Comper, Christopher Webb and Hugh Easton all created undeniably beautiful men with pageboy curls, floppy fringes and blow-dried fullness. Examples include the excellent hairdos by C. E. Kempe in St John the Baptist in Coventry and in Winchester Cathedral (and hundreds of other churches), and Comper's golden locks in St Wilfrid in Cantley and St Bartholomew in Moreton Corbet. For a good selection of hairstyles by Webb, see St Mary and All Saints in Chesterfield, and Hugh Easton gives his angels magnificent blonde coiffures in his Battle of Britain window in Westminster Abbey.

All this long, loose, potentially sensual hair is counterbalanced in other windows by neat and tidy stereotypical styles: the caring mother or Angel of the House with adeptly plaited and tightly coiled hair (Peterhouse College Chapel, Cambridge); the dutiful, obedient young Mary learning to read between her domestic duties, hair brushed smoothly and set tidily over her shoulders (Bristol Cathedral); sweet, innocent children with straight bobs and pudding-basin cuts (St Andrew and St Patrick, Elveden); various types and colours of hair in children and people of all nations in missionary windows (St Nicholas, Potterspury); twentieth-century men with carefully combed, fatherly or working men's haircuts plus the occasional bald head (e.g. St Clement, Hastings); and the many military short back and sides with ruler-straight partings in World War I memorial windows (e.g. Holy Trinity, Southport).

The subject of hair in stained glass is endlessly fascinating and worthy of much greater coverage than is possible here. But as it is ubiquitous, it is easy to discover plenty more about it *in situ*.

See also BEARDS, KEMPE

# HALOES

For anyone who is used to thinking of a halo as a simple circle or disc of light above the head of a person to represent saintliness and holiness, stained-glass windows are a revelation. They demonstrate just how far and in how many directions designers can go with one of the basic ingredients of ecclesiastical art.

There is seemingly no end to the variation that can be achieved. Haloes have gone through many developments and fashions in both art and stained glass over the centuries as artists have grappled with ideas of how to illustrate an aura around a person, and a halo can take many configurations. It may be a simple yellow ring floating above a head or a circular area of colour set behind a head vertically or at an angle. It can be small and modest or dramatically large and bright. Sometimes a figure is surrounded by an almond-shaped, full-body halo known as a mandorla, which often indicates a greater degree of sanctity and is thus frequently seen around Jesus and the Virgin Mary in, for example, *Te Deum*, Transfiguration, Ascension and Assumption windows.

In terms of construction, the simplest haloes are painted onto the glass. However (and this is where they become so interesting), most are made with glass *and* lead, using either a single piece or a number of pieces of glass, perhaps with the leads creating further shapes and sections within the halo (e.g. cruciform, four-leaf clover or Celtic cross). They may contain glass in almost any colour – not just the yellow gold so often associated with them – and bright-pink, coral, tangerine, deep-purple and royal-blue versions are especially eye-catching. In fact, many a halo is a brilliant spot of colour which stands out from or contrasts with the colour scheme in

the window. It may even match a person's clothes or shoes, as in Margaret Rope's stunning 1910s/1920s windows in Shrewsbury RC Cathedral.

The glass itself may be treated in many different ways. Medieval glaziers often applied large amounts of costly silver stain to haloes. Many surviving examples of these are exquisite, a mix of golden glow and silver-grey painted filigree patterns as in St Peter and St Paul, East Harling. Some designers such as Frank Brangwyn, Wilhelmina Geddes and Leonard Walker put unusual, rare and expensive glass in haloes to emphasise their specialness. A halo can also be filled with delicate grisaille patterns, flames, flowers, scrolls, spikes, zigzags, golden rays, inscriptions, lettering and owners' names. Nor does a halo preclude the wearing of headgear, and it is amazing how many figures advertise both their worldly and their saintly positions by means of what they have on and around their heads: St James the Less may wear a battered old hat with a pilgrim's scallop shell and have a large golden halo (St James the Great, Burford); a queen can squeeze a tall crown into her prominent aura and a bishop need not take off his mitre (St Mary, Preston on Stour); a memorialised World War I soldier may have a halo around his military cap; medieval-looking saints' haloes often enclose their metal helmets; and women's veils, headdresses and circlets of flowers can all be surrounded by the glow of a halo.

Some periods and makers have trademark haloes. I personally would choose a fabulous orange or yellow zigzag-patterned halo from the seventeenth century in Wadham College Chapel, Oxford, or one of the many Victorian versions which are predictably amongst the most ornate and decorative, or perhaps a contrastingly plain but sublime bright-pink and warm coral halo from a window by Henry Holiday or one of the Arts and Crafts makers such as Christopher Whall. Not long after the latter were making windows, stained-glass haloes went the way haloes in art had gone earlier, and began to disappear from windows. In the twentieth century there was greater discretion in their use, coupled with much reduced flamboyance and ornamentation (although some designers went the other way and took haloes to superhero, comic-book proportions). If you look closely you will see that many postwar windows contain no haloes at all, and instead light,

bright and glowing hair and headgear often stand in as secular versions of auras and haloes. Examples include clouds of golden hair, nurses' white caps, Mrs Mop's headscarf in Christ Church, Southwark, and Sunday-best hats in many of Harry Stammers' windows.

See also CROWNS, GRISAILLE, HAIR, LEAD, SAINTS

# HEARTS

Despite the many references to hearts and love in religious texts and contexts, there are comparatively few hearts to be seen in Anglican windows. More are to be found in the iconography of Catholic churches, with their references to sacred and bleeding hearts. However, there was a lovely, brief moment in the history of stained glass when hundreds of bright-pink and red hearts burst out.

Hearts are one of the key, decorative motifs of the Arts and Crafts period, one that, in the context of stained glass, does not belong to William Morris and Edward Burne-Jones but to a different set of makers who were active from the 1880s to the 1920s. The towering figure in this movement was Christopher Whall (1849–1924), who rejected Victorian Gothic in favour of a progressive Arts and Crafts ideal in which the designer was also the maker, and who ushered in a looser, less portentous and more organic style. Whall was immensely influential as both a maker and a teacher and brought together some of the finest designers of the period in his studio, making no distinction between male and female designers and makers. The hallmarks of windows by this group of makers include a silvery whiteness combined with brilliant colours (greens, blues, violets and pinks), the use of thick, irregular slab glass and distinctive rose-gold glass, as well as flowing, organic lines and leading, irregular quarries, areas of freely hand-painted patterns, dense, naturalistic detail, gorgeous wings, a profusion of snow-drops, anemones, fritillaries and lilies – and of course hearts.

This inclusion of hearts places the windows firmly in the wider design context of other contemporary applied arts. Hearts can be also be found

in many other forms of Arts and Crafts work: designers such as C. F. A. Voysey (1857–1941) and Charles Rennie Mackintosh (1868–1928) often favoured them in their domestic furniture and furnishings. In Arts and Crafts stained glass they are used as part of a storybook style which can also be seen in books illustrated by Kate Greenaway and Walter Crane. Not only are the children in these windows sweetly button-nosed and button-eyed, but the adult figures also have heart-shaped faces and are more winsome and childlike than chiselled and superheroic. Even the saints, archangels and memorialised soldiers look as though they would be asked for proof of age in a bar.

Whall, his daughter Veronica Whall (1887–1967) and close associates Karl Parsons (1884–1934) and Louis Davis (1860–1941) scatter hearts and heart shapes in many places, especially on clothes, trimmings and haloes. The resulting combination of shocking pink or bright scarlet shapes on a white background must have appeared amazingly fresh, zingy and cheerful after so many dark, crowded Victorian windows. The hearts are lightly, loosely and obviously hand-painted so that no two are the same and they may also be small, big, flaming, outlined, filled in or upside down. There are plenty of lovely examples. In his 1905 window in St Michael and All Angels in Ledbury Whall included angels in Persil-white and fuchsia-pink robes with pink flaming hearts and bright-violet and pinky-red wings. Veronica Whall decorated the surplices worn by her musical angels with glowing yellow hearts to match their heart-shaped faces in her 1929 window in Gloucester Cathedral's Lady Chapel. The unusually youthful Archangel Gabriel's amazing heart-covered, pink-fringed outfit in Karl Parsons' 1912 window in St Alban in Hindhead seems to modern eyes to be overly dressy – camp, even – and undermines his usual power and strength, even though it is delightful to look at. In the same church in 1907, Parsons painted a lovely woman's red-and-white striped mob cap with a red heart border, which looks like a strawberry jam jar cover. Also worth mentioning is the incredible pinkness of Louis Davis' 1920–1 Pure of Heart window in Cheltenham College Chapel, which features a long-haired, Rapunzelesque figure of Purity in a pale-pink robe holding a bright-pink heart.

Today the Arts and Crafts makers' use of the heart in stained glass appears to be a beautifully applied, simple and universal symbol of love, a shape which fits perfectly into the movement's aesthetic, a useful motif for patterns, and something which takes the modern viewer straight to the heart of their stained-glass art.

See also PINK, QUARRIES

# HERALDRY

Heraldry is a vast and complex subject, but you do not need a deep knowledge of its vocabulary and the meaning of the many symbols, crests, coats of arms, shields, badges, banners and mottoes to enjoy looking at it in church windows. I do admit, though, that purely heraldic glass does not interest me greatly, so instead of focusing on the minutiae of lineage, rank, genealogy and pedigree, I prefer to consider its artistic merits, the quality of the painting, the way the designers have chosen to present the information and, above all, the often strange and amusing combinations of inanimate objects, flowers, fruit, trees, animals, birds, mythological creatures, insects and angels it contains. In this way, heraldry becomes accessible and entertaining – and if I really want to know why there is a weasel or a seahorse, a battleaxe or a barrel in a window, I can find out later.

It is the strange mixture of seemingly disparate symbols which can make heraldic windows odd and delightfully surreal. Where else would you find three ducks, three queens and a bull grouped together (St James the Great, Stonesfield), four seagulls wearing golden crowns (St John's College Chapel, Oxford), tiny rampant frogs and camels almost hidden in a superb stained-glass tapestry of City of London heraldry (St Mary-le-Bow, City of London), or two disembodied hands emerging from a helmet and holding a crown (St Magnus the Martyr, City of London)?

All of this hints at the other reason I like heraldry in small doses: it contains lots of good visual puns. Some people might think stained glass is serious, solemn and po-faced, but this simply isn't true, and there is a

huge amount of humour in it. Take for example the windows in the chapel of Lincoln's Inn, London, where every past Treasurer since 1680 is commemorated in a small piece of painted and leaded glass with their name, date and coat of arms. Looking from a distance like enormous, gloriously dense, colourful quilts, these windows contain a huge amount of history told through symbols, colours, names and dates, often with a nice touch of drollness. So there is bright lemon-yellow for Sir Mark Lemon Romer (1933), a hunting horn for Wilfrid Hunt (1947), a little hillock with a cluster of trees for Sir Gerald Hurst (1944), neat lines of acorns and oak leaves for Sir Michael Ogden (1998), blossom-laden trees for Sir William Wood (1867), superhero wings for William Wingfield (1828) and, best of all, two rampant rats for Sir Donald Rattee (2006).

See also ERMINE

# HORROR

Depending on one's taste and tolerance for blood and gore, some stained-glass windows may be quite petrifying and shocking or, alternatively, riveting and revealing. There is no escaping the fact that the Bible itself is full of horror and, together with many scenes and stories of murder, cruelty, sadism, torture and martyrdom which have accrued over the centuries, there has always been plenty of scope for bloodthirsty illustrations and lurid images in church windows. Indeed, the medium and the messages overlap, and designers exploit the potential of ruby and flashed glass to depict blood with tremendous effect.

Although it is perfectly possible to convey horror through allusion, metaphor and symbol – and many twentieth-century designers have preferred this subtler approach – stained glass can be breathtakingly vivid and direct. Perhaps it should come with a warning about disturbing scenes of a graphic nature, reminders of death and terrible, grisly ways of dying, for the body count is high and windows can occasionally resemble stills from a slasher movie, spattered with blood and littered with severed heads. Some

windows can be unpleasant and upsetting: the relish with which some artists, Edward Burne-Jones for example, depict violence against women can make a modern viewer feel very uncomfortable (e.g. the beheading of St Cecilia at Christ Church, Oxford). But all are worth looking at in the context of religious and visual culture.

The two richest periods for blood and horror are medieval and Victorian, and while the latter can tip over into the theatrical and macabre, this is decidedly not the case with medieval depictions; instead they are wonderfully matter-of-fact, simple illustrations of murders, beheadings, loss of limbs, and bloodied stumps and swords. They have a naive directness which tells a story in chapbook or comic-strip fashion and thus renders them almost devoid of emotion, making them appear today rather bizarre. By contrast, the prolific firms and designers of the nineteenth century, many of whom were quite happy to exploit the contemporary taste for sensationalism, left a significant visual legacy of violence, suffering and sacrifice. Unlike the small medieval vignettes, the Victorian windows are often large and unmissable focal points which preach very strong messages, showing terrible scenes and horrifying moments in Royal Academy or Pre-Raphaelite style.

In the twentieth century this graphic style is reined in and tastefulness and bloodlessness predominate. Much of the horror is instead in what is commemorated: dead World War I soldiers, for example, are shown peacefully asleep on battlefields with no trace of injury. This trend continues after 1945 and even the standard biblical scenes of death and terror are mostly clean, polite and artistically realised, while the more shocking and bloody are replaced with allusions and symbols: Instruments of the Passion, Catherine wheels, crucifixes, and so on.

While researching this book, I discovered four particularly gruesome stories in stained-glass windows.

Firstly, I had not known until I came across a window containing three little naked boys standing in a barrel that there is a dreadful Sweeney Todd-style story to be found in stained glass. (Interestingly, it appears mostly in the twentieth century, although there is a medieval example which survives in Beverley Minster and a sixteenth-century painted example in

King's College Chapel, Cambridge.) It is one of the St Nicholas legends: an innkeeper who, running short of meat, kills three boys and stores them in a barrel, confesses with remorse to the visiting St Nicholas, who brings them back to life and forgives the innkeeper. In an excellent illustration of the story, the version made in 1928 by Martin Travers at St Nicholas, Barfrestone, shows the innkeeper in his butcher's apron with knife attached, and three sweet-faced, round-tummied boys praying for deliverance. By contrast, Sir Ninian Comper's plump-bottomed boys (1918) in St Peter, Oundle, have overtones of something distinctly less palatable. Evie Hone, though, adds clothes, avoids cannibalistic overtones and sanitises the story for modern viewers in her 1940s window in the Shirley Chapel at Ettington Park, Warwickshire.

Secondly, I discovered that beheadings are very common in stained glass. Although many are shown just as the sword is about to come down, some take place after the event; images of executioners carrying severed heads by the hair, at times very casually as if they were shopping bags or on a stake or sword, can be found in many churches (e.g. St Mary, Fairford). Equally chilling are the expressions on the faces of the executioners, not to mention those on the heads. In the case of David and Goliath, the slain giant's huge and hirsute head may resemble that of Rasputin, and sometimes the designer includes a mark on his forehead or a small piece of streaky red glass to indicate the wound (as in St Mary the Virgin, Datchet). Others show the headless body with blood pouring out. Edward Burne-Jones is fascinated by this gory scene, and there is a fine example by him in Jesus College Chapel, Cambridge. In addition, many more stories involve the beheading of various saints such as St Alban, St Cecilia, St James the Greater and St Paul. At Holy Trinity, Long Melford, a medieval window shows St Osyth carrying her own head, while unsettling images of John the Baptist's head on a platter, some truly horrible, are widespread.

Thirdly, we come to the Massacre of the Innocents. In Victorian depictions of the event, muscle-bound, wicked executioners, eyes popping with cruel anticipation, hold swords above cowering women who clutch their babies to their bosoms while a mob of the type described by Charles Dickens

looks on. Once again, Burne-Jones reveals a deep interest in portraying vio-
lence and evoking emotional responses (as his melodramatic 1894 window
in St Etheldreda, Hatfield, shows), while Frederick Preedy goes further as
his typically wild-eyed anguished mothers plead with a soldier who holds
a bloody sword while dead, bloodied babies – made with flashed glass – are
scattered about (1865, St Mary, Gunthorpe, Norfolk). The Victorian firm
of Heaton, Butler & Bayne can always be relied on for ramping up the
horror, and at All Saints, Fulham, the Massacre of the Innocents window
(*c.*1886) is a nightmare version of sentimental Victorian Christmas cards
with curly- and fair-haired, angelic children and babies being snatched
from their mothers.

Finally, zombie fans may want to look at Judgement windows, which
tackle the subject of the dead coming back to life and climbing out of
their graves. One of the finest is in the medieval west window in St Mary,
Fairford, in which the naked dead rise from their tombs to meet St Michael

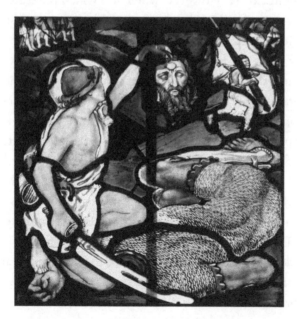

18. David and Goliath, designed by Ford Madox Brown, made
by Morris & Co., 1873. Jesus College Chapel, Cambridge.

and be judged. In a scene which might have inspired Stanley Spencer, the east window by Burne-Jones at St Michael and St Mary Magdalene, Easthampstead, shows people in ghostly pale clothing climbing out of graves, thus creating the unsettling illusion of them rising up from the ledge beneath the window. For a truly terrifying Judgement scene of skeletons and withered bodies clambering out of open graves, go to Ampleforth Abbey to see the windows designed by Patrick Reyntiens, which are part of a series made in 2003–7 by his son, John.

See also DRAGONS, SAINTS

# ICE

Despite all the references to snow, ice and frost in carols and secular Christmas stories, there are far fewer seasonal wintry scenes in stained glass than you might expect. However, when you widen the search terms and look beyond snow-filled English landscapes, there are some stunning and historically interesting depictions of snow and ice to be discovered.

Look for polar ice, for example. Perilous journeys across cold, white landscapes and the heroes of nineteenth- and early twentieth-century polar exploration are commemorated in windows of churches with links to expedition members, sometimes in scenes which would not look out of place in the pages of the *Boy's Own Paper*. Desperate attempts to pull HMS *Terror* out of the ice, illustrations of sledges, Eskimos, polar bears, seals, reindeer and walruses – all based on sketches by Arctic explorer Admiral Sir George Back (1796–1878) – make up an exciting 1860s window in St Mary, Banbury, which has a beautiful border filled with minutely observed snowflakes. Less gung-ho and far more sobering is the famous 1915 Kempe Studios window in St Peter, Binton, dedicated to Captain Scott and his failed 1912 expedition to the South Pole. Five panels illustrating the sequence of events are brilliant in their details of the clothes (Burberry outer layers, boots, headgear, goggles, huge gloves) and equipment (skis, tents, sledges, harnesses), and manage to evoke a terrible mix of optimism and despair. This

is one of the best, most apt memorial windows in England and a reminder of how remarkably similar glass and ice are in many ways: both are clear, solid and play tricks with light, making glass the perfect medium to capture and express the beauty and danger of ice.

Look also for Benedicite windows. The lines 'O ye Frost and Cold, bless ye the Lord… O ye Ice and Snow, bless ye the Lord' have inspired many delightful interpretations, but unfortunately some Victorian and Edwardian designers overfill their windows with architectural canopies, lush patterns and large figures, making it difficult to see the really interesting details, such as the glimpse of a lovely little icicle-hung, snowy scene of the starlit church (1909) in St Lawrence, Abbott's Langley, or the grand, Romantic, Swiss icescape (*c.*1920) in St Mary, Swaffham Prior.

The Benedicite ice and snow theme comes into its own with postwar makers. They declutter their designs and allow their storybook illustrations

19. Detail of Benedicite window, by Christopher Webb, 1948. St George, Toddington.

to stand out against plain glass in a way that recalls some of the best children's books of the period. Christopher Webb is the past master of the joyful 1950s Benedicite window. He makes icy white winters look fun and cosy: bobble-hatted skaters, people collecting firewood, a hand-warming brazier, red foxes and red-breasted robins in the snow are contrasted with interior scenes of Christmas trees and blazing log fires. Children (and many adults) can also enjoy his far-flung, frozen natural landscapes with spouting whales, polar bears, icebergs and icy continents, all reminiscent of posters for primary schoolrooms. Webb's finest ice-and-snow scenes can be found in his Benedicite windows and elsewhere, for example in St Mary the Virgin, Aldingbourne, and Lincoln Cathedral.

And look for mountains. Clichéd, rugged, snow-capped peaks can be spied in the backgrounds of seventeenth- and eighteenth-century painted-glass windows and roundels, even though the religious context and setting do not require them. Their presence can be explained by the influence of Romanticism with its ideas of the 'sublime', which focus on grandeur, awe and wonder: when backlit by daylight even the smallest of these blue-white glaciers and mountains do indeed look brilliant and breathtaking. Occasionally, too, a real mountain might be presented as the allegorical Hill of Difficulty in *The Pilgrim's Progress*, as in the 1951 memorial window by Francis Skeat in St Michael and All Angels, Hathersage, to a local woman climber who died on a peak in Snowdonia.

See also BENEDICITE, CANOPIES, CHRISTMAS, POSTWAR, WHALES

# INCENSE

The experience of looking at stained glass can be a multisensory one. There are time-worn wooden carvings to touch, pews to slide along and sometimes music from organ, piano or choir practice in the background. And, if a visit coincides with the end of an Anglo-Catholic or Roman Catholic service, there will be a fug of fragrant smoke and the unmistakable smell of burning incense which hangs and lingers in the church interior. On a

bright day this haze can create beautiful Turneresque or cinematic effects, with the light coming through the stained-glass windows, shafts and rays piercing the smoke like the sun breaking through gaps in clouds and giving a colourful, kinetic effect.

This effect is created in real life by a thurifer, or server, swinging an incense-burning thurible, a brass or silver-plated container shaped like a covered vase or bowl with holes, which is suspended on three or four long, thick chains or ropes. In stained glass, though, it is usually the censing angels – and the occasional boat-boy or altar server – who hold the thuribles. They appear in windows of all periods from medieval to modern and are often to be found high up or in the tracery, fulfilling their roles as celestial messengers who carry prayers up to heaven.

There is a skill to swinging a censer, and angels demonstrate an interesting range of swinging styles, bringing a sense of movement and vigour to what can be a flat and static art. Medieval censing angels are particularly sweetly enthusiastic and energetic, with the thurible poised just above their heads looking as though it is about to clonk them (St Bartholomew, Tong). In some Victorian depictions, the action appears to defy the laws of gravity with an upside-down censer, or it may be caught at the moment before the chains tighten and straighten, creating strong sinuous lines across the picture. Personally, I am keen on the sporty approach, in which angels look like hammer-throwing athletes in the moment before release, although there are plenty of angels with a more soothing and gentle to-and-fro rhythm. C. E. Kempe is fond of including censing angels, some of whom fling around exaggeratedly large thuribles and overlong thick chains as if handling a lasso. By contrast, postwar designers are more realistic with their scale, and simplify both the action and the object with firm lines and unfussy designs (e.g. Lawrence Lee's window in St Magnus the Martyr, City of London).

Just as tricky as conveying the swinging motion is the problem of how to paint incense smoke on glass (a problem which also arises with water). This can reveal the limits of both the materials and of the designer or painter. Too often, smoke looks risibly unreal and more like dense puffs of opaque

cotton wool, so delicate trails, translucent wisps or pale, billowing clouds tend to be more successful. Sometimes an artist is pragmatic and avoids problems and potential distraction by omitting the smoke altogether.

See also ANGELS AND ARCHANGELS

# INSECTS

You may feel a little foolish bringing binoculars into a church, but it does mean you will be able to see a great deal more in its windows. There are times, however, when a magnifying glass would not go amiss in church, particularly when it comes to insects. Tiny visual puns, *trompe l'oeil* effects and minute touches of insect humour such as Geoffrey Webb's (1879–1954) lovely spider-and-web maker's mark can easily be missed when looking at the greater scheme of things.

Like amber, glass has captured and held insects for centuries. One of the most famous examples of sixteenth-century medieval glass-painting features a spider in its web just as it is about to be eaten by a fat wren. It is in one of the quirky quarries in the Zouche Chapel in York Minster and is a lovely example of brisk, economical, humorous painting. Later, painters in the seventeenth century joked with their fantastically realistic *trompe l'oeil* flies, legs painted on one side of the window, body and head on the other, the bane of any duster-waving window cleaner. There is a highly convincing example from 1649 on a 'time flies' sundial window in St Mary the Virgin, Bucklebury. More recently, Hugh Easton included a tiny mosquito in a 1951 RAF memorial window at Biggin Hill Chapel, a pun on the Mosquito aeroplanes flown by the men commemorated there. Easton also added a lifelike fly, fine spider's web, caterpillar, chrysalis and butterfly to his windows illustrating the Seven Ages of Man in Oundle School Chapel (1949), crawling, hanging and alighting in places where they could realistically be found. Also requiring sharp eyes are the spider, grasshopper and butterfly included by Harry Stammers in his memorable 1963 window in St Mark, Broomhill and Broomhall, Sheffield – you need

to hunt for them, like a true entomologist, in the lower lights. An I-spy enthusiast should also make a point of examining Thomas Denny's exquisite 2007 windows in the Audley Chapel in Hereford Cathedral, which celebrate the life of poet, clergyman and theologian Thomas Traherne (*c.*1637–74). The borders contain a whole host of insect life, from an iridescent beetle to a camouflaged moth, from a half-hidden butterfly to a lacy-winged dragonfly. The joy is in finding each one and marvelling at the way Denny plays hide-and-seek with the viewer.

Happily, once you have your eye in, as they say, most butterflies and moths are not difficult to find, from the seventeenth- and eighteenth-century life-size specimens which resemble illustrations in butterfly-hunting guides to the delicate, fluttering, local species in many of the windows by Martin Travers, including his fine, butterfly-filled 1939 window in St Mary, East Brent, dedicated to a vicar whose collection of butterflies and moths is now in the British Museum. Others are even easier to spot. Large, colourful butterflies feature in several of John Piper's windows, their wings filled with bright colour and striking markings created by maker Patrick Reyntiens' use of paint, flashed glass, abrasion and silver stain. They dance across the John Betjeman memorial window in All Saints in Farnborough, Berkshire, and again in St Bartholomew in Nettlebed. By contrast with these weighty specimens, Marc Chagall conveys the lightness of butterflies by means of a few, fluttery strokes of a paintbrush in his famous scheme of windows at All Saints in Tudeley; some are at rest and closed, others display their violet and buttercup-yellow wings, and all evoke a sense of the wonder and fragility of life.

Less ethereal but equally delightful are the bees that buzz about in church windows. The most popular insect in heraldry, the emblem of work, industriousness and wealth, they appear in coats of arms and on shields, in Eleanor Fortescue-Brickdale's maker's mark rebus (her initials E. F. B. become E. F. plus a furry bee), and in mid- to late twentieth-century windows dedicated to beekeepers and celebrating the local countryside. Bees small and busy, or big and fuzzy like the fat bumblebees which hover near ripe fruit in Helen Whittaker's 2005–6 autumn-themed window in

St Peter and St Mary, Stowmarket, circle hives and old-fashioned skeps, settle on flowers, and add energy and an imagined soundtrack to otherwise silent windows.

See also QUARRIES

# JEWELS

It could be said that stained-glass windows themselves are the jewels of a church, displayed in window openings which act as settings of varying plainness or complexity. Like jewels, they play with light, flash and sparkle, and fill an interior with sapphire blues, emerald greens, ruby reds and glowing golds. For many, it is enough to enjoy the large-scale effects and the brilliance of a mass of pieces of glass held together by lead strips. But within these jewel windows are many more jewels which make up one of the most absorbing and intriguing facets of stained-glass detailing.

It is clear that many stained-glass painters do not hold back when it comes to bling. The opportunity to add extras like diamonds and pearls, necklaces and crowns, seems to unleash a sparkly fantasy in which clothes, accessories and headwear can be encrusted and adorned with precious stones and metals to the point at which the only limits are space and imagination. As a result, some windows have a touch of Hollywood glitter, a fairy-tale dream or a particularly well-stocked dressing-up box. There is no getting away from the fact that makers such as Max Nauta in his brilliant postwar windows in the Dutch Church, Austin Friars, City of London, appear to have had great fun painting egg-size gems, covering surfaces with precious beading and creating whole ranges of innovative jewellery.

No one, however, has quite matched C. E. Kempe in his pomp for lavishness, and jewels (pearls in particular) are an important part of his distinctive style. Throughout his long career he added them to any part of an outfit or accoutrement that could benefit from some surface excitement. Knights, kings, queens, prophets, saints, angels and figures from the Bible drip with ornament, from the edges of their robes to the tips of their tiaras;

Kempe's windows may not be to everyone's taste, but for sheer quantity of baubles they are unbeatable.

While Kempe tends to splurge on the decorations of robes worn by male figures, Harry Clarke is supremely good at delicately wrought and wearable jewellery. Although most of his work is in his native Ireland, he made a few outstanding windows for English churches (such as St Mary in Sturminster Newton, All Saints in Bedworth, St Mary in Nantwich and the former chapel in what is now Ashdown Park Hotel). Each is a tour de force of fabulous detail in his dreamy, Beardsley-esque style. There are filigree silver tiaras and close-fitting 1920s-style headpieces studded with gems, lovely pendant earrings, large oval brooches worn at the throat and multi-carat diamond rings on fingers, all of which, when combined with his attention to fabrics and shoes, make his ensembles of interest not only to those looking at stained glass but also to historians of fashion and costume.

One specific item of jewellery worth looking for is the breastplate worn by the Old Testament High Priests of Israel (e.g. Aaron). Featuring a set of what looks like a set of chunky rhinestones mounted in gold, it resembles a piece of costume jewellery made up of four rows of three gems to represent the twelve tribes of Israel, and includes amethyst, topaz, onyx, turquoise and jasper as well as sapphire, ruby and emerald. Some of the most impressive, shiniest examples can be found in the windows of the late eighteenth and early nineteenth centuries by glass painters such as David Evans (Lichfield Guildhall, previously in the cathedral, and Wadham College Chapel, Oxford) and William Peckitt (New College Chapel, Oxford). Very occasionally, the breastplate jewels may actually be small pieces of glass stuck or fused onto the window to give a three-dimensional effect. Over the centuries, makers have experimented with sticking 'jewels' on windows, but generally without long-term success, although there are a few rare examples still extant including one in St Michael, Spurriergate, York. Far more successful is the incorporation of small pieces of glass into a window, for example on robes or as trimmings, held in place by lead cames so that they are both an integral part and an embellishment. Arts and Crafts designers such as Christopher Whall, Karl Parsons and Louis Davis used this technique

to great effect. Recently, makers have included thicker pieces of glass which can look like just-mined, rough, uncut diamonds (All Saints, Benhilton) or like lightly tinted, circular bottle bottoms (St Andrew, Soham), and which act as jewels, flashing and sparkling and catching the light.

Not all jewellery is sparkly, splendid and precious, though. In nineteenth-century Empire and missionary windows and twentieth-century Children of All Nations windows people wear simple, colourful, hand-painted beads and necklaces made from wood and local materials (e.g. J. E. Nuttgens' 1957 window in St Andrew, Soham), although the double string of egg-size natural pearls worn like a lei by a Polynesian girl in C. E. Moore's 1920 window in St Nicholas, Potterspury, would be worth a fortune in a Bond Street jewellers'.

See also CROWNS, GLASS, KEMPE, LEAD

# KEMPE

Charles Eamer Kempe (1837–1907) occupies a unique place in the pantheon of stained-glass makers. His is the name that crops up in Pevsner's Buildings of England series more frequently than any other, more than William Morris, more than Burne-Jones, more than any of the famous Victorian firms such as Heaton, Butler & Bayne, Clayton & Bell, or Hardman. Simon Jenkins follows suit in *England's Thousand Best Churches* and, in a book that is light on coverage of stained glass, makes a point of mentioning Kempe (and often Kempe only) windows in many churches.

He has achieved this rare status by means of a combination of factors: he had a long life, he was remarkably prolific, his work can be found all over England and, crucially, he developed a unique and distinctive style which means that there is no mistaking a Kempe window for anything else. The fact that the style was closely copied and continued in the Kempe business after his death by his successor, Walter Tower (1873–1955), and ripped off by Herbert Bryans (1855–1925), who had trained with Kempe, adds to the feeling of ubiquity.

Kempe did not make all this glass himself; that would have been a physical impossibility. Instead it was the product of his large studio (which had up to 50 employees) and a great deal of reuse of designs. Unlike other well-known firms, though, which often gave credit to individual designers or painters and allowed them a measure of creative freedom, Kempe insisted that virtually all his painters remain anonymous, with only the Kempe name and mark going out with the glass. So it is not surprising that many people think – and many churches claim – that the windows are all his work.

So how do you recognise his windows? The key things to look for are the faces, the peacock feathers and pearls, the jewels and ermine-trimmed robes, the lavish use of silver stain, and the maker's mark. The Kempe style is nothing if not camp: extravagant, elaborate and embellished, and one often feels he could not possibly have got any more into a window. It is the apotheosis of Victorian Gothic Revival style, outdoing the other firms in fussiness and ornate detail and adding a good dash of Baroque luxury. Whether they are saints, soldiers or angels, Kempe filled his windows with youthful males whose key attributes are beauty and androgyny. Their faces are pretty and, slightly unsettlingly, virtually all the same, as if they have come off a production line (which, in a way, they have). They all share the same wide, hairless faces with mild, wide-eyed expressions, slightly flared nostrils and straight, neat noses, finely drawn eyebrows, big eyes, full lips and wide mouths, and a full head of golden curls. Even the faces of Kempe's women, older men and children bear a striking resemblance to this model.

A further sure-fire indication of a Kempe window is the use of peacock feathers (not always in naturalistic colours) in the wings of angels, which surround and frame them with exotic pattern and symbolism. More clues include Gothic, Renaissance-style vistas, backgrounds and perspectives; ultra-elaborate canopies, trees, vine leaves and grapes as framing and structural devices; a preponderance of dreamy-looking angels holding all sorts of musical instruments; and an often sombre palette which makes lavish use of yellow stain and gives an overall impression of a dullish greeny-gold. Kempe's windows are dense, full and complex, cluttered even, like a typical

Victorian interior in which every surface is covered and decorated – and, apart from his muscular, beardless, blond Christs, his figures are fully clothed, with just hands and faces peeping out from a wealth of decoration and ornament. The final giveaway is Kempe's maker's mark: a small, glowing wheat sheaf in a corner. Should there be a black tower, like a chess piece, superimposed on the sheaf, this indicates that it was made after Kempe's death under the auspices of Walter Tower.

Even if Kempe is not to your taste, there is still plenty to enjoy and admire. In this vast body of work, I would say that his early windows of the 1880s and 1890s are his best; they have great vigour and directness, a bright and varied palette, lovely use of flashed glass and a comparative simplicity. His later work becomes repetitive, with ever-diminishing power and effect, until it is almost a pastiche of itself. This is especially the case after his death in 1907, when other hands began to maintain the 'Kempe' brand and style. Even Pevsner, whose eye was caught by Kempe as by no other maker, noted the changes with regret.

Nevertheless, Kempe is still a force to be reckoned with on account of the sheer quantity of stained glass he produced for English churches. Whether or not he deserves to be the one individual name remembered, though, is a different matter, and one that depends greatly on personal taste.

Kempe's windows can be found all over England, with good examples in the cathedrals of Wakefield, Winchester and Lichfield, and in St Peter, Raunds.

See also ANGELS AND ARCHANGELS, CANOPIES, JEWELS, MAKERS' MARKS, PEACOCKS, VINES

# KNITWEAR AND KNITTING

There is a quiet delight and satisfaction in coming across something of very personal interest or meaning in a church window. It comes partly from seeing it translated into the medium of stained glass, and partly from knowing that it was deemed worthy by someone of inclusion in an

ecclesiastical setting. While it may not interest or excite anyone else, it can be added happily to your own collection of esoteric or obscure discoveries.

My special subject is knitwear – and knitters, balls of wool and knitting needles. I have been knitting for years and enjoy good examples and references in art, films and books, so was curious when I started looking to see if I could find any in stained glass. The answer is yes, but not many, and I now have a short but good list which grows as I go from place to place. Of course, I am not suggesting that everyone should search out knitwear; rather I am saying that making a point of looking for something privately meaningful can enrich your experience greatly, whether that something is model cars, butterflies or knobbly knees, or perhaps something relating to a hobby (birdwatching), an interest (postwar buildings) or work (stethoscopes).

I also chose knitwear because it injects an element of realism, and because it shows that ordinary people in ordinary clothes are just as worthy a subject for church windows as monarchs, saints and angels. The appearance of knitwear in early twentieth-century windows was part of a move away from Victorian neo-Gothic pomp and dressing-up to what could be called 'genre' stained glass. The humble, handmade products of a pair of knitting needles and some yarn, skill and patience make a welcome contrast to formal, historical, official, extravagant and expensive garments. It is also good to see that painters on glass apply just as much skill and care to them as they do to the robes of noblemen and royalty.

I prefer knitwear to have clear hand-knitting credentials with nicely defined stitches, patterns and textures. For those who take as much pleasure in knitwear as I do, I can recommend a few good pieces: homely, loosely knitted warm woollies worn by children (Karl Parsons, 1930, St Laurence, Ansley), men's sweaters with intricate Aran cables and Fair Isle patterns (Chris Fiddes and Nicholas Bechgaard, 1997, St Nicholas, Potterspury), a land girl's chunky, knee-high hiking socks (Hardman, 1952–4, St Martin in the Bull Ring, Birmingham), cosy bobble hats (Gabriel Loire, 1972, St Richard, Chichester), beanie hats with thick ribbing (M. A. Rope, 1912–16, St Peter and St Paul, Newport, Shropshire), ramblers' sleeveless pullovers (1935, All Saints, Walesby, Lincolnshire), a bright-blue hand-knitted, ribbed

fisherman's polo neck (Harcourt Medhurst Doyle, 1964, St Cuthbert, Aldingham, Ulverston), and a football goalie's green sweater and black-and-white hooped socks (1958–60, Christ Church and Upton Chapel, Lambeth North).

Unfortunately, there are very few images of knitters. The finest I have come across is the accurately observed, tall, imposing figure of Dorcas, who is knitting a long, brown woollen sleeve on four double-pointed needles while standing up (William Aikman, 1908, St Mary the Virgin, Hemsby). Knitting as a form of employment is illustrated in Sep Waugh's millennium window in St Margaret of Antioch, Hawes, where a man and a woman representing the knitters of the hamlet of Gayle knit, in a less convincing manner, on two needles. Honourable mention should also be made of the excellent, post-1960s window in Galway Cathedral which shows the Holy Family in a delightful ancient-meets-modern scene: Joseph at his work-bench, Mary sitting nearby knitting with a pair of huge needles, and Jesus bringing Joseph a cup of tea.

See also NEEDLES, TEXTILES

# LEAD

Black and obvious, breaking up pictures, designs, bodies and even faces, lead lines are what make stained glass instantly recognisable as such. They are an unavoidable part of the structure and, therefore, of the design itself. So, instead of looking past or ignoring the dark lines, or perhaps even pretending they are not there, it is far more interesting to look at them with a critical eye to see how they have been used, because quite often the overall success or otherwise of a stained-glass window is determined by these bold lines.

As anyone who has ever had a go at making stained glass will know, the materials, tools and techniques have barely changed since medieval times, and these include the use of lead. Despite modern concerns about lead poisoning, it remains the best choice for the job because it is soft,

strong, flexible, durable and easy to cut and handle. The pieces of glass are held together in H-section lead cames (or calmes) with cement to make a window weatherproof. Cames come in different thicknesses (between 5 and 20 mm) and can be flat or half-round (i.e. slightly curved), and the almost imperceptible variations influence the final overall result, as does the quality of handing, soldering and finishing. The leading can last up to a hundred years before needing attention. As necessary, windows are removed, taken apart, cleaned, repaired and sometimes repainted before being reassembled with new lead cames; it is a mistake to think that the medieval glass we see is unchanged since the time it was installed, for example. Lead cames have also been used for repairing cracks and breaks, which explains why there are so many lead lines like spider's webs or mad, black crossings-out in a lot of older glass. Today's stained-glass studios avoid using it where possible in favour of less visible mending techniques.

While some designers and makers over the years appear not to have exercised a great deal of thought and care in the matter of leading, with the result that their windows contain seemingly random, obtruding and sometimes ugly lines, the successful ones tackle the issue of leading head-on and acknowledge that it is an integral part of this very particular mix of art and craft. They deliberately exploit the many options of bold, thick, thin, wonky, angular, curved, obvious or subtle lines which intersect, outline, bisect or break up sections of a window, to the point that nowadays some artists include or paint lead lines on the surface of the glass where they are not necessary in structural terms but instead make a playful and questioning post-modern statement.

Many different styles and applications of leading can be seen across the churches of England. The most simple, basic, structural leading combines just plain glass and lead, and relies solely on light and black lines for effect. This is the purest expression of the two materials, and the best windows made this way reveal just how beautiful simply leaded, good-quality glass can be (it is interesting that such windows still look fresh and modern no matter how old they are). Some of the rarest and loveliest is in Commonwealth windows made in the mid-seventeenth century, which are densely leaded

and look like geometric lace (e.g. Halifax Minster), a style which was reinterpreted in a less severe manner by the architect George Pace in his postwar churches and restoration work. There is also a fabulous two-colour series of clear and aqua windows (1858) by Constantine Woolnough at St Mary, Dennington, leaded in a range of sinuous, organic, flowering patterns. It makes one wonder why more churches in recent years have not commissioned and do not commission more single- or two-colour windows. There is one outstanding exception, which is the exciting 1950s scheme by Joseph Ledger in St John the Evangelist, St Leonard's-on-Sea.

In more complex, colourful designs, lead lines can be used to create firm, bold outlines to delineate and emphasise the components of a window. This approach can be seen in medieval glass; here the leading is supremely simple and effective, making the black lines look like those in woodcuts and linocuts. It is a primitive style of leading which also suits twentieth- and twenty-first-century artists who use thick black outlines in their fine art; Evie Hone, for example, adopts a Cubist style with lines which look as though they have been applied with a thick felt tip or charcoal. Clever lead outlining which separates dark from light can also play tricks with perspective and make areas come forward or recede, thus giving a window greater depth of field.

In the interwar period, strong lead lines created a sculptural, Art Deco, carved bas-relief style

20. Detail of leading, by Joseph Ledger, 1952. St John the Evangelist, St Leonard's-on-Sea.

which recalls the work of Eric Gill. Bold, linear leading is the hallmark of Edward Woore's work (e.g. in Salisbury Cathedral), and that of J. E. Nuttgens, who was deeply influenced by Gill (e.g. Windsor Parish Church of St John the Baptist, and his masterpiece in St Etheldreda in Ely Place, London). This simplified style may have been a reaction to the Arts and Crafts designers in the Christopher Whall mould (e.g. Louis Davis, Karl Parsons), who employed a very different approach to leading, using lines to move the viewer's eye and to introduce a sense of energy and dynamism. Occasionally, they can be seen to overuse and overcomplicate the leading, but when used well, the thick, fluid, bendy, swaying and sweeping lines bring movement, sunbursts, explosions of light, zigzags, waves and plenty of visual excitement to a window.

In the later twentieth century, leading becomes a personal, artistic, stylistic choice, and you can sometimes tell a maker just from the lead lines. Take, for instance, Patrick Reyntiens and John Hayward. The former's personal style is dense, tangled, swirling and whirling, although he applied simpler, straighter lines in the stunning Coventry Cathedral baptistery window based on John Piper's design. It is also worth looking closely at the way he handled the lead cames: his skill and craftsmanship is exemplary, and his windows provide a masterclass in leading. Hayward also developed a distinctive leading style but with vast amounts of right-angle cross-hatching which create a dense network of close lines; his figures often look as though they are swaddled in bandages or a chrysalis (think Henry Moore and Barbara Hepworth drawings). Later he camouflaged and blurred his lines by using black paint on either side of them, a technique taken further by Keith New. New widens, almost hides, and thus integrates lead lines into his windows and softens them so that they look as though they have been added with wet paint or charcoal, making the glass look dirtier and therefore older. Lovely examples of this cleverness can be seen in St Nicholas Cole Abbey in the City of London, All Saints in Branston and the nave windows in Coventry Cathedral.

More recently, artists have begun to develop a questioning, deconstructing, post-modern and playful approach to lead, using lines that are

not structurally necessary, serve no practical purpose and lead to nothing. Some of the best examples are by the influential German designer Johannes Schreiter in a former church which is now the Royal London Hospital Medical Library, where lines dash off, suddenly disappear, break up and spike (a visit is highly recommended). Mark Angus also deliberately deconstructs ideas of 'the line' and subverts many long-held ideas about leaded glass. The viewer of his windows in Oundle School Chapel, Durham Cathedral and Immaculate Conception RC Church in Spinkhill has to look closely to see if a black line is part of the structure, or glued or painted on.

For all this carefully planned and expertly handled leading, there is still plenty that is clumsy, unsubtle and sometimes even laughably bad, and which draws the eye for all the wrong reasons: lines that cut across the genital area to avoid issues of modesty but in doing so make the issue worse; lead cames that enclose a beard so that it looks like a false cardboard comedy beard; lines that unhappily slash and maim bodies and faces; lines that create disjointed limbs and make a baby look like a porcelain doll and an adult like a stiff artist's mannequin; and lines that undermine the unity of a window. Ultimately, however they are used, lead cames cannot be ignored.

See also GLASS, HOW A STAINED-GLASS WINDOW IS MADE, LIGHT

# LIGHT

Although church windows are composed of glass, lead, paint and stain, it is in fact light that is the artist's primary medium. Unlike other arts, stained glass relies on daylight to make it visible and good windows use this dependency to create wonderful effects. Stained glass dies without light, but comes alive at daybreak and changes constantly according to the conditions – it is always rather strange to walk past a church at night and to see windows which during the day are so full of colour and brightness cast into gloom and darkness.

Once you start looking not just at the glass itself but also at the way a window manipulates the light, a new way of seeing emerges, one that is

specifically attuned to the subject. This is when it becomes clear just how dynamic and amazing it can be, and how well skilled designers manage to translate a small painted or watercolour design on opaque paper into a large, backlit, transparent or translucent window in which lead, colour and paint block, alter, filter and control light. It requires tremendous vision and understanding of the properties of light and glass in order to create stunning effects, skills that are often acquired empirically and through observation (as the best medieval windows demonstrate). Interestingly, the artists and firms who do great things with light are not always those who figure in history books, the big names with big reputations such as A. W. N. Pugin (1812–52) and C. E. Kempe, and even William Morris, Edward Burne-Jones and Ford Madox Brown, all of whose windows can be dull and deadening at times.

One has only to look at the way in which Patrick Reyntiens interprets John Piper's designs for the enormous abstract Baptistry Window in Coventry Cathedral to see how a maker can create spectacular effects with light. He moves gradually from pale to dark to create the effect of a huge central sun or ball of fire, and cleverly exploits halation – the spreading of light beyond the boundaries of the glass and creating a halo effect – to allow light to burst out exactly where he wants it to. Standing in front of a window of this calibre is one of the most affecting of all experiences, and although this may be one of the largest and most explosively impressive, there are countless more examples of beautifully mediated and modulated light in churches all over the country. (It should also be noted that glorious effects can be produced by otherwise unexceptional windows whose pieces of painted, stained and leaded glass together successfully alter and play with light. Sometimes it pays to 'unfocus' and simply experience the light.)

Some skilled designers also play with light in figurative windows in a theatrical, 'meta' and rather post-modern way, using the sun shining through a window to create a 'spotlight' on specific details, such as faces. David Evans of Betton & Evans employed this tactic frequently, for example in the lovely, shining clerestory windows (*c.*1830s) in St Mary, Shrewsbury, and in his 1840s chancel window in St Chad, Shrewsbury, which was

based on a Rubens triptych. Similarly glowing faces can be seen in Rachel Thomas' Millennium Window in St Paul, Birmingham, and in the 1997 and 2000 windows by Chris Fiddes and Nicholas Bechgaard in St Nicholas, Potterspury.

Countless articles and books on stained glass assert that a window's primary duty is to let in light. For designers, the difficulty is in deciding how best to do this, and in what way. For an in-depth consideration of this subject, I recommend Lawrence Lee's *The Appreciation of Stained Glass* (1977).

See also GLASS, HOW A STAINED-GLASS WINDOW IS MADE, LEAD

## MAKERS' MARKS

Searching for a maker's mark or monogram is one of the most gently entertaining aspects of looking at stained glass. It's like a game of I spy, a little visual puzzle, a challenge which often ends with a delightful discovery. It doesn't matter if the window itself is good, bad or indifferent: there is always a sense of triumph when you come across a mark and, even better, when you know whose it is.

This is because so much glass is unsigned. In the tradition of medieval artisan craftsmen working as a team in a workshop under the guidance of a master glazier, many makers have remained anonymous.

21. Maker's mark with spider, by Geoffrey Webb, 1911. St Mary, Sturminster Newton.

Even in the case of large firms or independent makers, it is amazing how often and how quickly their names and details are lost or forgotten and, without a signature or mark and with changes in clergy and congregation, the provenance of stained glass made even as recently as the 1950s can be a mystery. Although a handful of the medieval master glaziers, such as Thomas Glazier and John Thornton of Coventry, did not sign or mark their work, it can be recognised by their trademark styles (faces, noses and beards are the giveaways). In the sixteenth and seventeenth centuries, glass painters dated and signed their works in Latin with the words *pinxit* (painted), *tinxit* (coloured) or *fecit* (made). In St Ann, Manchester, William Peckitt signed and dated his window 'W:Peckitt pinx.ᵗ & tinx.ᵗ 1769'. From the nineteenth century onwards, however, makers began to devise their individual marks and monograms, sometimes using initials, a visual pun or a rebus to sign their works.

So it's always worth seeing if you can find something which tells you who has made a window. Examine the bottom left- or right-hand corner of a window for marks, names, initials, monograms, letters, dates, signatures, squiggles and tiny pictures or devices which do not appear to be part of the overall scheme. Occasionally, a mark can be found just above the base of a window or a little further up to one side but still close to the stonework, and sometimes they are cleverly incorporated into a pattern or section of the design – which makes them semi-hidden and difficult to spot. As a result, it is always satisfying when you find one, whether it is a maker whose trademark style you have already recognised (accompanied by a triumphant 'yesss!' as you confirm you were correct), or someone new.

Some makers have very creative marks, some employ teeny-tiny scrawly signatures, some sign with a flourish in large, painted handwriting, and some leave marks that resemble company letterheads (A. K. Nicholson and G. E. R. Smith both helpfully supplied a name, address and postcode). Many are done in formal Roman capitals, a few in neatly or flamboyantly entwined initials (William Wailes), and plenty are in virtually illegible real and neo-Gothic. Most are dated. There are intricate webs for Geoffrey Webb, hooded monks for James Powell & Sons, Whitefriars, a bell for M. C. Farrar

Bell, and a weathervane spelling out EAST for Hugh Easton. Theodora Salusbury (1876–1956) signed her windows with a range of tiny peacocks, Eleanor Fortescue-Brickdale's mark was E. F. and a bee, and M. E. A. Rope introduced a touch of humour with her tortoise signatures, which recall her childhood nickname, Tor. Christopher Webb signed his work with a figure of St Christopher, while Harry Stammers used a wheel, half ship's wheel and half cartwheel, because his father was a wheelwright and his father-in-law a mariner. C. E. Kempe made his mark with a miniature, beautifully detailed, golden sheaf of wheat. Upon this was superimposed a black tower, like a chess piece, after he died in 1907, and his studio continued to produce Kempe-style windows under the chairmanship of W. E. Tower. Sir Ninian Comper always painted a strawberry-plant motif but varied it with almost every window: there may be one or two red or yellow fruits, with leaves and/or flowers, and perhaps also a bee.

Unfortunately, even today some makers don't sign their work or leave a mark on it, which is a shame, particularly for those who enjoy this recondite looking game.

If you're interested in reading more about the subject of makers' marks, the Arts Society's publication *Stained Glass Marks and Monograms* is a very thorough and useful resource (see Further Reading section).

See also ANONYMOUS, INSECTS, KEMPE, NOSES, PEACOCKS, PIPER, TYPOGRAPHY

# MILLENNIUM

With many churches commissioning new windows to mark and celebrate the millennium, the year 2000 proved to be the biggest, most exciting opportunity for English church glass since the years immediately following World War II. The results are scattered all over the country, in little rural churches, grand parish churches and cathedrals. Looked at as a group, they offer a clear idea of the condition, quality and vitality of contemporary ecclesiastical stained glass.

Several things stand out. The first is that most recent glass is perfectly pleasant but lacks the punch, innovation and confidence that characterises the best examples made in the 1950s (or earlier high points in the history of the medium). They suggest churches are working hard to be inclusive and are dealing with concerns about falling attendance and respect for multicultural communities.

The second element to note is that little has changed since 1945 in terms of production. Modern English church glass is not at all the province of high-profile artists as it frequently now is in France and Germany, where major names of the art world have been commissioned to design glass in collaboration with studios and ateliers. Celebrity makers are few and far between in England, although it can be argued that within the smaller world of church glass, there are a few well-known names, such as Thomas Denny and Mark Angus. Instead, church windows are still generally produced by skilled designers and makers (often one and the same) working either independently or with one of the few stained-glass companies, such as Barley Studios in York. One welcome change, however, is that nowadays their names are far more likely to be mentioned (in press releases and church guides and on websites) than they were when the maker was just about the last person named in the dedication ceremony literature (or even omitted altogether). It is also good to see that many millennium windows were made by the handful of long-established firms still in existence, such as Goddard & Gibbs, now the last vestiges of the once thriving and busy companies which dominated the production of stained glass. Interestingly, the millennium also saw the return of the amateur designer, a phenomenon rarely seen since the mid- to late nineteenth century, when wives, sisters and daughters of vicars and rectors sometimes designed and helped to make windows. In 2000, it was not uncommon for a window to be designed by a member of the congregation or the clergy, by a group of local people, or with the input of local schoolchildren.

Thirdly, in design and content the windows are usually rather anodyne, light and bright, with many a sunburst and a great deal of clear

glass. In their choice of subject matter, they reveal the extent to which the secular now overlaps with the sacred; they are a long way from the moralising, sermonising and deeply religious Victorian windows which may often be found in the same church. In most cases, the powerful and overt Christian symbolism and stories which underpinned windows in previous centuries are no longer as evident or there at all, and churches have mostly preferred to avoid difficult, challenging or sensitive subjects or scenes by commissioning what are in effect conventional and crowd-pleasing designs. Consequently, a large number of millennium windows feature cheerful, upbeat, contemporary local scenes, local people, and illustrations of local history. They often resemble photo albums, primary school friezes or a montage of snapshots and illustrations of the church and its setting, with a good dash of nostalgia and Englishness. When well designed and well executed, they are fascinating for what they reveal about the way a church and its congregation see and portray themselves.

Fourthly, however, these 'postcard' windows do indicate that the quality of contemporary stained-glass painting and execution can vary wildly from the superb to the barely competent (harsh words, but true). This can be said of every period, but in the case of the millennium there is a marked variation in quality rather than a sustained high.

Despite this, some windows stand out because their designers have taken this important opportunity to use the medium in an entirely modern fashion (and who knows when the next big moment will be for stained glass, or if there will be one) or to update the visual tradition in a contemporary and beautiful way. Of the former, I would recommend looking at millennium (and other windows) by Mark Angus (see Durham and Guildford Cathedrals, Oundle School Chapel and St Mary in Maldon) and Thomas Denny (see Gloucester and Hereford Cathedrals and Great Malvern Priory). In the second category, Christopher Fiddes and Nicholas Bechgaard stand out, as do Ann Sotheran, Caroline and Tony Benyon, and Meg Lawrence: see, respectively, St Nicholas in Potterspury, St Thomas in Scotton, St Peter and St Paul in Edenbridge and St Andrew in Soham. It is also worth noting

that the millennium highlighted once again the large number of women involved in the production of stained glass, a business which has offered equal opportunities for more than a century.

## NATIONS

The young me would have been enraptured by postwar Children of All Nations windows filled with children in national costumes, like those in St Andrew in Soham (J. E. Nuttgens, 1957) and St John, Hoxton, London. She would have pored over the clothing details and spent a long time deciding which outfit she would most like to dress up in: a flower-covered kimono, a grass skirt, or perhaps a stripy blanket accessorised with wooden beads. Today, however, despite the fact they are inclusive, the national stereotypes portrayed in these windows can be the cause of some disquiet. They are just one of several types of church window which express different viewpoints of Empire, monarchy, race and missionary work to those which are now deemed acceptable.

These windows highlight the fact that you may not always like what you see, that at some point you will come across windows which cause discomfort or offence and encounter a few which may be dreadful by modern standards. It is not my intention to defend politically incorrect, morally dubious subjects, but to point out that they are there to be seen and dealt with – however you choose.

In a way, churches are remarkably open about the celebration and commemoration in stained glass of many far from admirable moments, events, movements and figures in history. It could be said that they are showing the acceptance and tolerance they preach by not smashing and destroying these windows, as others have done in the past when they did not approve of their content. Since windows are permanent architectural fittings and are very rarely removed – and almost never on taste or historical grounds – churches are not in a position to put them away when it suits them in the way that art galleries and museums can. This is despite the fact that there

are some windows now considered in very poor taste, and which may be the subject of internal and/or local debate.

Inappropriate and offensive windows leave the Church potentially vulnerable to criticism. Although it does not actively deny the presence of such windows, individual churches may avoid commenting on them in their guides and literature. So one can find windows which illustrate slavery, white missionaries, racial stereotypes, male privilege, women shown as passive, second-class citizens, unchristian natives, and the glorification of the Empire, to name but a few sensitive subjects which reflect the establishment and Anglican world views and popular culture at the time of commission. These present a challenge to today's viewers and my own approach is to look at them as valuable historical artefacts, the likes of which are rarely seen in public nowadays.

See also HAIR, TEXTILES, VICTORIAN

## NEEDLES

Although they are there, searching for sewing needles in church windows can be like looking for them in the proverbial haystack. However, windows which focus on the associations of needles and needlework in the context of the history and representation of women are widespread. They are part of the much bigger story of men's and women's roles and separate spheres, which is often symbolised in stained glass by references to the masculine sword or pen and the feminine needle or distaff.

For centuries, it was expected that women would spin and sew and do good works. As stained-glass windows have always acted as important forms of role-modelling sanctioned by church and community, such ideas and concomitant images of women's work and the promotion of 'virtuous' or 'righteous' women are inescapable. It is not possible to ignore or 'unsee' images of seated, immobile, quiet women such as Mary and Eve bent over their stitching or with their distaffs and spinning wheels while men nearby do active and often noisy work such as digging, carpentry and

beating hot iron. At other times, women are pictured at their looms in a Pre-Raphaelite and Lady of Shallot style, isolated and almost imprisoned, but showing the lovely female profile beloved of male artists including C. E. Kempe, who often used this pose. Astonishingly, this idealisation of the soundless, stitching woman, the 'Capable Wife' who 'seeketh wool and flax, and worketh willingly with her hand' (Proverbs 31) while wearing historical dress continued well into the twentieth century (see for example the 1937 Capable Wife window by G. E. R. Smith and Margaret F. Pawle for A. K. Nicholson Studios at St Aidan, Bamburgh).

More stitching and needles can be found in windows which present the biblical Dorcas as a 'woman of good deeds' whose charitable work includes making clothes to give to the poor (her name has also long been applied to the well-known brand of needles and to 'Dorcas meetings', or women's sewing circles). In many Victorian windows she is shown holding out, offering or helping people into her hand-stitched garments and, just like the Victorian women who organised so many sales of work to raise funds for churches and good causes, she can also be seen sewing. Fine Dorcas windows can be found in St Mary Magdalene, Mulbarton (A. K. Nicholson, 1907) and in Holy Cross, Seend (James Powell & Sons, *c*.1905), where she contemplates her needlework as she pulls a needle though her beautifully embroidered fabric while standing next to St John the Evangelist, who gazes into the distance while holding his quill in mid-air as he reflects on his writing. My favourite is the colourful – if rather sanctimonious – sewing group gathered around Dorcas in St John the Evangelist, Otterburn (John Hardman & Co., 1863), which is redeemed by the inclusion of an ordinary wicker basket holding beautifully detailed embroidery scissors, fabric, ribbon, wool and cotton, recognisable to everyone who has ever threaded a needle or tidied a mending basket.

Sadly, such glimpses of the tools for needlework are all too rare. As a result, a roundel such as that dedicated to an accomplished needlewoman in St Peter and St Paul, Fakenham (date and maker unknown), in a delightful Edward Bawden/Festival of Britain watercolour style with needle, thread,

scissors and an embroidery frame holding the work in progress, is to be treasured, and would make a beautiful print or poster.

See also BASKETS, *DALLE DE VERRE*, KNITTING AND KNITWEAR, TEXTILES

# NOSES

The first time a stained-glass nose excited me was when I realised that I could tell just from its sculptural shape and finely painted surface that the maker of the window was F. W. Cole, whose noses I had encountered once before. After that I began noting noses to see if this identification-by-nose formula had been a one-off – but no, noses can indeed be a variation on the maker's mark, with many designers using the same nose over and over again. Looking for and following hallmark noses is a good way of separating unexciting glass from characterful glass, and can lead you to many fine windows. This is because some of the most distinctive makers, the ones who have done something new, different or significant in stained glass – a difficult thing to achieve in a very proscribed, derivative and often conventional art form – have a very particular way with this part of the face.

This interest in noses can be traced all the way back to the early fifteenth century and the fantastically protuberant and bulbous noses in fifteenth- and sixteenth-century windows, for example by John Thornton of Coventry. They are the antithesis of classically beautiful or widely admired noses (e.g. aquiline, petite, retroussé, Roman). He created realistic, unidealised faces with close-set eyes and natural-looking, often unkempt hair, perhaps based on local people or even cathedral workmen. The finest noses are in his early fifteenth-century Great East Window in York Minster. His work proves that the ugly and grotesque can be powerful and moving, something which was exploited later by several artists, including Frank Brangwyn in St Mary the Virgin, Bucklebury, with his fantastic range of hooked, bumpy, ski-slope, bent and boxer noses (plus a few petite, straight and perfectly regular examples), which speak of great realism and an ability to see beauty in the unconventional.

It was exactly this approach that made me notice Cole's strikingly unusual noses, among the best of the twentieth century, which come in many shapes and sizes but all with his distinctive, finely shaded, smooth, polished finish, which reveals all the contours, bumps, lumps, bulges and imperfections. His imperfect but splendid noses are often thin and pinched at the bridge, long in length, and usually flare out at the end with two bulbs, thus creating superb profiles on both men and women. (Note: Cole worked for a long time in the postwar period to the 1960s for William Morris of Westminster and his windows may be signed with the company name and a portcullis rather than his own initials.)

Such noses are just one small but significant way in which an individual designer can express their personal creative impulses. Take for example the long, thin, needle-sharp noses in Harry Clarke's windows, which reveal a designer fascinated by the world of fairy tales he illustrated so brilliantly in books (e.g. St Mary, Sturminster Newton). Or, at the very opposite end of the spectrum, the phenomenal, granite-like, rough-hewn

22. Detail of St Giles window designed by F. W. Cole for William
Morris & Co. (Westminster), 1958. St Giles, Stoke Poges.

noses, like flattened squares and rectangles, on the powerful, monumental, sculptural figures (which remind me of Jacob Epstein's or Eric Gill's work) by Wilhelmina Geddes, who was deeply influenced by the Gothic statuary and stone carvings on the cathedrals of northern France (e.g. St Luke, Wallsend). On the other hand, a relatively unremarkable nose can become just as much a hallmark of a maker's work when it is repeated over and over, as with Edward Burne-Jones or C. E. Kempe. It is also possible to date glass by noses. The 1920s and 1930s saw a rash of sweet, upturned, cute little noses on children, while post-World War I Arts and Crafts makers such as A. J. Davies in Holy Trinity, Southport, conformed to the prevailing standards of magazine and cinematic beauty with fine, straight, picture-perfect, often dainty male and female noses, which could quite easily belong in magazine adverts for skincare, permanent waves and hair products.

See also EYES, KEMPE, MAKERS' MARKS

# PAINTING

One has only to look at the many examples of skilfully painted fur, feathers, skin and hair in windows to appreciate the immense skill that goes into painting on glass. It takes all shapes, sizes and textures of brushes and tools (many of which are the same as medieval glaziers used), extremely steady hands, a time-consuming build-up of layers and firings, and a lightness of touch to create beautifully realistic surfaces in almost forensic detail. It is no coincidence that in the past many artists in the field had also received training in engraving and mezzotint, for it is exactly this style of texture and detail that can be found in church windows.

By way of illustration, look at the exquisitely textured fur on the squirrels and mice, the bat wings, hedgehog prickles, toad markings and dragonfly wings in the 1920 Gilbert White memorial window in St Mary, Selborne, and elsewhere at owls' feathers, seals' skin, stags' antlers, lambs' wool, rabbits' ears and cockerels' combs to see how a glass artist is effectively playing with

dark and light all the time – or 'painting with line and shade', as Christopher Whall described it in his 1905 book *Stained Glass Work* (republished in 2010 and still regarded as one of the best books on the subject). Painting techniques and styles vary according to individual maker and company, but almost always involve taking off as much paint as is put on. To create subtle effects, before it is fired the dried paint is softened, shaded and picked off by means of matting, scrubbing, badgering, stippling, stabbing, scratching and scraping with sticks and special brushes or whatever the artist chooses to use, often with multiple firings which permit a build-up of layers. It's a laborious, labour-intensive process of painting, treating and firing over and over again, one that goes some way to explaining why stained glass is expensive and sometimes astoundingly good.

Although this is very different to painting on canvas or paper, it is not unusual to come across a church window that you might have seen (or something very like it) before. And indeed you may have, in the form of a painting, for many windows are copies or adaptations of famous paintings. Once coloured vitreous enamels became popular for painting on glass in the eighteenth century they enabled new church windows in England to resemble oil paintings, which were considered a much higher art form than stained glass. William Peckitt, Henry Gyles and Francis Eginton were all prolific glass painters who turned easel paintings into windows, with varying degrees of success. They used a background of clear glass with minimal leading in place of a canvas, and applied designs by artists such as Joshua Reynolds and Benjamin West or copied paintings by the likes of Rubens, Cipriani and Guido Reni. Many of these windows were removed by the Victorians, but those that remain, mostly in late eighteenth-century and early nineteenth-century churches, show just how variable the quality is. The worst reveal that large-scale painting with enamels on glass can be awful: badly aged, dark, murky and muddy. But the best, such as the seven female figures in the late eighteenth-century west window in New College Chapel, Oxford, by Thomas Jervais after Joshua Reynolds, achieved tremendously delicate beauty and translucence in the finely painted hair, facial features and drapery. (Ironically, the section of window above them

is one of the poorest examples of eighteenth-century painted glass you could hope to find.) These designs by Reynolds were reused several times and the individual Virtues can often be spotted in different colourways, for example in Birmingham Museum and Art Gallery, which has a version by Eginton (*c.* 1816).

In the same way that a few paintings were made spectacularly popular by mass-market reproduction and prints in the Victorian era, church windows brought versions of several famous paintings to large audiences. Churches all over England have stained-glass versions of Holman Hunt's painting *The Light of the World* (1851–3), an image which has been used over and over again right up to 1959 (Francis Spear, St John the Baptist, Eton Wick) and perhaps even more recently than that. Designers may take liberties with the layout and details of the original, just as they do in windows inspired by two of the best-known paintings of the early twentieth century. One of these became a favourite for World War I memorials: the dead soldier in *The Great Sacrifice* by James Clark (popularised in 1914) has been transposed several times to stained-glass settings, often standing in for the lost son or brother (e.g. St Mary in Maldon, St Mary Magdalene in Enfield). *The Pathfinder* (*c.*1907–17) by Ernest Stafford Carlos (1883–1917), known for his depictions of the early days of the Scout movement, has also been interpreted in glass, with gloomy, ghostly results (e.g. St Mary, Nottingham, and in Carlos' own memorial window in Holy Cross, Hornchurch). It underlines once again that stained glass is best when it is original and site-specific.

See also HOW A STAINED-GLASS WINDOW IS MADE, LEAD, LIGHT

# PASSEMENTERIE

One of the reasons I am so keen on church stained glass is that it is full of unintentional distractions and diversions which take me away from the obvious and intended content and messages of the windows. When I saw the famous late fifteenth-century windows in Holy Trinity, Long

Melford, I knew I should be focusing on their history and the local families and dignitaries they depict, but instead spent more time fascinated by the plump cushions on which the donors were kneeling to pray. Not only did they appear to be made of rich silk jacquard fabrics, they also had lovely big tassels at the corners, a nice detail which made me wonder at the way the wealthy and influential managed to make their devotions so luxurious and comfortable.

At that point I didn't know that church windows are packed with *passementerie*, one of those categories of traditional products which always look as though they are in danger of disappearing but somehow survive together with their wonderful vocabulary: ropes, galloons, tie-backs, rosettes, gimps, frogging, bullion, ball and drop fringes, all of which can be found in stained glass. I perhaps had rather Protestant expectations of asceticism and plainness when I started out, but soon adjusted my viewpoint when I found such a huge range of intricate, elaborate and rich trimmings, which designers used not only generously, but often to excess. While on one level this points to a fascinating commentary on money, piety, power, presentation and display which goes beyond the scope of this book, it can also be enormously enjoyable to look for them and marvel at the variety of designs and uses.

*Passementerie* makes a statement in thousands of windows. Ribbons, braids, cords, edgings, tassels and piping can be seen on military, royal, ceremonial and religious outfits as you would expect, but also on the garments of saints and angels. A full and fabulous array adorns upholstered furniture, curtains, screens, drapes

23. Detail of Nativity window, by Kempe & Co, 1913. St Peter, Binton.

and canopied beds. Some designers use cords and tassels as a device to frame and tie together a design while others, such as Brian Thomas, create stunning *trompe l'oeil* effects with soft furnishings (e.g. the billowing curtains with fringes and tie-backs in St Andrew Holborn, City of London). The only limit on trimmings, it seems, is the artist's imagination, and if sumptuousness is to your taste, Victorian windows make especially good hunting grounds: a garment fringe hung with sizeable bells and pendant pomegranates in St Mary the Virgin, Bucklebury, a never-ending array of exquisite and intricate *passementerie* designed by C. E. Kempe, and a lovely range of nineteenth-century pink, gold and blue tassels and trimmings in St John the Baptist, Peterborough. This is just the start: everywhere you look you will find beautiful furnishings and finishings, and even the plainest churches and normally restrained designers can revel in a riot of *passementerie* in their windows, suggesting a far from austere love of sumptuous interior design.

See also DONORS, ERMINE, PINK, TEXTILES

# PEACOCKS

One of the strange but common sights in English church windows is that of beautiful golden-haired angels with a profusion of flamboyant, theatrical peacock feathers in their wings. As their creator, C. E. Kempe was remarkably prolific (his studio made around 4,000 windows), and as one of his trademarks was the use of the peacock feather, there are an awful lot of them to be seen. The feathers may be gold, green, blue, pink or yellow (but never realistic peacock colours), and they surround the sweet heads like an elegant fan or luxuriant feather nest.

This is strange not only because angel wings are not normally associated with peacocks, but also because the birds and feathers have more than a hint of *fin-de-siècle* decadence due to their connections with the likes of Oscar Wilde and Aubrey Beardsley; one might have thought this would have put them beyond the pale for church artists. However, although the

outbreak of peacock feathers in stained-glass windows at this time (1870s to 1920s) coincided with the Aesthetic fashions of the day, it also had Church approval because in Christian iconography the peacock is associated with immortality. The ancients believed that the flesh of the peacock did not decay after death, so it became an early Christian symbol of eternal life. The peacock is also associated with renewal and resurrection, since legend has it that the bird sheds its feathers each year only for them to grow back more beautiful than ever. As a result, Kempe had carte blanche to create his wildly theatrical, fantasy angel wings – although he may have been influenced by medieval makers, who sometimes gave angels peacock-feather wings (there are some exceptionally beautiful fifteenth-century examples in St John the Baptist, Cirencester). And he was not the only designer to do so: Henry Holiday, another masterful painter of wings, imagined peacock feathers in a gorgeous, glowing combination of coral, rose and gold for Worcester College Chapel, Oxford.

It is possible to spy a few actual peacocks, too, although they are rarely shown with their feathers fully displayed – it is ironic that such a showy bird should be often half-hidden, semi-camouflaged and difficult to spot. This makes it quite exciting when you do find one, for example the very small but spectacular peacock on its way into Noah's ark in the 1886 window by Joseph Bell in St Mary Redcliffe, Bristol, and the brightly coloured, pink, aqua, scarlet, blue and emerald version which cleverly fills a quatrefoil tracery opening in the sanctuary of St John the Baptist, Cookham Dean (Lavers & Barraud, *c*.1864). Even less obvious peacocks can be found in the corners or lower parts of windows designed by Theodora Salusbury, who used the bird as her maker's mark. Although they are mostly painted with their feathers spread behind like a fan or halo, these miniature peacocks vary in aspect, size, colour and detail with every window and suggest a remarkably inventive artist; each is a work of art, as are the windows themselves. Salusbury, the daughter of a churchwarden, was born and lived mostly in Leicestershire, the county with the greatest number of her windows. Her work is in the Arts and Crafts vein and is exceptionally good, with tremendous presence, strong figures, skilful handling of paint and brilliant,

jewelled colours. If a window is signed with a tiny, exquisite peacock, you know it is one of hers.

See also ANGELS AND ARCHANGELS, BIRDS, CORNERS, KEMPE, MAKERS' MARKS, SUNFLOWERS

# PERSPECTIVE

Many church windows look like the pages of flat, illustrated storybooks (early medieval windows, for example) or perhaps like layers of a transparency, with different planes which combine oddly unrelated objects and figures in a naive and primitive artistic style. Because they may associate stained glass with these traditional, flattened designs, people do not always expect a church window to employ perspective in the same way a work painted on an easel might. And yet some artists use it to create incredibly clever, sometimes photographically realistic three-dimensional effects and stunning spatial illusions with paint and light.

The painted glass of the seventeenth and eighteenth centuries often achieves a remarkable depth in its backgrounds, shadows, reflections and vistas, as well as a convincing roundness to people, by means of exquisite shading and skilful painting. Poorer examples can look like bad scenery painting in a theatre, but the best *trompe l'oeil* effects suggest very realistic perspective, helped by the fact that the glass is backlit. These windows may not be what purists are looking for, but if you do like this style, there are plenty of fine examples to be enjoyed in English churches, particularly those built in the Georgian era, such as St Chad in Shrewsbury.

Consider also the point of view within a window; it may be cleverly unorthodox and inventive, as in Stanley Spencer's paintings, where he looks at scenes from above, below and from many different angles. When you remember that a window is constructed in a very different way to a painting on a canvas, involving the painting and piecing together of innumerable pieces of glass and lead, you realise that it takes tremendous artistic vision to move beyond flat planes to create a light-filled scene or

tableau with convincing perspective. In St Andrew, Aldringham, Alexander Gibbs, a Victorian designer whose windows are always worth seeking out, creates a powerful illusion of depth to his window which illustrates the lowering of a paralysed man on a mattress through an open roof and makes the viewer feel as though they are in the room with the crowds of people pressing to see Jesus while others above hold ropes and look in. Chris Fiddes and Nicholas Bechgaard achieve stunning effects with unusual perspective in St Nicholas, Potterspury, with a fisheye-lens view of craftsmen at work, while Rachel Thomas in St Paul, Birmingham, takes a God's-eye view so that the viewer is looking down on the fore-shortened angels, who are in turn looking down over Birmingham, spread out below them.

See also EUROPEAN, LIGHT

# PEVSNER

The county guides in Nikolaus Pevsner's renowned Buildings of England series are invaluable for 'church-crawlers' (to use John Betjeman's phrase) and anyone interested in architecture. When it comes to their coverage of stained glass, however, the original editions can be disappointing; it is surprising and revealing to see just how much Pevsner misses or chooses to leave out, and to note his preferences and blind spots (to be fair, his notes and comments do suggest that windows are not one of his many areas of expertise).

His prejudices are clear: he is inordinately fond of C. E. Kempe, his church window superstar, but this may be because he is so prolific and easily identifiable; William Morris and Edward Burne-Jones come a close joint second. He regularly devotes an inordinate amount of space to cataloguing every last fragment of illegible, faded medieval glass, and he wilfully ignores huge numbers of twentieth-century and postwar windows. He is frequently cursory in his notes on fine Victorian and Arts and Crafts windows, neglects many female makers, and can be quite

witheringly dismissive of stained glass and its makers if he does not rate them. His attitudes and omissions have in turn influenced many readers, critics and authors, and have undoubtedly contributed hierarchies of value that continue today.

Having said all that, a 'Pevsner' is still the best starting point when planning where to visit and, while the early editions written by Pevsner himself can be irritating and frustrating, they are also often engaging precisely because of his firm opinions. He can be acerbic and harsh ('terrible', 'not good', 'dreadful', 'typically dark and miserable'), inconsistent, amusing ('E window [...] unsigned, perhaps wisely, the artist had trouble with eyes'), disdainful of local companies' efforts, weary ('bits in several windows'), and often surprisingly limited in his vocabulary when it comes to stained glass ('Expressionist' is applied to an alarmingly wide range of different twentieth-century windows).

But his was an enormous task and his groundwork has led in time to a fuller inventory. Although the old Pevsners are collectable and historically interesting, later editors and contributors have vastly increased the guides' coverage of stained glass, which means it is now always worth using the most recently published Yale University Press edition of a county guide. While all the recent editors are precise and thorough, indicating where there is glass worth seeing, a number are clearly enthusiastic about windows and interestingly articulate on the subject, and their guides can be wonderfully informative, entertaining and helpful. Having worked my way through every up-to-date Pevsner in search of good glass, I have discovered both the best counties for glass and the outstanding contributors.

Warwickshire has a fine concentration of stained glass, particularly Arts and Crafts, and Chris Pickford has covered the topic thoroughly and usefully in the 2016 edition of the county guide. In *London 1: City of London* (1999) Simon Bradley writes an excellent introduction to the postwar windows in the City and gives full accounts in the individual church entries. Matthew Hyde has an eye for interesting glass and allows his engaging personality to emerge in *Cumbria* (2010), *Cheshire* (2011) and *Lancashire: Manchester and the South East* (2004). In his clear-sighted reactions

to windows he can be mildly opinionated, funny ('delightfully bad') and sometimes gently provocative ('an unsophisticated display of niceness'). David Verey and Alan Brooks (*Gloucestershire 1: The Cotswolds*, 2003, and *Gloucestershire 2: The Vale and Forest of Dean*, 2002) are reliably observant, moderate and balanced in their intelligent comments and suppositions, as is Alan Brooks (*Worcestershire*, 2007) who builds up a balanced catalogue of glass of all periods. In *Shropshire* (2006) John Newman comes across as a very safe pair of hands: his energy and interest are evident; he is fair and observant but not too dry, particularly adept at describing colours, and he includes many pithy reactions to windows. Alan Brooks (*Herefordshire*, 2012) is a fine companion, skilled at identifying and dating glass and generous with details and praise, and readers can rely firmly on James Bettley (*Suffolk: East* and *Suffolk: West*, both 2015) to bring to their attention churches with good collections of glass.

See also BUILDINGS, CATHEDRALS

# PHOTOGRAPHY

## PHOTOGRAPHY IN WINDOWS

Nowadays we are used to seeing photographs of faces reproduced on all sorts of surfaces, from handbags to tea towels, but in a church it can still come as a shock to find a lifelike face, a photographic image of a real person, superimposed on a stained-glass body, in a kind of church version of the popular seaside 'head in the hole' photo boards. A black-and-white photograph of a head is completely at odds with a painted, fragmented, leaded body, and it is unsettling to see a studio portrait or press photo printed above Crusader tabards or the fancy-dress armour of St George. As one of the main attractions of looking at stained glass is its quality of other-worldliness and transcendence, a dated photo breaks the glass equivalent of theatre's fourth wall, shatters the illusions of art, and can have the unfortunate effect of looking both incongruous and comical.

Many of these black-and-white or sepia photos appear in World War I memorial windows, when there was a brief flirtation with incorporating lifelike images of the lost soldiers into the glass instead of painted portraits (although faces faithfully painted from photos are almost equally out of keeping with the rest of the figure). The new popularity of photography meant that most soldiers going off to the war had a studio portrait taken in full uniform which could be given to family and loved ones, and it is this type of self-conscious, formal, unsmiling photo with military haircut, ruler-straight parting, neat moustache and no airbrushing or improvements that is trapped in many windows. So churches such as the Priory Church of St Peter, Dunstable, and St Mary and St Nicolas in Spalding still have the ghostly, transparent faces of dead soldiers looking down at the congregation, and there is a particularly surreal but heartbreaking window in St Peter, Harrogate, dedicated to the three sons of the church's first vicar who are seen dressed up as St George and the archangels St Gabriel and St Michael. It is no wonder that this type of memorial did not catch on, although artists have continued to use photographs on glass either directly or as the basis for painted portraits, particularly in large ensemble or official windows. It is also possible with a sharp eye to find strange and peculiar juxtapositions of real and imagined faces, like manipulated and altered Soviet propaganda images, so there may be local and well-known clergy who stand out amongst the artistically painted faces because of their individual features, contemporary haircuts, receding hairlines, bald patches and metal-rimmed glasses. In the great West Window by Hugh Easton (1955) in Holy Trinity, Coventry, and the huge window by Christopher Webb (1940) in the Chapel of the Holy Spirit in Sheffield Cathedral, the real-life clerics are shown in their real-life ecclesiastical robes, which means they blend in reasonably well. Less successful is the highly visible 1954 Royal Window by Sir Ninian Comper in Canterbury Cathedral, in which the photographic likenesses of the royal family have been placed on outsize heads, out of all proportion to their bodies, with predictably awful results.

Photography is now used in far more subtle and creative ways, which are sympathetic to the mixed media of glass and light, lead and paint. An

image becomes an integral part of the overall surface and design rather than a cut-out from a photo album, and although this screen and digital printing is more common in architectural and non-church glass, it can be found occasionally in contemporary and millennium windows (for example, Adam O'Grady's recent work incorporates screen-printed images of nature in collage-style windows).

## TAKING PHOTOGRAPHS

A great deal has been written on the subject of taking photos of stained-glass windows in churches, with the majority of writers saying how difficult it is, how much equipment is needed, and how much editing needs to be done afterwards. In fact, it is quite straightforward once you have had some practice sessions to learn how to deal with the light and your positioning.

This is my approach: I use a Nikon D7000 and just one lens, a Nikon AF-S Nikkor 55–200 mm telephoto lens. I could perhaps add a wide-angle lens to get whole windows into frames and a macro lens for close-ups, but I like to travel light. I use manual settings, normally f5.6, and 1250 ISO (unless I need to go higher). I don't use a tripod as I like to be unobtrusive and to take photos as quickly as possible. I check the photos as I go along on the camera screen and often allow a little more or less light in than the meter reading suggests. I find I get better results on overcast days with diffuse light, and I prefer not to take photos of windows with bright light streaming through in order to avoid problems with halation and seeing the lines of the support bars, protective grilles and mesh. I do not switch on the interior lights in the church as they can reflect off the surface of the window and create a shine on the photo. I stand squarely in front of the window or section I am photographing.

Once the photos are uploaded I don't do anything to them except crop them as necessary. I aim to get the best colour and clarity when I am in a church. Finally, I have found that it takes practice – rather than any smart piece of equipment – in order to get better photos.

See also EXPLORING A CHURCH, PERSPECTIVE

## PINK

For me, colour is just about the most exciting aspect of stained glass. It is what drew me to looking at it in the first place and got me hooked. It was also through looking at colour that I first understood that stained glass is a wonderfully dynamic, kinetic art: it changes all the time according to the light, with different colours coming forward or receding as the day progresses, and casts beautiful, dancing spots and areas of colour on walls, floors and pews, as if someone were shaking a huge kaleidoscope.

Everyone has their own colour preferences, a personal palette which pleases, and I would be willing to bet that whatever your preference, it can be found in stained glass. Although some people might think of church windows as primarily red, blue, yellow and dark, in fact they contain all colours under the sun, from the palest, most delicate tints to the deepest, most intense shades, and in every combination imaginable. Whether you like pale blue and conker brown (St Mary, Wirksworth), lime green and scarlet (Winchester Cathedral) or warm coral and royal blue (Salisbury Cathedral), you will find it somewhere.

It is lovely to simply wander into a church or cathedral and to embrace what you happen to find in the way of colour. But it also pays to make a mental note of which windows make an impression, so that you can be on the lookout for more of the makers whose colours you like and wish to wallow in. Makers and firms often have very specific 'house palettes', and those who use colour with verve and skill stay in the visual memory bank. This is why David Evans of Betton & Evans (so often described as 'garish', but I prefer 'brilliant'), Heaton, Butler & Bayne, Alexander Gibbs and Frederick Preedy are memorable for me personally. Individual artists have their own distinctive palettes, too, such as the natural, organic palette of John Hayward, John Piper's rich, deep, paintbox palette, or the unique combination of turquoise, scarlet and orange used by Ervin Bossányi. Successful colour work is also all about placement and juxtaposition: Wilhelmina Geddes' windows are superb illustrations of the impact of careful choice and control. Her obsessive concerns about having exactly

the right colour in the right place pay huge dividends, and the tiny drops of lemon, searing pink, flaming tangerine and cool aqua are genius touches which move the eye and animate her design in St Michael, Northchapel (1930).

An alternative approach, which can be fun for a while, is to take a single colour and look for it. I am always attracted to pink, and spent a while making a point of searching it out. This was after I came across some particularly vivid examples in St John the Baptist in Peterborough which surprised me, as I had not previously considered hot pink to be part of the stained-glass palette. I was wrong, and looking for pink subsequently proved to be a quick and easy route to many outstanding makers and windows. This is how I discovered nineteenth-century firm Lavers & Barraud with their combinations of rose, magenta and lilac, the gorgeously rich gold-pinks in the work of Edward Burne-Jones and Henry Holiday, the vivid fuchsia pinks used by Louis Davis and Karl Parsons, and the slightly dirty, dusky, swirly pinks which make such an impression in Marc Chagall's windows in All Saints, Tudeley. As for the remarkable late nineteenth-century/ early twentieth-century window in Peterborough, it uses bright, shocking pink to create popping highlights in a beautifully pure and clear mix with sapphire blue and white plus a little old gold. This is an unusual window for its time in terms of the clarity of the colours and the way it uses white (clear) glass and a very limited number of colours. While the subjects may be traditional and what you would expect of the nineteenth century, their treatment is anything but, and I remain convinced that the pink suggests a quite unusual designer was at work here.

Colour can be incredibly enjoyable, and there really is no need to complicate things. The moral of the story when looking at stained glass is to abandon preconceived ideas and expectations, ignore colour theories and colour wheels, take no notice of what allegedly constitutes good taste, be confident in your own tastes and preferences, and, above all, to revel in the glorious colours used by the designers and makers who handle them with such skill and confidence.

See also LIGHT

## PIPER

The name of John Piper (1903–92) is usually the first – and often the only – one to spring to mind when the subject of postwar stained glass comes up. His high profile means that for many people he *is* postwar stained glass, the innovator and the trendsetter – this despite the fact that he was just one of a number of designers whose collective work transformed the quality and profile of church glass after World War II and made it a significant part of the new visual culture. Nevertheless, his renown in other fields, such as painting, printmaking, collage, mosaic, fabric, theatre, photography and tapestry, has ensured that his name stands out. With his many connections and high-profile commissions, he brought glamour from the art world into the sphere of stained glass and generated enormous amounts of publicity. His windows have been tremendously influential in raising awareness of and interest in the potential of stained glass as a modern medium, and in his writings he made a huge contribution to the development of ideas about colour and light in windows.

Piper himself never made any of the windows which bear his signature. He was the only significant English designer of stained glass in the mould of the postwar French artists such as Chagall and Braque, who were paired with long-established ateliers or studios to fulfil commissions. He maintained a strict division of labour between the artist-designer and the painter-maker, and almost all of his windows were executed by Patrick Reyntiens from 1954 onwards, although a few were made shortly before and after Piper's death by David Wasley, who had been trained by Reyntiens. He explains his reasons for this separation in his thought-provoking book *Stained Glass: Art or Anti-Art* (1968), a somewhat contentious, self-serving argument for not leaving stained glass to craftsmen, in which he is also terribly rude about a great deal of glass and makers. (It is definitely worth reading.)

As for the windows themselves, you should not fall into the trap of assuming that every 'Piper' is brilliant. The earlier windows, such as those in Oundle School Chapel, Coventry Cathedral and Eton College Chapel, are indeed superb and combine a true mould-breaking newness with a deep

knowledge of the Bible expressed in ultra-modern interpretations. He often uses powerful symbols and synecdoche – hands, fishes, lilies, swords, keys – rather than narratives. The best explore the painterly possibilities of leaded glass, display a unique sense and use of colour in striking, postwar palettes and, because of the masterful Piper/Reyntiens understanding of the medium of light, create enormous impact. It has to be said, though, that his later windows can look rather clumsy, with odd choices of sometimes banal subjects, heavy-handed leading and loose, almost slapdash painting, and often lack the finesse and modernity of the early windows.

As many people who have done a 'tour' have discovered, day trips based around looking at Piper's windows can be very enjoyable. There is plenty of information online about the locations, as well as in June Osborne's *John Piper and Stained Glass* (1997) and *John Piper and the Church* (2012). For the best of the Piper/Reyntiens collaborations I recommend the following: the places mentioned above; the churches in the Chilterns near to his home in Fawley (in particular Pishill Church, St Mary the Virgin in Fawley, St Bartholomew in Nettlebed, St Mary in Turville); the churches of St Peter in Wolvercote and St Martin Sandford in St Martin, both near Oxford; Nuffield College Chapel, Oxford; St Margaret, Westminster; All Hallows, Wellingborough; Robinson College Chapel and Churchill College Chapel in Cambridge; and Liverpool Metropolitan Cathedral. In addition, it is still possible to see the large, very fabulous 1960 glass mural the pair made for the Arthur Sanderson & Sons showroom, now the Sanderson Hotel in London.

See also ANONYMOUS, POSTWAR

# POSTWAR

John Piper was one of a group of postwar makers whose approach to stained glass was modern, experimental and daring. Many approached it as an artistic, sculptural medium and brought to it a much greater sense of vigour, freedom, experimentation and abstraction than prewar designers. As a result, these makers broke new ground, moved away from the Gothic,

neo-Gothic and Arts and Crafts, took inspiration from contemporary art and design and made interesting, exciting windows in new styles for the new era. They developed alternative ways of working with colour and shade, leading and surfaces, bold abstraction and semi-abstraction. They also pushed the limits with symbolism and iconography, and brought a freshness, vitality and energy to the medium, which was on track to becoming moribund.

Most of these makers who stand out in the field did not have a high profile in the art world, and many remain little known and underappreciated, but they each created superb bodies of work in their own, distinctive styles. If you come across a window by any of the following artists made in the 30 years or so after the end of World War II, you can be sure you are looking at the kind of work which makes this such an exciting period for stained glass: Carl Edwards, Tom Fairs, Eric Fraser, D. Marion Grant, Henry Haig, Tony Hollaway, Jasper and Molly Kettlewell, Ceri Richards and Francis Spear.

In addition, I would also recommend looking carefully at the makers who continued in a more traditional idiom but brought modern life into their colourful, often densely detailed windows: A. E. Buss, F. W. Cole, George Cooper-Abbs, Harcourt M. Doyle, M. C. Farrar Bell, Edward Payne, G. E. R. Smith and Christopher Webb.

See also BOMBS, PIPER

# QUARRIES

Quarries are the unsung heroes of stained glass. They are the small pieces of glass – diamonds, lozenges, squares, rectangles, circles, hexagons – often used en masse for plain glazing, borders and backgrounds. The pieces may be clear, lightly tinted or made of reamy, bubbly, streaky, thick or slab glass, painted, stained or left plain and unpainted. Quarries can be pieced together to create a pattern which is usually (but not always) regular – grids, lattices, zigzags, honeycombs or combinations of patterns. They may also

be the component parts of a larger pattern, as in grisaille windows, or they may contain their own individual motif or image.

The list of subjects you might see in a quarry is enormous and includes animals, bobbing ducks, chirpy little birds, emblems and symbols, fishes, fleurs-de-lys, flowers, foliage, heraldic devices, Instruments of the Passion, loaves, marks for makers, rebuses for donors, seasonal scenes, and vines. Many are sweet, funny and whimsical, little spots of light relief. It is thought that medieval quarries were often sample or practice pieces done with a sense of humour by apprentices, perhaps for sections which would be invisible to the naked eye. Excellent examples include the quarries in the Zouche Chapel in York Minster and the delightful sets of lively birds in St Mary the Virgin, Clothall, and in St Mary, Clipsham. Victorian makers could on occasion be equally light-handed and make fine copies of medieval quarries, as in St Peter and St Paul, Lavenham.

As quarries offer so many options, many designers do quietly lovely things with them, almost as a sideshow, and they become so much more than mere filler or something you might find in a pub or fanlight (although there are times when opportunities have been missed and quarries do appear to be there just to make up the numbers). This is particularly true of postwar glass with vast expanses of clear quarries around central sections, although these may be the result of financial constraints.

Medieval and Victorian painters used grisaille in quarries to build up intricate and elaborate patterns with repeats, which are tremendously effective. They also created beautifully elegant single- or two-colour patterns such as black and gold, made with iron oxide paint and silver stain, which grow and spread across the glass, each quarry painted with a small section of pattern. See, for example, the delicately painted foliage and acorns in the thirteenth-century quarries in Merton College Chapel, Oxford. Quarries are also perfect for repeating patterns in which a single motif is delightful, but even better when multiplied. The windows in the passage which runs from the choir to the cloisters at Lincoln Cathedral are filled with beautiful nineteenth-century quarries containing vine leaves and bunches of grapes, each one slightly different because they are hand-painted and individually stained.

This quality of handmade individuality is what makes many quarries so interesting. It was an approach embraced by late nineteenth-/early twentieth-century Arts and Crafts makers who exploited all the possibilities of even the simplest shapes, such as diamonds, in beautifully creative ways, often using translucent, reamy, textured glass with light washings of paint, painted patterns such as cross-hatching and chequerboard, or quarries within quarries to create little works of glazing art. Christopher Whall, his followers, and makers such as M. E. A. Rope and the brilliant Florence Camm also used the very effective trick of inserting tiny pieces of richly coloured glass into the leading, making them look like little jewels.

See also BIRDS, FRAGMENTS, GRISAILLE, JEWELS, LEAD

## RESTORATION

Church windows are not always all they appear to be (or all they are claimed to be). Just as the question of attribution is complex, so too is the question of dating. Since windows have to be repaired and restored after a certain amount of time in order to deal with the effects of time and weather, virtually no window more than a hundred years old is in an untouched, original condition. And yet guidebooks can be rather coy and even misleading about this, often glossing over subsequent work to repair breakages, re-lead or repaint, or even to replace pieces which are beyond repair, leading the viewer to assume that they are seeing the window as it was when it was first installed. This is particularly true of medieval glass: everyone wants to lay claim to authentic glass from this period, with the result that many people believe it has survived centuries in the condition they find it in today. In fact, what they are looking at is an accretion of interventions.

Restoration and conservation work these days is extremely sophisticated, sensitive and careful, and the subject of scrutiny from many interested parties. But this has not always been the case. The stories of botched jobs by jobbing glaziers – as opposed to dedicated companies and

studios – are legion, especially during the huge programme of restoration undertaken by the Victorians. Much medieval glass was scrubbed and repainted with overly bright colours and in poor imitation of medieval style. The famous medieval glass in All Saints, North Street, York, for example, should be appraised with caution, as much of its astonishingly bright colours and clear painted lines is in fact the work of William Wailes in the 1840s.

Stained glass is an architectural art, part and parcel of the building surrounding it and subject to the same depredations and changes. It is best not to consider it as a static, unchanging material or art form, but as one which requires maintenance and care which inevitably alter it with varying degrees of perceptibility, and, ultimately, to trust the evidence in front of your eyes rather than the claims of an overenthusiastic and reverent guide.

See also ANONYMOUS, MAKERS' MARKS

# SAINTS

Saints are one of the staple subjects of stained glass, and they populate thousands of church windows. They are worth examining because they have inspired so many artists and makers to create spectacular, theatrical, moving, colourful and sometimes gruesome windows.

But what if you know little or nothing of saints and their stories? Well, there are several approaches you can take when looking at them. The first is to simply enjoy what you see: beards, clothes, figures, gestures, hair, haloes, hands and feet, period details, the individual style of the maker or firm (if known), and the style in which a saint is depicted and constructed. The second is to consult the church guide, if there is one, and learn more on the spot. The third approach mixes a little knowledge with a lot of looking, and is by far the most rewarding and interesting; when you are able to recognise some of the major saints you begin to spot them easily and to regard them as heroes, heroines, old friends and interesting characters.

I have found that it pays to know at least some details of a few of the best-known saints, and perhaps have a few personal favourites. Once you are a little more familiar with them, looking at your chosen saints with their individual emblems and symbols becomes ever more entertaining and instructive, especially as there are so many aspects of saints and their stories that are strange to modern viewers, including the grisly instruments of torture and violence associated with some of them. I memorised the emblems of the 12 apostles from the superbly clear and instructive window by W. T. Carter Shapland (1960) in St Mark, Surbiton, and there are many more fine, multi-saint windows which can be studied this way, such as the medieval window with ten apostles in St Mary the Virgin, Drayton Beauchamp, and William Wailes' 1870 east window, featuring 12 apostles, in St Editha, Tamworth.

The following are a few of the saints who appear regularly in churches and cathedrals. If you are fond or interested in a particular individual, it is worth looking inside a church dedicated to that specific saint, as you are bound to find them in a window somewhere.

**St George** is undoubtedly top of the saints' popularity charts, what with being the patron saint of England, slayer of dragons and rescuer of fair maidens. St George can be recognised by a red cross on a white background, which may be on his armour or on a tabard, shield or flag, and he normally carries a sword or spear. He is sometimes shown in full armour on a pure white stallion, either in the midst of slaying a dragon or with a ready-slain one at his feet. St George is frequently dashing and heroic, and often has a strong, chiselled jaw unobscured by a beard. More poignantly, he can also be found in many World War I memorial windows, often with a heart-breakingly youthful, beautiful face, which may sometimes be that of the fallen soldier. One of my favourites, though, is of the gung-ho variety and is in a World War I memorial by Percy Bacon (*c.*1922) in St Edmund the

King and Martyr (now the London Centre for Spirituality), City of London. Here, St George looks like an Edwardian actor, complete with eyeliner and mascara, gesturing theatrically in extravagantly jewelled armour while a huge scarlet banner swirls around him. (See also DRAGONS.)

***St Michael*** can be confused with St George when he, too, is shown as a warrior saint spearing a dragon, but the difference is that Michael is an archangel and therefore has wings, which are sometimes spectacularly huge. It is he who, according to the Bible, weighs souls on Judgement Day based on their deeds on earth and symbolises the victory of good over evil. So when you see a figure holding a set of scales with the virtuous humans on one side and decidedly devilish, naughty creatures on the other, you know this is St Michael, and you may be looking at one of the many brilliantly scary stained-glass illustrations of Judgement Day which must have kept many a soul on the straight and narrow. St Michael, like St George, is often pictured spearing a dragon or monster, the symbol of his victory over Lucifer or evil; there is a superb fifteenth-century example in York Minster which has large, beautiful golden-stained wings and feathered legs, and a powerful modern version by John Hayward (1968) in St Michael Paternoster Royal, City of London.

***St Margaret of Antioch*** strikes a blow for feminists and proves that you do not have to be male to be a dragon-slayer. She is usually pictured skewering the biblical dragon (the Devil in disguise) that swallowed her after she refused to renounce her faith and marry a pagan. She often looks remarkably sanguine and unruffled considering she has just escaped alive. It is interesting that where the male saints are depicted killing dragons with great swagger and drama, St Margaret usually appears far more matter-of-fact. There is a lovely early twentieth-century St Margaret window in Holy Trinity, Brathay, with a fabulously multicoloured, teeth-baring, attention-seeking dragon whom the saint is calmly ignoring. I also very much like the tall, fair, strong-looking St Margaret, wearing a beautifully draped brown and green robe, who has speared the dragon with her cross so forcefully that it looks as though it is on a kebab stick (1340, St Denys, York).

**St Cecilia** is, perhaps, the more common type of female saint, or at least the one who embodies the qualities many artists have imagined a woman to possess: gentleness, beauty and talent. She is the patron of musicians and easy to spot because she either carries a musical instrument or is pictured with or playing an organ. She is a virgin martyr, and is almost always depicted as delicately beautiful, pure and very feminine, with a faraway look, usually directed heavenwards. There is a wonderful St Cecilia window in the Musicians' Chapel of St Sepulchre, City of London, a church with a great deal of fine postwar glass. This is the 1946 memorial window by G. E. R. Smith to Sir Henry Wood, conductor and founder of the Proms, and St Cecilia steals the show. She looks rather like a 1930s actress, delicately beautiful and glamorous, with flawless skin and pencil-thin eyebrows.

**St Catherine of Alexandria**, by contrast, is usually straight-backed and firm, a stance which is at odds with the nature of her martyrdom on the viciously spiked breaking wheel with which she is usually pictured, sometimes also with a martyr's palm branch, a symbol of triumph, peace and eternal life. She is, perhaps, a saint for strong-minded women (she is also the patron saint of scholars) and is certainly a figure to be reckoned with. The barbaric instrument of her torture is a reminder of the violent side of the saintliness and stories that are enshrined in stained glass, and it is always discomfiting to come across a truly awful wheel (although a few look more like ship's wheels). There is a small but extremely nasty fourteenth-century wheel like a circular wood saw in St Mary, Deerhurst, near Tewkesbury, and a larger, spiky version in what is an otherwise utterly serene, flower-filled, gently beautiful window by Henry and Edward Payne (1937) in All Saints, Turkdean, which causes the viewer to either miss the wheel or do a double take.

**St Apollonia** is another female saint whose story is shudder-inducing and graphically horrible. She was tortured by having her teeth violently pulled out or shattered with pincers, and is depicted with tongs or forceps slung

over her shoulder and a cartoonishly large extracted tooth which looks like an advert for dentists, of whom she is the patron saint (as she is of those with toothache). She is not easy to find but can occasionally be seen in old glass, usually in tracery. There are several wonderful medieval examples, including those in St Laurence in Ludlow, St Mary in Fairford, St Andrew in Mells and St Mary Magdalene in Sandringham. In St Mary in Chilton there is a definite well-brushed sparkle about the gold pincers and the rather gross tooth with three long roots.

Also pictured with large tongs as an instrument of torture is *St Dunstan*, but this time we are happy to see them being used to overpower the Devil in an act of explicit cartoon violence. St Dunstan was a blacksmith from Glastonbury who became Abbot of Glastonbury, a bishop and Archbishop of Canterbury. He is often shown in his workshop nailing a horseshoe to the Devil's hoof or pulling him along by the nose with red-hot tongs. Images of a nonchalant Dunstan dragging the writhing Devil along as if this were an everyday occurrence are one of the comedic highlights of stained glass. There is also a fine modern grotesque version by Wayne Ricketts in, appropriately, Glastonbury Abbey, and one by G. E. R. Smith (1950) in St Dunstan-in-the-West on Fleet Street in London, in which the saint appears to be using his tongs to duel with the hopping-mad Devil. Alternatively, you may find St Dunstan dressed in his ecclesiastical robes carrying his large tongs as an attribute, or holding a small red devil at the end of his tongs as if it were a piece of speared litter, as in Geoffrey Webb's twentieth-century window in Worcester Cathedral.

*St Lawrence* (or Laurence) is another saint who has become familiar for the grim symbol of his martyrdom, this time the gridiron on which he was roasted alive. St Lawrence is usually pictured holding the gridiron and looking remarkably sanguine, considering. In medieval windows it may be very small and more like a toasted-sandwich maker, but in later depictions his gridiron is certainly large enough to cook a man whole (it is difficult to decide if it is highly appropriate or in dreadful bad taste that he

is the patron saint of cooks, chefs and restaurateurs). He stands next to a very large gridiron in the highly stylised 1950s window by Christopher Webb in St Lawrence Jewry, City of London, where the weathervane is also in the shape of a gridiron. However, some windows show St Lawrence on the gridiron itself, perhaps lashed to it, and surrounded by fire which one or more men may be stoking, sometimes with evident sadistic glee. See for example the medieval window in St Laurence, Ludlow, and the small but remarkably detailed illustration by Margaret Agnes Rope in the St Laurence window in Shrewsbury RC Cathedral (1910s), which reveals the saint's taut sinews and contrasts strongly with the bigger figure of an incredibly attractive St Laurence holding his black gridiron in the neighbouring light.

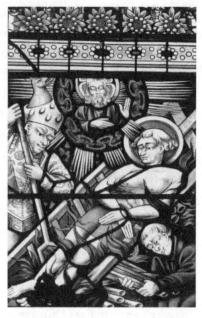

24. Detail of the life of St Laurence, maker unknown, fifteenth century. St Laurence, Ludlow.

**St Martin of Tours** is an appealingly compassionate saint whose goodness never fails to shine out of windows (he often has a very nice face, as in the *c.*1320 Becket window in Christ Church, Oxford). He was a Roman officer, later Bishop of Tours, who in a vision cut his own cloak in two with his sword to share it with a barely clad beggar, sometimes shown at the feet of the saint's horse. Although his full story, like those of other saints, is far more complex and detailed than this brief explanation, it is this symbolic, generous act for which he is known. Windows featuring St Martin are easy to read because they usually include clear gestures: the saint slicing the brilliantly coloured cloth with a sword and leaning down from his horse to give it away, and the beggar's beseeching or receiving hands.

St Martin is not always one of the superstar saints of stained glass, and windows depicting him vary enormously in style and scale. You may find some realistic illustrations (there is a marvellous 1930 St Martin by Veronica Whall in St Michael and All Angels, Ledbury, in which a beggar shivers in an ice-cold, snow-filled scene), artistic interpretations (the Burne-Jones design used in 1894 in the saint-filled window in St Etheldreda in Hatfield is dreamily handsome and youthful) and many wonderfully realised horses. I also very much like the small, cleverly abbreviated 1974 St Martin window in Sandford St Martin, by John Piper and Patrick Reyntiens, which simply shows three hands against a background of beautiful red and blue fabric: that of God directing St Martin, that of the saint holding the sword and, reaching up at the base, that of the grateful beggar.

*St James the Greater* is another endearing saint with his floppy pilgrim's hat, symbolic scallop, staff, water holder, bare feet, shaggy beard and benevolent air. He is a popular saint in stained glass, and generally appears to be older and more touchingly human and weary than some of the more muscular and dramatically heroic saints. The idea of life as a journey is as relevant now as ever, and St James represents the many wanderers in the world. There is a huge range of St James windows of all periods, but he is one of the most easily recognised saints to have survived in medieval windows and fragments; I particularly like the suitably aged fifteenth-century St James' head in St John the Baptist in Burford, which looks forbearing yet determined, and the much grander fifteenth-century St James with a bejewelled cloak and huge, wavy hat in St Laurence, Ludlow.

*St Elisabeth of Hungary* (sometimes spelled Elizabeth) is one of my favourite saints because her story involves bread, roses and good works. She was a princess known for her acts of charity and the 'miracle of the roses'. This occurred when she was taking bread to the poor in secret and was challenged by her disapproving husband to reveal what was under her cloak only for it to fall open and reveal a vision of roses, symbols of God's protection. She has inspired some truly lovely, colourful windows with a profusion of flowers

by artists who depict her as a gentle, compassionate-looking young woman (she was 24 when she died), and they are mostly to be found in Catholic churches. One of the most stunning and unusual is in St Mary, Sturminster Newton; it was made by Harry Clarke of Dublin in his inimitable, minutely detailed, fairy-tale illustration style.

St Elisabeth may be confused with **St Dorothea**, who also carries flowers, but the former's cloak should help to identify her. St Dorothea was tortured and condemned to be executed for refusing to make a sacrifice to the gods during Emperor Diocletian's persecution of the Christians. On the way to her execution, she met a young lawyer, Theophilus, who mockingly asked her to send him fruits from 'the garden' to which she had joyously declared she was going. She prayed as she knelt to be executed and an angel appeared with a basket of three roses and three apples, which she sent to Theophilus, telling him she would meet him in the garden; thus she is usually pictured with a bowl of fruit or basket of flowers. There is a very young, beautiful 1905 St Dorothea with blowsy roses and peonies in St Oswald, Ashbourne, by Christopher Whall, in what is one of his most outstanding and best-known windows.

**St Sebastian** was a covert Christian in the Roman army who converted many people and was punished by being shot at with arrows (he recovered and later died after being beaten with cudgels). He is one of the most famous and popular saints in art from the fifteenth century onwards (Guido Reni made seven St Sebastian paintings), but while the iconic image of a virtually naked, muscular man tied to a post or tree, pierced with arrows and contorted in pain is immediately recognisable, there are relatively few examples in stained glass. Those that can be found, though, raise all sorts of interesting questions about depictions of male beauty and nudity, suggestions of sadomasochism, the male/female gaze and, particularly in more recent windows, same-sex desire. Bloodless medieval versions of St Sebastian, such as that in St Mary, Fairford, make him look rather wooden or like part of a fairground knife-throwing act, but those made by

early/mid-twentieth-century designers such as Sir Ninian Comper move into very different territory with their incredible physiques, teasingly placed loincloths, and open wounds and blood (see for example his *c.*1908 window in St Giles, Wimborne St Giles). St Sebastian may also be depicted fully clad in his Roman officer's uniform and holding arrows (he is the patron saint of archers).

Finally, some less well-known saints who have intriguing associations and representations in stained glass. **St Crispin** is, together with **St Crispinian**, the patron saint of shoemakers and cobblers. Windows dedicated to him are often found in places that are historically connected with shoemaking, such as Northamptonshire, and he is frequently shown as a working man, often in a leather apron and holding traditional tools and materials. But the really interesting windows show him at his workbench or with the products of his industry, and there are some fascinating shoes in them. In a late nineteenth-/early twentieth-century window in St Mary, Barwell, it's a pair of soft purple boots; in St Martin, Kensal Rise, the *c.*1907 window contains a pair of large men's sandals with very obviously mended patches and stitching, and there is a very attractive pair of strappy red sandals in St Peter, Raunds, by Francis Skeat (*c.*1954). St Crispin may occasionally be pictured with St Crispinian (often a less recognisable figure), as in the marvellous 1962 window by Jean Barillet in All Hallows, Wellingborough.

**St Veronica** is a fine example of the strangeness that we come to accept in stained glass once we are accustomed to its almost surreal qualities. She was a pious woman of Jerusalem who took pity on Jesus as he carried his cross to Calvary and offered him her veil so that he could wipe the blood and sweat off his face. He handed it back, now with the image of his face miraculously imprinted on it. St Veronica is easily recognised as she holds up her veil so that the face of Jesus can be seen and, of course, it is fascinating to see how this is handled by the designer. Sometimes it is a sketchy, ghostly face (e.g. Harry Stammers' early 1960s versions in St Mary Redcliffe, Bristol, and St Mark, Broomhill and Broomhall, Sheffield), which does not look

too strange to modern eyes. But when you come across what looks like a large handkerchief with a high-definition, hologram-style face resembling a decapitated head, the effect can be very strange. There is a good 1898 example by Sir Ninian Comper in St Mary and All Saints, Beaconsfield, which closely resembles the detailed late fifteenth-/early sixteenth-century veil in St Mary, Fairford.

See also ANGELS AND ARCHANGELS, DRAGONS, FEET, FLOWERS, SHOES

# SCIENCE

They may not be the first thing that comes to mind when looking for public celebrations of scientific and progressive thinking, but in fact church windows often prove to be very much in line with contemporary ideas, issues and discoveries. It was the unexpected and memorable sighting of the Lovell Telescope at Jodrell Bank in a window in St Mary in Stoke Newington that altered my thinking about the subject of science in stained glass. Since that day I have discovered that many eminent scientists and different branches of science and their developments, applications, tools and equipment have inspired commissioners and designers over the last 150 years. I also now know that nothing scientific is beyond the realm of stained glass: power stations, pylons, industrial drills, chromosomes, atoms and double helices, microscopes, test tubes and laboratories are all part of the wonderful mix. Design-wise, too, science has made a significant contribution to the look of stained glass, particularly in the second half of the twentieth century, when it supplied a huge number of structures, motifs and symbols: 'Atomic', Festival of Britain and futuristic 1960s aesthetics are just as likely to appear in windows as in other contemporary arts and crafts.

Famous scientists such as Sir Isaac Newton and Charles Darwin are popular subjects, just as they are for statues, but this time appear in full colour. In fact, Sir Christopher Wren (1632–1723) comes across as quite a dandy dresser: he may be holding a model of a telescope, but it is his intricately woven jacquard frock coat and waistcoat and full, flouncy lace cuffs

and neckerchief which catch the eye in St Mary the Virgin, Little Bromley, while Christopher Webb's sharp-featured Wren in St Lawrence Jewry sports a dashing, gold-buttoned, deep magenta frock coat with coordinating rose-pink stockings. Other scientists may be less sartorially exciting but are always good finds, for example Joseph Priestley (1733–1804), who mingles with saints and famous figures in Mill Hill Unitarian Chapel in Leeds, where he was the minister with a sideline in research and the discovery of oxygen. Happily, it is also possible to come across a white-coated scientist in their laboratory full of test tubes and petri dishes: Sir Alexander Fleming, who discovered penicillin in St Mary's Hospital, Paddington, is commemorated thus in nearby St James in suitably microscopic detail.

Botanists in particular make appealing subjects because they must include plants and flowers. In Lincoln Cathedral Sir Joseph Banks gestures stiffly to a colourful floral discovery after landing in Botany Bay (Christopher Webb, 1955). By contrast, John Hayward takes a far more imaginative and botanically interesting approach in his window to William Curtis (1746–99) in St Mary, Battersea, in which he sites the man and his work firmly in the locale; Curtis's portrait appears in a Wedgwood-style cameo surrounded by a profusion of delicately painted flowers set against a lightly traced historical map of the area.

Astronomy is a major scientific preoccupation in windows, perhaps because churches and congregations have always been looking heavenwards, and it turns out to be an excellent vehicle for tracing the ways in which artists have historically tackled science in glass. Planets are likely to be found in earlier Creation windows, as in St Mary, Chipping Norton, where a late nineteenth-century example presents them as evidence of God's creative powers and design; compare this, however, with postwar windows, which focus more on a celebration of space exploration as a great human achievement, for example the aforementioned window depicting Jodrell Bank, one of the finest on the theme of science anywhere. Made in 1960, it is by the little-known but brilliant W. T. Carter Shapland, and is an exciting tour de force of modern stained-glass design in jewel colours and rich patterns. In it he mixes styles, subjects, symbols, scientists and sciences: astronomy,

clocks, photography, George Stephenson, evolution, woodcuts, astronomy, mosaic, biology, atoms, line drawings, atoms and physics, all whizzing and banging and flashing – and there is even a worm in the shape of an omega (reminding the viewer that Jesus is the Alpha and Omega).

As this ingenious window proves, there is a huge difference between an interesting but rather pedestrian illustrative astronomy window which appears to tick items off a list of contents (there are quite a few of these) and a window which exploits the artistic possibilities of the subject and reveals the similarities between stained glass and contemporary art and popular visual culture. Margaret Kaye (1912–2002) applied her highly individual textile collage style to a 1940s window in St Mary the Virgin, Radnage, using a rich warm palette and lots of texture to combine disparate astronomical elements with a very Picasso-esque result. By contrast, later planetary glass takes in pop art and psychedelia with acid-trip colours, rainbows, clouds, starbursts, bright planets and flashes of lightning: see Hugh Easton's 1957 window in Grimsby Minster, which presages the style of the 1970s. It may also depict night skies fizzing with energy and constellations, as in the 1997 window by Andrew Taylor at St Laurence, Slough, in which a tiny Sir William Herschel, who discovered Uranus and is buried in the churchyard, is seen peering into his 40-foot homemade wooden telescope.

The themes of energy and power began to appear in windows after 1945, when they were the subject of national importance and investment, and it is difficult now to look at them without being reminded of Soviet socialist realist art. The 1959–61 series at Christ Church, Southwark, by F. W. Cole, which celebrates local industry and service and includes the monolithic Bankside power station and a landscape covered in electricity pylons, portrays the workers as heroes while Southwark itself is reimagined as a quasi-Stalinist illuminated hub of productivity. Even in later windows, wherever there is a steam turbine, an electric lamp, a woman operating a lathe (as in a 2006 window in the Cathedral Church of St Mary, Newcastle) or a huge first-generation computer (as in a *c.*1981 window in St James, Ansty), there is always a whiff of socialist realism which adds an interesting dimension to church glass.

PLATE 17

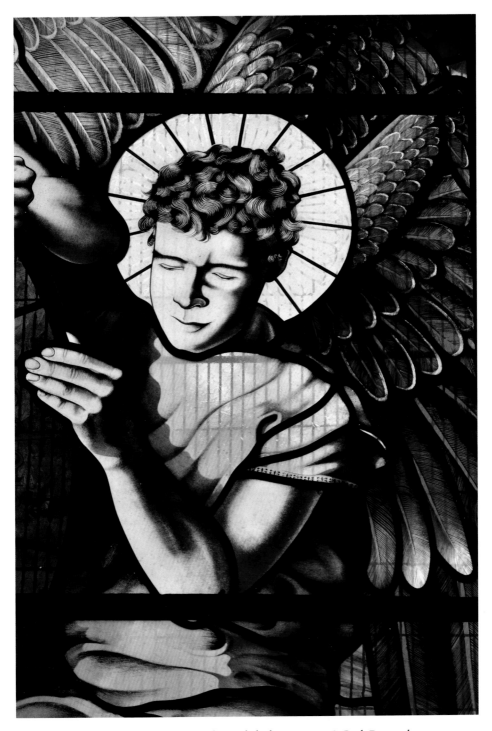

Detail of Millennium Window, by Rachel Thomas, 2000. St Paul, Birmingham.

PLATE 18

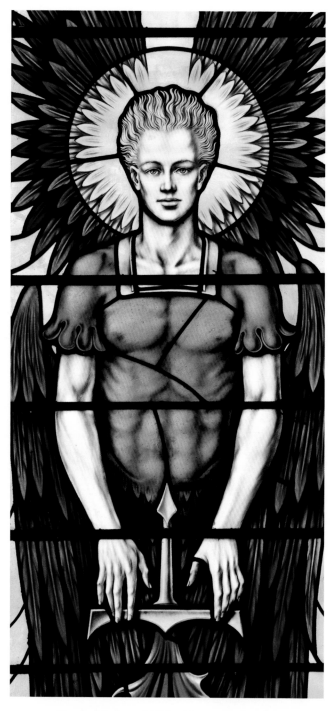

Detail of Archangel Michael in east window, by
Hugh Easton, 1953. St Paulinus, Crayford.

PLATE 19

*(Top)* Detail of Virgin and Child window, by A. J. Davies, 1926. Priory Church of St Peter, Dunstable.
*(Bottom)* Detail of St Barbara's shoes, by Harry Clarke, 1921. St Mary, Sturminster Newton.

PLATE 20

Detail of maker's mark, by William Peckitt, 1769.
St Ann, Manchester.

PLATE 21

*(Top left)* Detail of east window, probably by Heaton, Butler & Bayne, 1882. St Paul, Brentford. *(Top right)* Detail of abstract window, John Hayward, 1970. Blackburn Cathedral. *(Bottom left)* Detail of Dame Nellie Melba memorial window, by Brian Thomas, 1962–5. St Sepulchre, City of London. *(Bottom right)* Detail of Nativity window, designed by Frank Brangwyn, made by J. Silvester Sparrow, 1917. St Mary, Bucklebury.

PLATE 22

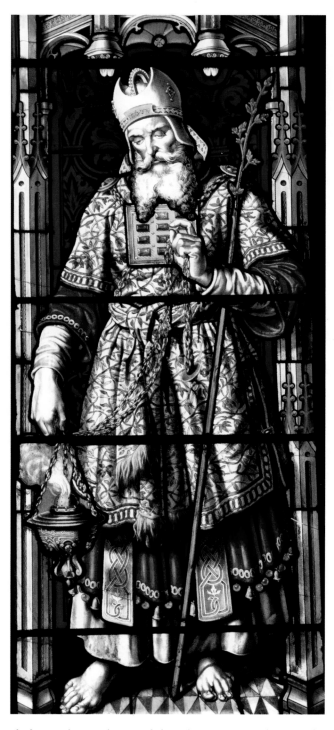

Detail of Aaron, by David Evans of Shrewsbury, 1853. Winchester Cathedral.

PLATE 23

*(Top left)* Detail of St Giles window, by F. W. Cole for William Morris & Co. (Westminster). 1958. St Giles, Stoke Poges. *(Top right)* Detail of Annunciation window, by Christopher Whall, 1920. St Mary's Parish Church, Iwerne Minster. *(Bottom left)* Detail of Pentecost window, by Harry Stammers, 1960. St Mary Redcliffe, Bristol. *(Bottom right)* Detail of Nativity window, designed by Frank Brangwyn, made by J. Silvester Sparrow, 1917. St Mary, Bucklebury.

PLATE 24

Detail of passion flowers, by Lavers, Barraud & Westlake, early 1860s. Part of the sanctuary window, south side, of St John the Baptist Church, Cookham Dean, courtesy of the vicar and churchwardens.

PLATE 25

*(Top left)* Detail of maker's mark, by Martin Travers, 1932. St Margaret of Antioch, Iver Heath. *(Top right)* Detail of window featuring local luminaries, designed by Brian Thomas, made by James Powell & Sons, 1968. St John the Baptist, Peterborough. *(Bottom left)* Detail of Nativity window, by Louis Davis, 1921. St Matthew, Surbiton. *(Bottom right)* Detail of Dick Whittington's cat, by John Hayward, 1969. St Michael Paternoster Royal, City of London.

PLATE 26

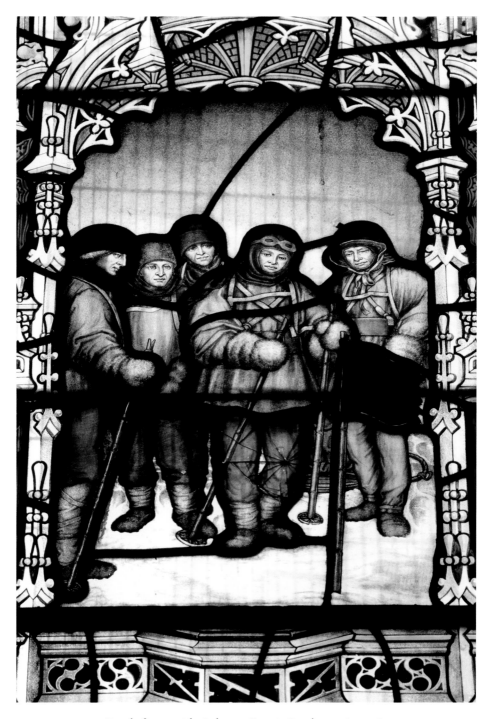

Detail of memorial window to Captain Scott's 1912 Antarctic
expedition, by C. E. Kempe & Co., 1915. St Peter, Binton.

PLATE 27

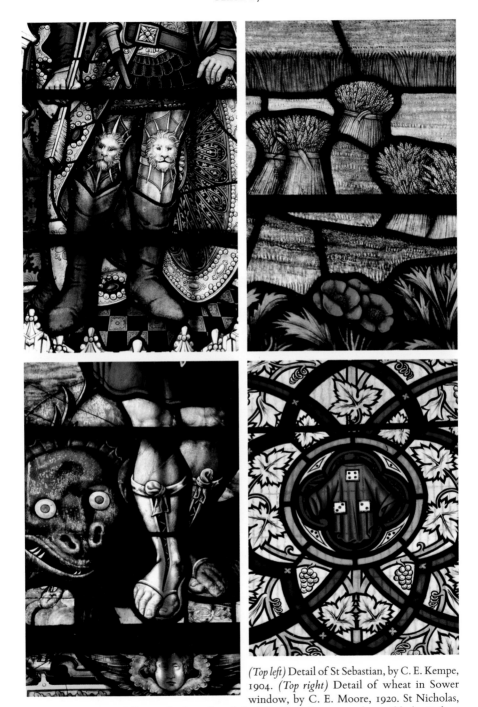

*(Top left)* Detail of St Sebastian, by C. E. Kempe, 1904. *(Top right)* Detail of wheat in Sower window, by C. E. Moore, 1920. St Nicholas, Potterspury. *(Bottom left)* Detail of Jonah and the Whale, undocumented, possibly by Robert Rudland, 1616. Wadham College Chapel, Oxford. *(Bottom right)* Detail of dice on shirt, by Lavers & Barraud, 1861–3. St Mary Magdalene, Battlefield.

PLATE 28

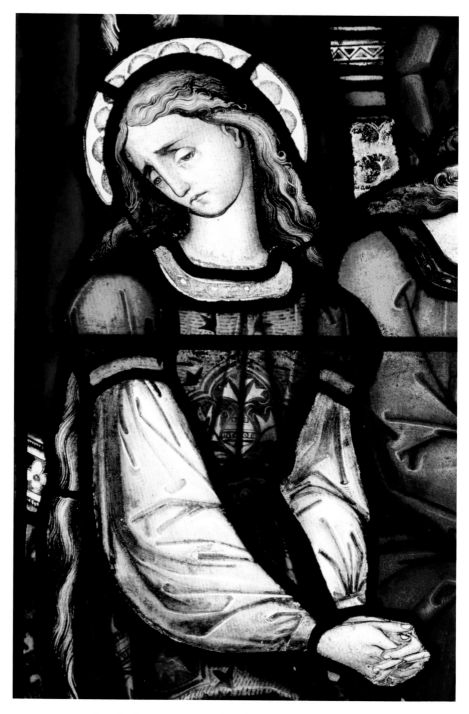

Detail of Resurrection window, by Hardman & Co, between
1853 and 1880. Magdalene College Chapel, Cambridge.

PLATE 29

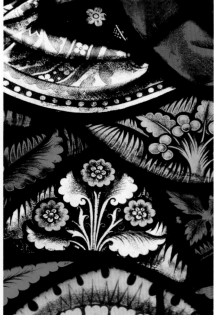

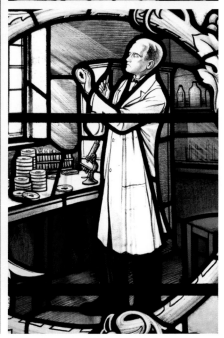

*(Top left)* Detail of Acts of Mercy window, by Harry Harvey, 1967. Sheffield Cathedral. *(Top right)* Detail of foliage and flowers, by Clayton & Bell, 1858. St Michael, Cornhill, City of London. *(Bottom left)* Detail of tracery windows, David Evans of Shrewsbury, 1820–9. St Mary, Shrewsbury. *(Bottom right)* Detail of Alexander Fleming in east window, by A. E. Buss, post-1945. St James, Paddington.

PLATE 30

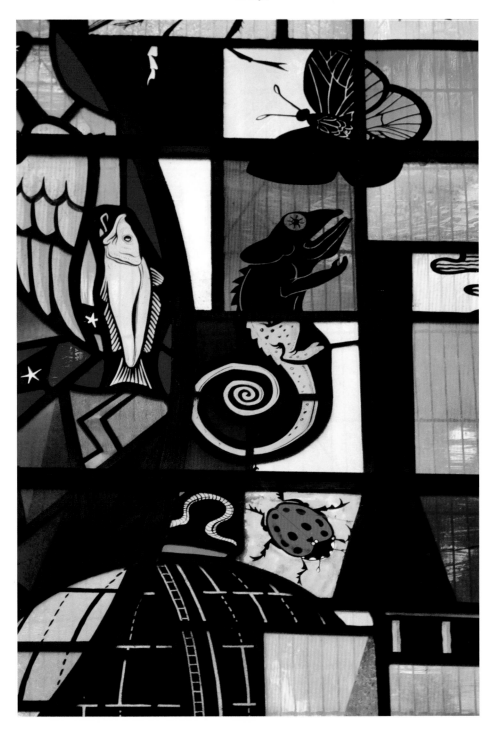

Detail of memorial window, by W. T. Carter Shapland, 1960. St Mary, Stoke Newington.

PLATE 31

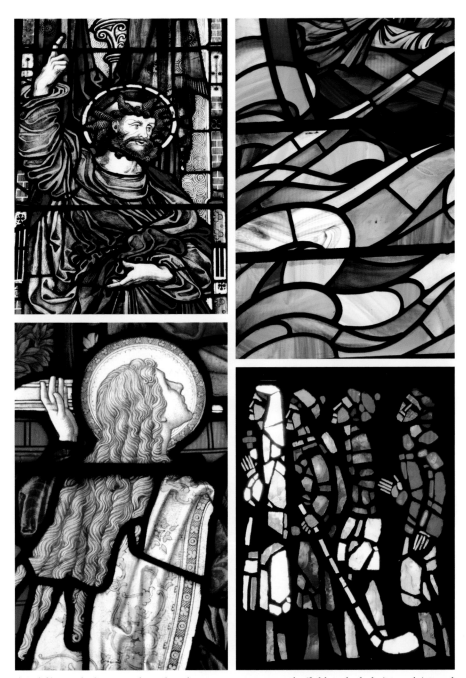

*(Top left)* Detail of memorial window, by W. F. Dixon, 1881. Sheffield Cathedral. *(Top right)* Detail of Christ walking on the water, by M. C. Farrar Bell, 1963. St Katharine Cree, City of London. *(Bottom left)* Detail of Creation of Eve, by Clayton & Bell, part of a scheme conceived in 1882 and completed in 1925. St Edmundsbury Cathedral. *(Bottom right)* Detail of *dalle de verre*, by Gabriel Loire, 1958. St Richard RC, Chichester.

PLATE 32

Detail of Nativity with children window, by M. E. A. Rope, 1944. All Saints, Hereford.

A study of the theme of science could also take in windows in university and college chapels and libraries. One of the most recent, Joseph Nuttgens' 2001 work in King's College Chapel, London, shows Jesus leading a discussion of scientific progress. In a thought-provoking blend of theology and science, he has a fabulous atomic halo around his head while an open book shows illustrations of genes, chromosomes and the double helix of DNA, a reference to Rosalind Franklin and Maurice Wilkins' work at the college.

Today we are in a new era of scientific progress, technology and communications. Already we can see the year 2012 set out in large digital numbers in Douglas Hogg's Jubilee window in the Savoy Chapel, London, and it is only a matter of time before mobile phones and laptops appear in church windows. When they do it will be entirely within the continuing tradition of stained glass reflecting, no matter how obliquely, the modern world.

See also MILLENNIUM, POSTWAR

# SEEDS

The image of a tall, muscular, good-looking man striding out across fields and scattering handfuls of seeds is instantly recognisable as an illustration of the Parable of the Sower, one of the best-loved Bible stories and one which has inspired some of the most impressive and yet down-to-earth windows in English churches. He frequently embodies vigour, energy and manliness and can occasionally even resemble a twentieth-century film star, such as Kirk Douglas or Charlton Heston, cast in a historical drama; see for example the sower in the 1971 window by F. W. Cole in All Saints, Culmstock. There are wonderful interpretations all over England, from the famous late twelfth-century sower in Canterbury Cathedral, who dances delicately over the beautifully seeded earth with rows and rows of little dots lifted out of the paint (so simple and so effective), to Meg Lawrence's well-built, modern-meets-Pre-Raphaelite sower (2007) in St Andrew, Soham, with details of seeds like chickpeas, delicate little seedlings and golden buttercups.

The sower can easily be identified by his specific pose and gesture, one foot forward and an arm outstretched or across his body, like a humble, rural but dignified version of a military statue. He is clothed in plain (although often nicely colourful) garments, headgear and shoes, and is most often seen in historical dress of sandals, a simple tunic and a cape which billows behind him. There is an excellent Victorian sower of this type in Ely Cathedral and a 1930s version by Florence Camm in St Giles, Sheldon, Birmingham. Medieval dress remains popular even today, but it is also good to see many post-medieval, Thomas Hardyesque sowers in a variety of soft felt hats, tweedy waistcoats and laced-up gaiters, heavy leather boots, corduroy or moleskin work trousers perhaps tied with bale string, and open-neck shirts with rolled-up sleeves to show rippling forearms. Good examples include the 1930s sower with a windswept fringe, who can be found in St Mary, Linton, and Caroline Townshend's 1903 window in St Mary Magdalene, Chulmleigh. The sower invariably carries his seeds in a simple, shallow basket or a bag slung across his body, and makes an open-handed gesture as he strews them, although the question of how to show seeds can cause problems, and they sometimes look more like a torrent of hail emanating from the sower's hand.

Windows that illustrate the parable appear at first glance to evoke a rural idyll and the joy of nature, the land, and annual cycles of sowing and reaping; that is, until you look more closely and notice the barrenness in the background elements. In fact, sower windows are tremendously interesting for these positive/negative tensions and for the motifs which illustrate them. The setting is frequently English and may portray familiar, local landscapes: fields, hedges and trees and even the church itself, thus at one level making a window a celebration of a community's rural and agricultural life. Within this are all the elements which contribute to a good illustration: the 'good ground', lines of ploughed fields, colours of rich earth, wildflowers and many red poppies, undulating golden hills, heads of wheat, barley and oat, haystacks, ploughs and strong horses. Then there are the less positive (but still often beautifully rendered) aspects of the poor and barren ground: weeds by the wayside, tall, sculptural thistles, nasty thorns and tangles of

brambles, birds hovering and stealing seeds, and glimpses of dry, harsh and unyielding landscapes. These are what make a window so much more than a simple visual of a Sunday-school story.

As the parable's message is about reaping what you sow, you often do not need to go far to find a reaper, who may be in the same set of lights or a neighbouring window. The reaper, too, is a superb subject for stained glass and has a similarly distinctive pose, this time either bending over to scythe or holding a huge sheaf of yellow wheat, set against an appealing background of stooks, fields and flowers with an aura of golden, late summer. Interestingly, the reaper is not always a man. It is also possible to find a few strong, energetic women in the fields; see for example the statuesque reaper in the 1880s window by Henry Holiday, a great supporter of women's suffrage, in St Editha, Tamworth. The wheat itself with its height, shape, colour and repetition of form is perfect for making small-scale patterns and decorative detail, and there are acres of carefully and beautifully painted and stained crops in church windows.

Nor are the sower and his harvest ever too far from bread and its important associations with St Philip, breaking bread, the Eucharist, the Last Supper, the miracle of the loaves and fishes, Acts of Mercy windows, and Dorcas distributing bread to the poor. It is rather ironic that in the Bible, Jesus resists the temptation to turn stones into bread in order to prove he is the son of God; it is very easy to confuse the two in stained glass, as many artists end up making bread look like lumps of stone or pebbles with crosses slashed on them. Disappointingly, there is very little

25. Detail of the Parable of the Sower, by Heaton, Butler & Bayne, between 1865 and 1881. St Mary, Banbury.

convincing bread in church windows, and it is also rare to see it being made. However, there is one fine example in St Mary Magdalene in Chulmleigh (see earlier in this section), where Caroline Townshend depicts a lovely domestic kitchen scene, complete with terracotta bin for proving, in which a woman wearing a white apron kneads dough while a young boy looks on. In this way the sower's work comes full circle.

See also ACTS OF MERCY, BASKETS, SPADES

## SHEEP

With so many references to sheep in the Bible, it is no surprise that there are innumerable specimens in windows. Jesus as the Good Shepherd is often seen carrying the lost sheep on his shoulders or in his arms, flocks of sheep gather around him to be guided, shepherds and their sheep sit in starlit fields at night or visit the newborn Jesus, and many sheep appear in windows dedicated to the animal-loving St Francis of Assisi. Even if you know little or nothing about the biblical connotations and symbolic meanings surrounding sheep, lambs, flocks and shepherds, there is much to enjoy when looking at stained-glass sheep – and much that can be guessed at.

Victorian sheep, especially those of the mid- to late nineteenth century, have a Pre-Raphaelite clarity and attention to detail which makes them often almost hyperreal, as if in a Holman Hunt painting (although many makers did not succeed in avoiding sheep grins and other oddly human expressions). These are in marked contrast to the earlier Victorian designers (1840–60) and the medieval makers they emulated, who created much simpler, economically drawn sheep which are often small, curly-fleeced and look endearingly gentle and patient. Arts and Crafts makers (1880s to 1920s) were also freer in their approach, and combined anatomical accuracy with a looser, more painterly style. In particular, it is worth taking time to look at any lambs and sheep by Christopher Whall and Karl Parsons, who created textured fleeces and beautiful heads

and grouped the animals together artistically rather than in a random flock formation. See Whall's work in Holy Trinity and St Thomas of Canterbury, Ettington (*c.*1906), and that of Parsons in St Laurence, Ansley (1930), in one of the most spectacular late Arts and Crafts windows you could hope to find.

It is in the twentieth century, especially during the postwar period, that designers break away from lifelike and correct depictions of sheep to develop more creative, interesting and individual styles that have more in common with illustration, woodcuts, stencils and linocuts than easel painting. The sheep painted by Harry Harvey of York look as though they have sprung out of the pages of a 1950s or 1960s children's book, a Puffin Classic, perhaps, so similar are they to the work of the marvellous illustrators of the period who created a new, clean, unfussy and very modern postwar aesthetic. (In his 1957/8 window in St Martin in the Bull Ring, Birmingham, he also includes a wonderful sheepdog.) Other postwar designers created equally distinctive sheep according to their personal style: John Piper's firm lines give his lost sheep in Eton College Chapel a monumentality and dignity, while Ervin Bossányi's Middle European folk-art-inspired sheep, with their enormous almond-shaped eyes, are cartoonishly endearing and appealing.

When looking at sheep, you are also bound to come across the haloed Lamb of God (*Agnus Dei*), shown standing or sitting side-on with its foreleg lifted slightly to hold a pennant – or sometimes with the cross of St George, often at the top of a window or in the tracery, particularly in heraldic windows. Even these lambs, which are essentially symbolic devices, manage to have personality: they may be forbearing, proud, youthful, upstanding or military in mien, but rarely are they sweet and frolicsome. (Sweet, bouncy lambs tend to appear more in twentieth-century Easter and children's windows, and in millennium windows.)

Finally, there is many a curly-horned ram trapped in a thorny thicket, peeping out of a bush or standing next to a small tree. If you look around the window you are bound to find Abraham about to kill his son Isaac, sword lifted, unaware that God, whose test of faith he has passed, has

sent a ram for him to sacrifice in place of his son. It is fascinating to see how designers treat this poor sacrificial ram. Although the large, curling horns are a given, the ram may be a sad little thing waiting to be noticed by Abraham or a hefty, mature specimen trapped by thick brambles. Christopher Whall created some especially good rams stuck in nastily thorny bushes (e.g. in Southwell Minster and St Alban, Hindhead), Abraham van Linge painted a wonderfully large-eyed, puppet-like ram stuck up a tree in University College Chapel, Oxford, and Gabriel Loire focused on the ram's symbolism by creating a simple and powerful head and set of horns with just a few pieces of *dalle de verre* at St Richard RC, Chichester, Surrey.

See also DALLE DE VERRE, DOGS, HALOES

# SHOES

Better than any shoe shop or famous person's collection, the range, variety and sheer brilliance of shoes in stained glass will please anyone with even a passing interest in footwear. And happily, like feet and the sheep above, shoes are easily spotted and examined because they are normally at the base of windows, putting them at eye level.

There is much to appreciate when looking at shoes: amazingly imaginative detail and brilliant colours (sensibleness and practicality are often disregarded), plus a vast range of designs from the fantastically extravagant and possibly totally unwearable to the totally and delightfully ordinary and everyday. As I mentioned in the Introduction, this book began with a pair of Mary Janes in an early postwar window in St John, Hoxton, London, and this was the very first time that I felt a personal connection with stained glass. They are worn by a young girl in a Children of All Nations window and reminded me of being the 'English girl' in a themed assembly at my infant school; as a result, they fundamentally changed the way I looked at stained glass. Shoes immediately became an important point of contact with windows, and I made a point of looking for them from then onwards.

Many shoes belong in the 'historical' category, based on what we know real people wore – or at least what we think of as historical, according to what artists and illustrators have imagined people in other periods and in the Bible might have worn – with a good dash of artistic licence and creativity regarding styles and periods, which are often confused. Of course, there are plenty of sandals and variations on open-toed footwear suitable for hot, dry climates, but these are also often worn in English pastoral scenes, worn on cool grassy riverbanks dotted with spring flowers. Some saints and prophets wear leather flip-flops, which may be jewelled and tooled and come in gloriously vivid colours, while others sport ultra-plain slip-ons. Virile soldiers and prophets with remarkably well-developed calves show them off in open-toed Roman or Greek sandals with straps and laces which come up to the knee and accentuate the curves and expanse of leg. And there are lots of lovely, delicate, women's Middle Eastern-influenced slippers and sandals, for example in the windows by Edward Burne-Jones in Jesus College Chapel, Cambridge.

There is a similar male theatricality about the sabaton or solleret, the flexible shoe part of a suit of armour, which may be outrageously long, tapered and articulated like an armadillo's back and is usually beautifully designed and carefully painted. Many an archangel's dramatic stance and his armour emphasise the contours of his shapely legs, which then end in balletic, pointy sollerets, often on or just above a slayed dragon. This is true of all glass of all periods, but there is a mania for Arthurian armour in later Victorian windows, in which you will also come across glimpses of the feminine version, a maidenly, soft, pointed Pre-Raphaelite Maid Marion/ Lady of Shallot peeking out from beneath flowing robes.

A fan of historical footwear can also find plenty of entertaining pairs: thigh-high cavalier boots with spurs; clumpy, buckled Cromwellian and Puritan boots; dandyish eighteenth-century men's shoes with heels, square toes, bows and pompoms; ceremonial military shoes; huntsmen's boots with much complex lacing; farmers' boots and buttoned gaiters; standard-issue twentieth-century Royal Air Force and Navy shoes; a full array of military boots both with and without puttees; and peasants' simple leather

footwear. Almost any type, in fact – although I have yet to find a pair of spats in a window.

The increased verisimilitude and contemporaneity in twentieth-century windows is reflected in the appearance of everyday, work and activity footwear. Although some may not be worn by the majority of the population (polar explorers' enormous fur-lined boots, highly polished Grenadier Guards' boots, miners' hobnail boots), there is a pleasing number of sensible lace-up shoes on the feet of nurses, policemen and policewomen and office, factory and mill workers, plus children's school shoes, summer sandals and more Mary Janes. One can even add sports shoes to the list, and there are several good and rather endearing small-scale portraits of mid-century footballers in heavy boots, hooped socks and roll-neck sweaters discreetly fitted into larger themes. G. E. R. Smith made this style his own and included in his windows many ordinary figures with whom the congregation could connect, and whose role and meaning are made clear by their clothes and shoes. He created many postwar windows for churches in Buckinghamshire, and in St Peter and St Paul in Great Missenden the little sportsmen and -women at the base of his 1948 window wear hockey, lacrosse, rugby, football and riding boots, fishermen's waders, and cricket, tennis and boxing shoes.

Shoes can also be both a way of dating a window and a fashion statement. Many windows of the 1950s and 1960s contain women wearing neat court shoes, sometimes with matching handbags and hats for church services and christenings, or in sensible outdoor and work shoes such as the fur-lined, zip-up ankle boots in Christ Church, Southwark, this time teamed with shopping bags and turbans. But by far the most delightful shoes are those by Harry Clarke of Dublin. Although his windows and shoes are mostly to be found in Ireland, there are three gorgeous fairy-tale pairs in his 1921 window in St Mary, Sturminster: low-heeled, square-toed and made of satin, with buttons, buckles and tassels, they would fit perfectly into one of today's leading shoe designer's collections and are just right for tripping the light fantastic.

See also BASKETS, DRAGONS, FEET, *PASSEMENTERIE*, SAINTS

# SPADES

Everyday objects in stained glass have a wonderful way of bringing the viewer down to earth. One minute it is angels, heavens and glory, and the next it is something as solid, humble and ordinary as a spade. Indeed, the pleasure of looking for spades lies in the occasional discovery of an object which could quite easily be found in a shed or propped up in someone's garden, and the realisation that it might have nobler qualities than perhaps previously imagined. Keen gardeners will also enjoy spotting different types of spade used for different soils and jobs, such as that in the W. F. Dixon nave window (1880s) in Sheffield Cathedral, which would be perfect for splitting perennials.

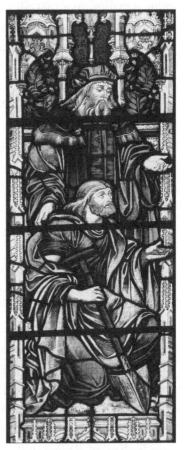

Adam is the archetypal digger: he is given a spade by an angel (Eve gets a distaff) after being expelled from Paradise, his punishment being that he will have to live by his own work, digging and delving to provide food. Some medieval scenes show Adam being taught to dig by the angel, but others depict him working independently (as in the famous late twelfth-century window by the 'Methuselah Master' in Canterbury Cathedral). The spades in these windows are basic, handmade designs in wood and metal, a contrast with the larger, more sophisticated Victorian spades which often show off some nice contemporary industrial metalwork. However, the latter often become props for poses rather than

26. Detail of Thomas Memorial Window, by W. F. Dixon, 1880s. Sheffield Cathedral.

tools for working; it is striking just how far removed the various Burne-Jones versions of Adam and the camp, moustachioed Kempe version in Wakefield Cathedral are from the medieval images of hard labour in the fields, and how much closer they are to classical studies of the male body, with the spade there more to suggest muscular activities than a likelihood of actual digging.

Even though a spade will often lead you to images of Eve spinning – and perhaps looking after the child at the same time – while Adam digs, spade equality does make it into windows in the postwar period. Harry Stammers was a keen gardener himself and often included gardening themes in his wonderful windows. In the 1961 window in St Stephen on the Cliffs, Blackpool, he depicts Mary Magdalene with a fine spade when she meets Christ at the tomb and she mistakes him for a gardener. (She is ready to prepare his body for burial, and we are reminded of another use of the spade: to dig graves.) Spades were also used by the Women's Land Army to dig for victory, and in several of Christopher Webb's postwar commemorative windows (e.g. Salisbury Cathedral, 1949) and those by G. E. R. Smith (e.g. St John the Baptist, Little Missenden, 1940s) there are land girls in uniform workwear of jodhpurs and green sweater, whose stances, spades and rakes echo many a hearty wartime propaganda poster.

There are also a few common or garden spades whose significance lies in the fact that they belonged to and are associated with local people. There are not too many of these, which makes quite special the two examples I have discovered. William Peckitt creates a witty gardening coat of arms with 'imployments of Husbandry' – spade, rake, hoes, ploughshare – for Lady Ibbetson in St Helen, Denton, Yorkshire (1776). The lovely roundel containing a spade, hand fork, sun, soil and lily in St Peter and St Paul, Fakenham, was donated anonymously by a parishioner who wished to remember her parents who were keen gardeners (anonymous, undated, but very Festival of Britain in its aesthetic and colours).

See also APPLES, FLOWERS, NEEDLES

## SUNFLOWERS

The art of stained glass is not a separate, purely ecclesiastical art, but one bound up with contemporary culture, with which it has many overlaps. Window designers also often work in other fields as painters, mural artists, illustrators, letterers, sculptors or textile designers, and bring these skills and related influences to bear on their windows. As a result, all church stained glass is of its moment, even when it imitates another style (e.g. Gothic, Baroque), and its contemporaneity is revealed by clear clues and giveaways.

One of the best examples of this is the presence of a sunflower, which immediately dates a window to the period from 1870 to 1900 when the influential Aesthetic movement, of which it is one of the major symbols, was at its height. It points to close parallels with what was happening in interior design, domestic furnishings and glass at the time, and demonstrates how ideas of what constitutes fashionable good taste can find their way into churches. This was when William Morris was putting huge sunflowers into his wallpaper designs (1879) and in an 1873 window in Cragside, near Rothbury in Northumberland, one of the most modern houses of the time.

It could be argued that sunflowers and Aesthetic ideas are incompatible with church windows, given that they were made popular by the likes of Wilde, Whistler and Beardsley, who were known for their dandyism, effeminacy and *fin-de-siècle* decadence. This was a movement that emphasised aesthetic values above all, and believed that art should not have a moral or educational purpose, something that is clearly at odds with the purpose of most Victorian stained glass. Nevertheless, designers began, rather tentatively at first, to introduce Aesthetic motifs, clothing and attitudes, marking a small but significant move away from the Gothic.

Interestingly, sunflowers mostly appear in late nineteenth-century windows which at first glance might be dismissed as unremarkable, run-of-the-mill, mass-market glass in provincial churches. Look carefully at windows from the 1870s onwards and you may find a vase full of brilliant gold sunflowers, as in W. F. Dixon's 1880s window in Sheffield Cathedral,

or a background of burnished, coppery blooms straight out of an Aesthetic interior, as in the surprising window by Heaton, Butler & Bayne (also 1880s) in St Paul, Brentford. The latter is mostly a conventional window of the period, but in the lower section is a lovely piece of Aesthetic art which combines repoussé-style sunflowers with a late Pre-Raphaelite woman wearing a loose dress with billowing sleeves, plus the sorts of peaches, pomegranates and foliage which could be seen in Morris & Co. wallpapers, and which might perhaps have been found in the houses of the more style-conscious members of the congregation.

Sunflowers can also be found in the work of two northern companies which made their name with Aesthetic-influenced glass for churches in the north-east of England and in Scotland. Daniel Cottier of Glasgow (1837–91) was immensely influential in the spread of Aestheticism both in Britain and America and created beauty-for-beauty's-sake windows with plenty of yellow stain and sunflowers but very few discernible biblical messages (e.g. St Nicholas, Cramlington, and Holy Trinity and St Cuthbert, both in Darlington). The early work of the Gateshead Stained Glass Company (1879–1926) was chiefly by Thomas Ralph Spence (1845–1918), who started out as an 'architectural decorator' and became a respected architect, glass designer and artist. The decorative aspect of his windows is purely Aesthetic – there to please, delight and make beautiful – and can be seen at its best in St George, Jesmond, which he also designed (1888). Sections of the late 1880s glass are embellished with waving, almost moving, sunflowers in gold and grisaille and these, plus a languidly exotic, theatrical Last Judgement, turn his windows into a superb catalogue of Aesthetic motifs and ideas.

Sunflowers enjoyed only a brief flowering in stained glass, and it could be that the more serious Arts and Crafts artists consciously omitted them because they were tainted with moral dubiousness. Nevertheless, the flower is now part of a very aesthetically pleasing piece of art and stained-glass history.

See also FLOWERS, GRISAILLE, PEACOCKS

## TABLES

Tables are such everyday items of furniture that it may seem odd to suggest making a point of looking for them in church windows. Yet stained-glass artists and designers demonstrate that they are the locus of so many different activities, groups and objects, and that they are crucial props in the *mise en scène* or a tableau. As a result, wherever there is a table, there is a bigger story: they are focal points of rooms, kitchens and workplaces and are used for suppers, weddings, feasts, counting money, looking at plans, business transactions, carpentry, reading, studying, typing and even, in King's College Chapel, Cambridge, circumcision.

The Last Supper takes place at a table seating 13 (Jesus and 12 disciples), which allows a designer to play with the tableau: they may be crowded round a small table, seated at a rectangular table or along an E-shaped table (minus the central section) with the perspective front-end on, or the point of view may be angled upwards along the table, or even, as is the case with Mark Angus's ingenious 1984 semi-abstract window in Durham Cathedral, seen from overhead, with circles for the tops of the heads. The most familiar Last Supper table of all, the one that features in so many set-piece Victorian windows, is a very long one with everyone ranged along the far side and facing the viewer. Some are so unfeasibly long they can stretch across three or even five lights – or even six, as in St George, Everton. A large table is also the hub of the Wedding at Cana, at which Jesus turns water into wine, depicted as a more informal, sociable, casual and celebratory gathering, with people moving about, leaning across and pouring liquids from amphorae, jugs and vessels. Some medieval and medieval-style versions may be rather flat, stiff and wooden, but others are delightfully lively, crowded and even raucous, like the medieval wedding window in Canterbury Cathedral and the nineteenth-century one in Ely Cathedral. Smaller, plainer kitchen tables for chopping vegetables, plucking chickens, gutting fish and eating family meals can be found in scenes set in the house of Mary and Martha with Jesus as the guest. These tables, with their connotations of domesticity and cooking, take the viewer right into the heart of the home. Many

interpretations simply illustrate the story, but the best tell it and bring it to life. In his remarkable window (made in the 1640s) in University College Chapel, Oxford, Abraham van Linge depicts it in the way a Dutch genre painter might, as a crowded, noisy, busy scene in which Jesus sits calmly in the foreground at the table while Mary kneels and Martha waves a ladle; in the background, fowl are ready to be roasted on a spit, a cauldron is being stirred, a helper carries a stack of plates and a dog sniffs out scraps. This is a world away from the more stylised and posed Victorian windows with their very heavy emphasis on Mary and Martha as exemplars of female service and even subservience. Postwar designers toned down this aspect: in his 1951 window in St Nicholas, Guisborough, Harry Stammers painted a scene in which the focus is on the gilded and velvet chairs, the ornate, Baroque table and a Constance Spry flower arrangement rather than the tall, dignified figures in plain, Puritan-style dress.

If you focus in on one of these table scenes, you can often find some of the most pleasing and delightful still lifes which are contained everywhere in stained glass, many of which would make lovely individual windows on their own. There may be candlesticks, gold goblets and tableware, elaborate flagons, plates full of grapes, peaches and figs, slim-stemmed glasses filled with red wine, and a whole lamb ready to be eaten. Alternatively, a meal may be perfectly modest: homely loaves of bread, plates of small fish, wicker flasks, an apple or a bunch of grapes. Hands surround the table, ready to share and pass, slice and break bread, dogs nap underneath, feet and shoes are visible. Tablecloths are often plain and white, gathering in folds and reaching the floor, but some are fine examples of richer textiles: jacquard weaves, tasselled edges, beautifully embroidered blackwork borders or goldwork monograms.

However, tables are not just for food and eating. They are part and parcel of so many different aspects of life and work. Some are timeless: monks' reading tables, shoemakers' and carpenters' benches, St Dunstan's workbench, stained-glass makers' glazing tables, courtroom tables, bedside tables. With the increase in secular and everyday subjects in the twenti-eth century, in particular during the postwar period, almost any sort of

worktable can be found in windows, including modern office desks with telephones in Christ Church, Southwark; Alexander Fleming's laboratory table full of test tubes and chemistry equipment in St James, Paddington; a draughtsman's desk in Christ Church, Sheffield; a schoolboy's desk in St John the Baptist, Peterborough; and a hospital radiographer's table in St Nicholas, Guisborough. And of course there are altars in windows, sometimes the church's own altar, mirroring the most important table in the church and underlining the fact that all stained-glass tables are significant symbolic and material pieces of furniture worthy of further investigation and scrutiny.

See also SAINTS, TEXTILES

# TEXTILES

Stained-glass windows in English churches are a gorgeous repository of textile treasures and contain a stunning collection of fabrics, furnishings and fashions through the ages. The mix of contemporary textiles, historical costumes and wonderfully imaginative designs make windows a rich source of fabric inspiration and a superb record of the country's textile heritage.

The jump from textiles to church stained glass is not a big one. If you were to ask why, the answers would be simple and numerous: patterns, colours, surfaces, fabrics, trimmings, clothes, furnishings. The huge variety of robes, dresses, drapes, capes, curtains, bedspreads, tablecloths, folds, pleats, tassels and embellishments in churches and cathedrals makes one think of artists and designers from medieval to modern times going wild in a textile warehouse or creating a fantasy fabric land. There are satins which shimmer like those in a painting by Ingres, and velvet, prints, devoré, appliqué, brocade and jacquard worn by archangels, angels, kings and queens. Pattern-wise there are complex Celtic knots and simple dots, extravagant florals and modest sprigs, suns, moons and stars, hearts and heraldic devices, and garments may be trimmed with ermine, fur, braids, ribbons, fringes and jewels.

While there is much drama and theatricality, sumptuousness and a great deal of dressing-up, stained glass can also be just as interesting for plain, everyday textiles associated with saints and ordinary people. Look hard and you will find snow-white aprons and sheets, patchwork quilts on beds, plain blue robes, sweet smocked dresses, hand-knitted sweaters, scarves and socks, corduroy trousers and tweed waistcoats, hard-wearing worsted and woollens for shepherds and farmers, and rough hessian and tough canvas in outdoor scenes.

In this vast textile catalogue, certain makers are worth seeking out. The big Victorian names such as Heaton, Butler & Bayne, Lavers & Barraud, Clayton & Bell, Alexander Gibbs and Frederick Preedy were all masters of large-scale, dynamic patterns and interesting fabric surfaces. Their backlit painted glass glows with brilliant colours: kingfisher blue, emerald, scarlet, shocking pink, violet, turquoise, lemon and gold. Any historian of fashion should not miss the work of Irish designer Harry Clarke, who dressed his figures in Fortuny pleats, fabric-covered buttons, gold-threaded and beaded cloche hats, ostrich feathers, ruffled gloves and collars, and pink silk tasselled shoes. His fabulous 1921 window in St Mary, Sturminster Newton, resembles a 1920s Parisian couture house mixed with a good dash of Biba and fairy-tale illustration. Like Clarke, many subsequent designers took their cue from contemporary fashions, from Art Deco to the Festival of Britain to 1970s psychedelia.

On a side note, it is perhaps no coincidence that several designers of stained glass have also been known for their needlework. This suggests close connections and parallels between the two crafts (which both produce flat surfaces with texture, colour and detail), something borne out by John Piper's designs for church and cathedral tapestries and furnishing fabrics, which closely resemble his stained-glass work, and also in the designs of William Morris and Edward Burne-Jones, for example, whose intricate, clever patterns and repeats with flowers, fruit and foliage for fabrics, tapestries and embroidery can be seen in the garments and background drapes

in their windows. But it is in the twentieth century that the significant overlap between art embroidery and glass is apparent, when a number of female makers, who are still perhaps better known for their stitching and embroidery, were also successful with church glass. Looking at their work is an education in transferable skills. It is also worth noting that, in turn, many forms of domestic needlework – knitting, crochet, needlepoint, cross-stich, patchwork – may take design and colour inspiration from stained glass.

A member of the Bromsgrove Guild, Mary Newill taught needlework at Birmingham School of Art and designed a stunning 1909 window for St Peter, Wrockwardine, which looks like a mix of medieval tapestry and blackwork with fine lines and tiny, perfectly placed stitches. Margaret Kaye, who trained in both textiles and stained glass at the Royal Academy, was instrumental in developing a new style of bold, colourful, textured postwar embroidery in her wall hangings. She successfully scaled up her collage style to create unusual and highly contemporary-looking windows in St Mary The Boltons, Kensington (1955), and St Mary the Virgin, Radnage (early 1960s). The more prolific Margaret Traherne was trained and mentored by Constance Howard at Kingston School of Art and later specialised in stained glass at the Royal Academy. Her often abstract windows are both delicate and powerfully moving, with careful, quilt-like choice and placement of blocks of colour and high-quality glass. She also worked with *dalle de verre*, and her windows in Liverpool Metropolitan and Coventry Cathedrals play with the ever-changing light in the way gold and silver threads might in a piece of embroidery. Unlike much of their textile work, which is in private hands and/or rarely displayed, these women artists' stained-glass windows remain *in situ*, on very public and accessible display. One wonders if this scale, visibility and permanence are the reasons why so many women whose stitched work might otherwise not be seen took up stained glass and displayed their work in churches.

See also *DALLE DE VERRE*, KEMPE, KNITTING AND KNITWEAR, NEEDLES, *PASSEMENTERIE*, PINK, SHOES

## TIN LEG

Before I started looking properly at stained glass, I would never have imagined it would have the power to constantly surprise and amuse me. But the realisation came when I found a tiny tin leg in a window in an Oxford college chapel. I had noticed a set of Olympic rings and, just above them, what looked like a whizzing leg, there perhaps to suggest fast running or a race won. When I did some background reading I discovered that it was in fact a false leg, and that it was just one of several fascinating and – to a novice window-gazer – startlingly personal reminders in a window to commemorate a famous figure. It also includes his pet squirrel and tortoise, his cigarette holder, and a postcard view of Rochester Cathedral.

The window is by John Hayward and is a 1964 memorial to Dr Christopher Chavasse, the first Master of St Peter's College. It is packed with detail, some more religious and rarefied than the tin leg (the subject of a family joke), and it completely altered my perception of church windows as being terribly solemn and serious. If a tin leg can be deemed suitable for inclusion, I wondered, what else could be found in stained glass which I might never have imagined to be there? The answer, I have discovered, is almost everything:

flamingoes (St Edward, Cheddleton)
flat caps (St Nicholas, Potterspury)
forceps and rubber gloves (St Mary, Wargrave)
hair nets (Christ Church, Southwark)
kitchen sinks and colanders (St Mark, Broomhill and Broomhall, Sheffield)
knobbly knees and nudes (University College Chapel, Oxford)
opera singers (St Sepulchre, City of London)
rifles (Salisbury Cathedral)
tigers (St Nicholas, Guisborough)
trenches (St Mary, Kettlewell)
tulip pickers and potato packers (St Mary and St Nicolas, Spalding)
walruses (St Mary, Banbury)

The list is endless, and the joy of looking is that you just never know when you might come across that elusive second tin leg.

# TOYS

It was a child holding a teddy bear tightly, sitting next to another child looking at an illustrated book of animals in an interwar window in St Nicholas, Kenilworth, which set me off looking for toys and games in church windows. I have since found plenty, and discovered in the process that twentieth-century designers have not completely put away childish things. By including toys, they have often created lovely evocations of childhood and introduced welcome elements of playfulness into their windows.

Much early medieval glass captures a sense of real, everyday and domestic life, and even though Victorian glass was tremendously influenced by this Gothic style, it somehow lost touch with ordinariness and daily secular life. However, from the late nineteenth century onwards and the development of the Christopher Whall-influenced Arts and Crafts style, with its heavy focus on charming children, more and more windows showing Jesus with children – and, later, children with children – began to appear in churches, particularly in baptisteries and children's corners. Toys add to the realism in uplifting, heartwarming scenes, as in All Saints, Hereford, where M. E. A. Rope conjures up the excitement of Christmas toys and games, which also play multiple and metaphorical roles in a Nativity window (1944). Here the children replace the adoring kings and shepherds, with one offering his woolly toy lamb to Mary and another cradling a baby doll, while the Nativity kings are glove puppets and a mass of wooden creatures from Noah's ark suggest the animals in the stable. A ball and a toy Great Western Railway (GWR) train bring the story up to date and into the modern world.

Scenes with toys can also be reminders of less cheerful places where stained glass was once frequently seen, such as chapels in orphanages and

hospitals. The panel now in Harrogate Pump Room Museum by Robert Anning Bell (1863–1933), which came from a local children's home, is heartbreaking precisely because of the toys it contains. A stationary red and white dappled pull-along horse sits by the feet of one child while a little girl clutches a rag doll closely. Take away the toys and it is just another Suffer Little Children window with Jesus at the centre, but with the inclusion of desirable toys and the knowledge that this window would have been seen by orphaned children, it has a quite different, upsetting effect.

Happily, many toys and games which evoke a sense of carefree, happy childhood days and express the exuberance and energy of young children can also be found. They are in windows with a direct, obvious appeal, and would themselves be good subjects for games such as I spy or a toy treasure hunt. M. E. A. Rope's windows in St Mary Magdalene, Munster Square, London (which were moved there after the closure of St Augustine, Haggerston, the church for which they were designed and made between 1931 and 1947), are extraordinary in that they depict real East End life and scenes as lived by the people who saw them. Many children must have been delighted to identify with young boys playing cricket in the street ('Boston St, E.2') and to spot more toys dotted about the windows.

Since then, many twentieth-century windows have included and thus recorded for posterity popular games and toys played with by children in contemporary dress, thus returning to the medieval practice of mirroring the lives of those who were looking at windows and at the same time increasing their relevance and appeal. Some are decidedly modern (toy cars, planes, trains, sailing boats), others are traditional and timeless (balls, skipping ropes, hoops and sticks, kites, daisy chains, buckets and spades, Noah's ark sets), and still others are enduring (dolls, rag dolls, teddy bears, pull-along toys, bicycles). Finding a toy in a window can bring a jolt of recognition, a smile, a memory, and is a sure-fire way to help a viewer, however young or old, identify with a window.

See also ARK, CHRISTMAS, TRANSPORT

# TRACERY

Tracery is the decorative stonework which supports the glass in the openings above the main light or lights of a window. A huge variety of designs were used during the Gothic period (late twelfth to sixteenth century), many of which were repeated in Victorian neo-Gothic churches. In the intervening period and since, tracery may be either absent, as in Sir Christopher Wren's churches, or highly simplified, as in many twentieth-century churches. There is a specific vocabulary for the church architecture of the different medieval periods and their associated features (Early English, Decorated, Perpendicular, often abbreviated to EE, Dec and Perp) and for the various types of tracery (e.g. intersecting, geometrical, flowing, rectilinear, curvilinear, reticulated, flamboyant, rayonnant) and the many foils (trefoils, quatrefoils, cinquefoils, and so on), which enables historians to date a building and pinpoint a style. Although it is not necessary to know all this to appreciate tracery, the language does reflect the wonderful variation in its design in English churches, and one of the pleasures of wandering round an old parish church such as St Wulfram, Grantham, is the discovery of many types of window shape and tracery design in one place, the result of changes and additions over the centuries.

Despite this mass of visual and architectural detail above, it is very easy when looking at stained glass to focus on the lower, main parts of a window and to forget to lift your eyes to appreciate the intricacy of the upper parts. But as soon as you make a point of doing so, you are in for a delightful voyage of discovery, as many designers reveal their ingenuity, imagination and cleverness in the ways in which they use often unusual and awkward shapes and exploit the repetitions in more regular tracery.

Some artists extend patterns into the tracery as though the stonework is a cut-out template which has been placed over the design, like the flames rising from the blitzed and burning city in Harry Stammers' window in St Martin-le-Grand in York, or Hugh Easton's window in Salisbury Cathedral, which depicts a sword piercing the stonework and going into the tracery. More often, though, it is filled with separate, individual designs and can

be brilliantly varied. It may contain decorative or colourful glass which sits like little jewels in stone settings, or it can be filled with a collection of fragments, a lovely way of reusing old glass. Tracery openings can be useful means of introducing traditional, biblical and easily recognised details and motifs such as the Instruments of the Passion, coats of arms and other heraldic devices, flowers, foliage, fruit, suns and moons, clouds, doves, the hand of God, the Pelican in Her Piety, scrolls and lettering, angels (musical angels and cherubic angels' heads on wings are very popular), rows of saints, prophets or real historical figures (as in St John the Baptist in Peterborough), or even a peacock with is feathers filling a quatrefoil (St John the Baptist, Cookham Dean). Sometimes a glittering, shimmering vision of Jerusalem stretches across the tracery (Christopher Whall employed this design several times, e.g. in St John the Baptist in Burford), while in other settings a huge burst of light explodes across its components.

Spectacular tracery can be found in the huge rose windows in English cathedrals. With these windows, though, the detail of the individual glazed areas can be lost, partly because they are so high up, and partly because the complex stonework is so incredible on its own that it, rather than the glass, becomes the focus of the eye. However, a few reveal clearly what has been cleverly inserted and squeezed into the spaces, as in the eighteenth-century glass in the rose window in the north transept of Westminster Abbey, which looks like a richly coloured roulette wheel of prophets. Fragments, too, work particularly well in this type of window: the openings in Bishop's Eye in Lincoln Cathedral within a remarkable design based on two ears of wheat are filled with an abstract mass of colourful, sparkling glass which looks like the end of a just-shaken kaleidoscope.

There is no doubt that where tracery works well it adds, sometimes almost imperceptibly, to the whole effect of a window, and can top it off brilliantly, making it appear taller and more soaring. I am particularly fond of Victorian tracery glass, which is often rich in colour and bold in design, and frequently squeezes beautifully detailed scenes and stories into small spaces. My personal favourites include the simple patterns and ribbon-style edging in a lovely palette of brilliant red, gold, aqua, jade and grass green

by the brilliant Frederick Preedy (an outstanding Victorian designer) in Ely Cathedral, the phenomenal and inventive range of designs employed by William Morris and Edward Burne-Jones, and the painterly swirls and lightness of touch in the tracery glass by Marc Chagall in All Saints, Tudeley, which renders each little piece a work of art in itself.

See also ANGELS AND ARCHANGELS, CANOPIES, EXPLORING A CHURCH, INCENSE, VICTORIAN

# TRANSPORT

### BUSES

When Margaret (M. E. A./'Tor') Rope created a set of windows in 1933 for St Augustine, Haggerston, she was taken aback by the level of press interest that focused on the 'everyday incidents in East London', as she described them in a letter to her family, rather than any other aspect of the windows. The act of including a pub, boys playing cricket and a double-decker London bus was sufficiently newsworthy to make headlines, and even today these windows, now moved to the crypt of St Mary Magdalene, Munster Square, London, still look decidedly modern and quite different to most stained glass of the period.

Nevertheless, 'Tor' Rope was not able to say hers was the first bus to appear in a church window, as her cousin, also named Margaret (M. A./'Marga') Rope, had already included a very old-fashioned model in one of her superb early 1920s windows in Shrewsbury RC Cathedral. However, it remains one of just a handful which will delight any transport historian or enthusiast, or anyone who has a soft spot for a red bus in a window. Another is the number 4 bus, which still runs past Christ Church in Southwark and makes an appearance in that church's excellent and important postwar scheme (1961).

This everyday realism indicates to what extent the Church had to adapt after two world wars. It also reflects a greater awareness of life outside the

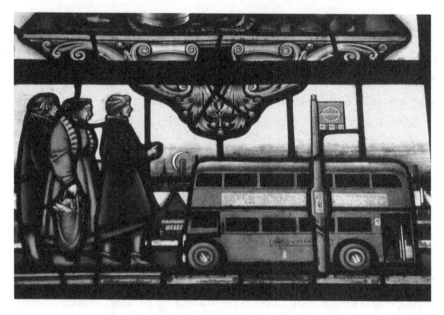

27. Detail of Routemaster bus, by F. W. Cole, 1960.
Christ Church, Southwark, London.

Church and a move towards depicting a world that would be recognised by congregations. The images may be less exalted, but they make far more connections with local people.

## TRAINS

Trainspotters will be happy to know there is a pleasing number of trains to be found in church windows. They mark the enormous impact the railways have had on the English landscape and life over the last two centuries, and cover a history which is traced in glass all the way back to the early days of steam and the famous, familiar form of Stephenson's Rocket, as seen in the Tyneside Industrial Heritage window (2006) in the Cathedral Church of St Mary, Newcastle.

The major railway companies such as the Great Western Railway (GWR) have left their mark on church glass. St Andrew in Taunton has a fine 2002

GWR train window by Clare Maryan Green: a billowing plume of steam rises as the locomotive, which can be identified as 2913 St Andrew, rushes through the station and signals, commemorating the role of the railway in developing the parish. Meanwhile in St James, Paddington, the wonderful World War II memorial window by G. E. R. Smith is bound to provoke a rush of nostalgia with the sight of a GWR train – this time 4979 Wootton Hall – coming towards the viewer as it departs Paddington Station. All this borders on product placement and corporate marketing, and the power of stained glass as an advertising medium is emphasised by the sight of the GWR logo on the brand-new toy engine clutched by a young boy in Margaret (M. E. A.) Rope's Christmas window in All Saints, Hereford.

Church windows also have the ability to capture and communicate the youthful, boyish enthusiasm for railways and steam trains which lasts into adulthood. A would-be train driver might, for instance, like the 1954 window by Christopher Webb in St Boniface, Bunbury, with a driver and two navvies pictured next to tracks and signals. One of the best train-mad window stories is told at All Saints in Cadeby, in a lovely 1979 window by Alfred Fisher with an illustration of a very old, ghostly steam locomotive in a woodland clearing. This is 'Pixie', a WG Bagnall 0–4–0ST from a local quarry, which was bought by the rector Rev. Teddy Boston (d.1986), a railway enthusiast who created the narrow-gauge Cadeby Light Railway in the garden of the rectory and opened it regularly to the public.

A vintage style of illustration taps into the vein of nostalgia that surrounds steam and railways, which is perhaps why many trains continue to be depicted in a style which would not be out of place in a children's book. Trains often puff through idealised landscapes, although it is good to see the breathtaking Ribblehead Viaduct in St Margaret of Antioch, Hawes, in Sep Waugh's millennium window. And the most famous illustrated engine of all, Thomas the Tank Engine, makes an appearance in a memorial window for its creator, the Reverend W. Awdry (1911–97), in St Mary Magdalene, Rodborough. A smiley Thomas can also be found in St Edmund, Emneth, in a window which marks the dates – 1953–65 – when the Reverend W. Awdry was vicar there.

As a postscript, I should add that stained glass can sometimes also be found in railway stations, as for example at Waterloo, London, where there is an impressive window with the coat of arms for the London and South Western Railway. The London Underground installed stained glass at Uxbridge Station, although the mix of 1937 Moderne architecture and the beautifully made, medievalesque heraldic windows by Ervin Bossányi is a little jarring. More suited to their sites are the huge glass Underground roundels for Charles Holden's futuristic Northern Line stations which act as beacons of light and warmth to travellers (e.g. Morden, 1926).

## BICYCLES

There is a lovely moment when you go into a church you haven't visited before and are not sure what you are going to find in the windows, only to discover that there is something for your 'collection' or perhaps something to inspire a new collection, such as an Aesthetic sunflower, a rare butterfly or a bicycle. There are, admittedly, very few bicycles in stained glass, which is odd when one considers just how many people have ridden them. However, it does make finding one quite special, like coming across a rare stamp or bird, and means you live in a constant state of hope when opening a church door.

There is a funny little 'bicycle window' in St Giles, Stoke Poges (where Thomas Gray, who wrote the 1850 poem 'Elegy in a Country Churchyard', is buried), which is interesting for two reasons. Firstly, it is often claimed to be an image of a bicycle painted long before the bicycle was invented (yet no one is able to date the piece of painted glass, which is possibly eighteenth century), although no one is quite sure whether the naked young man blowing a trumpet is sitting on a very early version of a bicycle or something quite different, such as a hobby horse. Secondly, it is a good example of how stories and myths can grow up around a window, many of which are patently untrue. It is therefore a warning not to unquestioningly accept everything that guides, wardens, locals and guidebooks tell you about a

window, because oral tradition and the enjoyment of a good tale are strong and can override or sometimes replace the truth, which may simply have been lost over time. Instead, it is always better to trust your own eyes and judgement, rather than allowing what might be a fabricated story to obscure the window's actual contents.

A more freewheeling and recognisable bicycle with solid mudguards is ridden along a Derbyshire country lane by a young boy in Christopher Webb's 1950s Benedicite window in St Mary, Wirksworth, which celebrates local life, sports and pastimes. And in St Peter and St Paul, Edgefield, there is a lovely upright reverend in a cape and priest's 'Saturn' hat on a bicycle with, fittingly, a large front light to illuminate the road ahead. This is Canon Walter Marcon (1884–1984), the 'cycling parson', about whom a good deal of factually accurate detail is shown in the 1984 window in John Hayward's wonderful 'scrapbook' style (see also St Peter's College Chapel, Oxford). There is thus no danger of myth springing up around this bicycle.

See also AVIATION, BENEDICITE

28. The Bicycle Window, maker unknown, 1643. St Giles, Stoke Poges.

## TYPOGRAPHY

Given that stained glass has in the past often been described as the poor man's Bible or regarded as an art form for the illiterate, it is ironic that it is actually full of words and numbers. Church windows contain innumerable labels, scrolls, plaques, texts, books, seals, inscriptions, dates, ages, banners, quotations, exhortations, signatures, makers' marks and messages, and words and numbers can also be found in haloes and on noticeboards, memorials and gravestones contained within a design.

As a result, to look at letters and numerals in stained glass is to discover an alternative history and catalogue of typography. Virtually all lettering in church windows is painted by hand, although there are a few exceptions such as recent screen-printed lettering and the occasional engraved signature, such as that scratched by the Victorian plumber-glazier Constantine Woolnough on his beautiful nave windows in St Mary, Dennington. Much of this lettering borrows from and/or combines one or more typographical sources. Many of these can be traced back to medieval arts and crafts, but windows also mirror fashions in handwriting and mimic other forms of lettering carved into stone, painted on wood and printed on paper. The individual characters might be might be serif or sans serif, hand-drawn block capitals or neatly laid out lower-case letters, printed, cursive, in beautiful italics or copperplate, thin and spindly, rounded and fat, written in the individual handwriting of the artist/designer or made up of what looks like old letterpress blocks picked from a compositor's bench.

Stained glass also contains many classic typefaces associated with different periods in history. It ranges from the virtually unreadable Latin words in original Gothic script in medieval windows to the countless beautiful examples of Victorian Gothic lettering which are sometimes only marginally easier to read, and from the free, loose and deliberately hand-formed lettering of the Arts and Crafts makers to examples of Times New Roman and modern digital numbers. The latter two represent 1952 and 2012 in Douglas Hogg's 2012 Diamond Jubilee window in the Queen's Chapel of the Savoy in London, which also includes a large reproduction

of Elizabeth II's signature, boldly mixing typefaces. In some recent windows letters themselves have become part of the artwork, as for example in the stunning 1980 window by Tony Hollaway, one of several by him in Manchester Cathedral, which features a range of letters and words in a variety of sizes and styles scattered throughout the window. And although contemporary lettering is often light, airy and legible, sometimes straying into feel-good, greetings card territory, I have not yet come across an example of Comic Sans.

Looking at words within windows, it becomes clear that some designers are verbose and like to include a long narrative or history, sometimes overfilling the available space and rendering the text almost unreadable (although it may be that commissioners and donors have stipulations and requirements). Others are remarkably succinct and ultra-economical with words, some to the point of literary silence, suggesting that the exclusion or inclusion of lettering is also an artistic decision. This is borne out by

29. Detail of World War I memorial window, by
Burlison & Grylls, *c.*1920. St Peter, Harrogate.

the windows of several twentieth-century designers who also trained in calligraphy and typography at art school. Postwar makers in particular bring a serious understanding to lettering on windows. L. C. Evetts, who studied under Edward Johnston at the Royal College of Art, was an expert in historic calligraphy, and it shows in his beautifully elegant, restrained windows and his immaculate, delicate lettering, which works with the artwork perfectly (e.g. Grimsby Minster). Harry Harvey was a talented and experimental fine-lettering artist who also carried out gilded, painted, heraldic lettering commissions, and his stained-glass work is modern, bold, fresh and technically brilliant (e.g. St Peter and St Paul, Stainton-in-Cleveland). Other designers with a specific, personal design aesthetic cleverly match typography to their own window style: Lawrence Lee produces wonderfully neat, plain and clear hand-printed lettering like that found in a children's primer or first reading book to match his illustrative style (e.g. St Andrew and St Patrick, Elveden); Brian Thomas' modern Baroque flourishes and serifs work perfectly in his gorgeously rich windows (e.g. St Sepulchre, City of London); and Ray Bradley's wonky, playful, mismatched lettering fits the mood of the 1960s in St James the Less, Dorney.

Whatever the style of lettering used, it does need to suit the style of the window. There are sadly many lovely windows which are marred by poor choice of typeface or execution. It fascinates me that some artists who exercise such control with their brushes when painting do not write well with them. Nevertheless, stained glass is a rich resource just waiting to be discovered by fans of typography.

See also MAKERS' MARKS, PAINTING

# URINE

Urine is one of those traditional substances, like gelatin and isinglass, the origins and applications of which many would rather gloss over these days. Yet it plays a small but significant part in both the history and the subject matter of making stained glass.

Readily available and free, human urine was, with wine or vinegar, one of the liquids used until the end of the medieval period as a binding agent when mixing vitreous paint powder. It was also used for tempering cutting tools and again in the cutting process: glass was scored with a red-hot rod or iron and urine was poured over, causing the glass to fracture along the line. But it couldn't be any old urine. Writing in his twelfth-century text *De diversis artibus* ('On Diverse Arts'), which documented various medieval arts and making processes and is the major source for what we know today about stained-glass production in medieval times, the pseudonymous author Theophilus Presbyter (*c.*1070–1125) stipulated using the urine of a small red-headed boy or a three-year-old goat fed on ferns for tempering tools. Of course, if this advice had been followed, a lot fewer windows would have been made in medieval times, leading one to ask if he was taking the piss.

Urine also appears in medieval stained glass that satirises the medical profession. Windows often depicted monkeys holding urine flasks up to the light and scrutinising the contents; the flask was a well-known symbol of physicians, who claimed to be able to diagnose and cure ailments by smelling and assessing the colour and opacity of the patient's urine, various shades of which could be replicated accurately with yellow silver stain. A few of these scurrilous medieval monkeys survive in English windows, as for example the fourteenth-century monkeys with flasks in the tracery in St Lawrence, Whitwell, and several in the Thomas Becket Miracle Windows in Canterbury Cathedral, as well as in a small number of carvings, screens and misericords in, for example, St Mary, Beverley, and Manchester Cathedral.

Monkeys with urine flasks can be also be found in borders of windows where they were once a common subject, just as they were in the marginalia of illuminated manuscripts. These carnivalesque peripheral elements frequently contained rude and scurrilous illustrations and commentary, and give the lie to the idea that all church glass was devotional, official and solemn. Instead it often contained the kind of grotesque faces and creatures that today we associate with gargoyles and corbels. Fragments of a fourteenth-century border in St John the Baptist, Dronfield, include a monkey with

a flask, a bearded face atop a pair
of hairy animal legs with trotters,
and a half-man, half-lizard crea-
ture. Occasionally a full 'besti-
ary border' scene survives, as in
the famous Pilgrimage Window
(*c.*1330) in York Minster, the base
of which contains a parody of a
funeral: one monkey examines a
urine flask while another looks
after a sick ape, and several more
carry the funeral bier.

Very occasionally and unusually
a urine flask appears in a non-satirical
situation. It is an angel who holds
one in the fifteenth-century glass
in St Lawrence, Harpley, perhaps

30. Detail of Pilgrimage Window, maker
unknown, *c.*1330. York Minster.

suggesting angelic healing power or the carrying of requests to heaven
for intervention and a cure. Similarly, the saintly physician twins, St Cos-
mas and St Damian, who accepted no payment for their services, may be
pictured separately or together with a urine flask as an attribute (e.g. St
Kenelm, Minster Lovell, late fifteenth century), although they are rarely
seen in stained glass.

See also GLASS, HOW A STAINED-GLASS WINDOW IS MADE

# VICTORIAN

Victorian stained glass may have been mocked and reviled over the years,
but it is impossible to ignore. The sheer quantity of windows installed
from the 1840s onwards which have survived bombs, wars, vandals and
vicissitudes makes sure of this. Whatever your personal taste, Victorian
glass has to be dealt with.

Unfortunately, it is often treated as a single entity, yet it really pays to tackle Victorian glass by separating out and learning to identify individual companies and makers; this will allow you to concentrate on those which intrigue and delight. It is also worth ignoring what some disparaging commentators say on the subject, instead looking at and enjoying the windows on their own merits. Some Victorian glass is undoubtedly sentimental, sententious and kitsch (sometimes entertainingly so), and some is badly made and in poor condition, but there is much which is highly underrated and deserves notice for it its verve, richness, colour, boldness and fabulously varied subject matter. Victorian windows are also a rich source of information about the Victorian era, its codes, fashions, tastes and visual culture.

Early Victorian designers wanted to revive the noble art of stained glass as practised in medieval times, as opposed to what they considered to be the degenerate art of painting on glass and copying oil painting, and they removed many of the seventeenth- and eighteenth-century windows they inherited. They had to start almost from scratch, as so many techniques and skills had been lost due to the huge rupture with medieval stained glass caused by the Reformation, the destruction and removal of many windows from this period, and the subsequent taste for clear glass (Wren, for example, did not put stained glass in his churches). When the medium was picked up again in the 1840s, A. W. N. Pugin (1812–52) was the prime mover of the Gothic Revival and believed that Gothic was the best style for churches. As a result, the first Victorian windows by the likes of Wailes, Willement and Warrington were early medieval in style: pictorial, rather primitive, but with brilliant colours, lively narratives in a quasi-comic strip style, and beautiful borders and patterns. I particularly enjoy the work of William Wailes of Newcastle (1808–81), whose windows are often dismissed with the words 'hard-boiled sweets' but who pulls off the incredible Great West Window (1859) in Gloucester Cathedral with a combination of medieval richness and Victorian energy.

The 1850s to 1880s marked the high point of Victorian glass, when designers and makers mixed sentiment, superb design, immense character

and flair, and plenty of borrowing from other types of art (botanical, still life, portrait, landscape). As with so many High Victorian enterprises, the best was executed with vigour and confidence, bravura and bravado. The problem came with the urban population explosion and the need for new churches which, for reasons of cost and expediency, were often filled with windows ordered by size and scene from church furnishers' catalogues. Today this is the glass that puts so many people off the very idea of stained glass, especially that from the Victorian era: dull, dark, brown and red, sanctimonious, pious, humourless, fading, and sometimes in poor condition. Some vicars are reputed to have been delighted when bombs blew their Victorian windows out in World War II, while others have allegedly not been unhappy when vandals have thrown bricks through theirs. And yet even this heavy-handed, run-of-the-mill glass can contain some redeeming features – sometimes for the wrong reasons and for making you laugh – and it's often possible to find good foliage and flowers, fabrics and hair; sadly, though, there is little of great quality. For that you need to look at the glass of the leading firms, and you may be surprised by just how wonderful it can be.

Most of the large firms supplied windows for churches all over England, although there are a few (e.g. Shrigley & Hunt in the north-west) with a more specific geographical concentration. It is worth being aware of local companies (Pevsner's guides are very useful for this) and to cultivate an interest in a few individual names. I make a point of looking for windows by Heaton, Butler & Bayne (especially those designed by Alfred Hassam between 1842 and 1869) and Lavers & Barraud (later Lavers, Barraud & Westlake). I will go out of my way to see work by Alexander Gibbs (*c*.1831– 86), whose luminous windows have a lovely mix of delicacy (lots of lemon yellow, rose pink, sky blue) and straightforward clarity. Likewise, I am always delighted to find a mention in Pevsner of Frederick Preedy (1820–98) because of his superb draughtsmanship, wild colours (purple, gold, scarlet, emerald, jade, blues and pinks), melodrama, theatricality, swagger, sweeping cloaks and smouldering looks. There are many examples in his native Worcestershire,

such as the marvellous collection of ten windows which spans much of his career from the 1850s to the 1880s in St John the Baptist, Fladbury, and more in Herefordshire and Norfolk.

Later Victorian glass from the 1880s onwards is much easier to identify by maker as by this stage there was a greater variation in style and an increasing naturalism and looseness influenced by William Morris and Edward Burne-Jones. Towards the end of the century, my top pick would be Henry Holiday (1839–1927), who carried out many commissions for James Powell & Sons (a fine company who did a sterling job in crediting their designers) from 1861 until 1891, when he set up on his own. See for example the exceptional east window in St Mary the Virgin, Buckland, Oxfordshire, and the set of beautiful windows in Worcester College Chapel, Oxford. With his monumental scale, lack of fussiness and decoration, utterly gorgeous colours, patterns, fabrics and hair, he is the meeting point and the crossover between the High Victorian and the Arts and Crafts makers who took stained glass into the twentieth century.

See also ANONYMOUS, HEARTS, PEVSNER, PINK

## WALKERS

Walkers, pilgrims and seekers of literal and metaphorical paths and ways have been represented in the Bible and in Christian books and art since long before we all started talking about our 'journeys' in this life. As a result, windows contain many bare-footed pilgrims who emulate St James the Greater with staffs or walking sticks, floppy hats with scallop shells, and bare feet or soft felt shoes, plenty of illustrations of John Bunyan's *The Pilgrim's Progress* (1678) and, more recently, a burst of pathfinders, Scouts and ramblers in thick hand-knitted socks and sweaters. With their plain, practical outfits, lack of worldly goods and outdoorsy style, these walkers are some of the most engaging and likeable figures in stained glass.

Pilgrims and pilgrimages were popular in medieval windows. Canterbury Cathedral has several little scenes of bare-headed stalwart walkers, some

with stout sticks or perhaps crutches (e.g. the window in the south ambu-latory, *c.*1220), but they are now rare elsewhere. Surprisingly, there are few windows based on *The Canterbury Tales*, but in the mid-twentieth century *The Pilgrim's Progress* was a popular source of material. Christian appears in many types of walking outfits, from the classic black-and-white, Puritan, tall-hatted, large-collared and buckled-shoes rig, to torn and ragged trousers, country smocks and wide-brimmed hats. I particularly like his makeshift backpack – a fabric-wrapped bundle tied with rope around his chest and shoulders – in the three vivid, storybook Pilgrim's Progress windows by G. E. R. Smith in St Helen, Skipwith (1954).

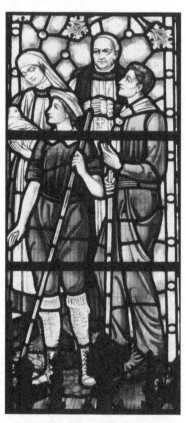

Scouts are also well prepared for treks and hikes, and although Scout windows are often poor quality but well-meaning amateur efforts, they have become inter-esting period pieces. As many Scout troops were originally run by vicars and curates, and as the movement has until recently had a firmly Christian ethos and prom-ise, large numbers of English churches have windows dedicated to Scouts, Cub Scouts, Girl Guides and Brownies, all in neat uniforms, with nicely brushed hair, whistles, badges and sturdy shoes. Founder Baden-Powell in a quasi-mili-tary/colonial get-up of lace-ups, knee-high socks, khaki shorts and safari shirt can be seen in St James, Paddington, and there is a splendidly old-fashioned Scout campfire and tent scene in St Mary the Virgin in Nottingham, one of several windows based on *The Pathfinder*, the famous 1913 painting by Ernest Stafford

31. Detail of walkers wearing hand-knitted socks in east window, by Hardman & Co., 1952. St Martin in the Bull Ring, Birmingham.

Carlos (1883–1917), which brings together Jesus the Pathfinder and a young Scout pathfinder with his map.

Then there are the walkers who, apart from the implied metaphorical journey, seek fortune or simply enjoyment of the countryside. The magnificent 1969 window by John Hayward of Dick Whittington in St Michael Paternoster Royal, City of London, combines legend and social commentary. Although he is with his cat and carrying the usual red-and-white spotted knapsack, his flat cap, soft collar and tie, heavy overcoat and the waterproof rough sacking over his shoulders are perhaps emblematic of postwar seekers of work, with more overtones of unemployment and echoes of the 1936 Jarrow March than fairy-tale riches. On the other hand, the enjoyment and heartiness of walking as a pastime which was highly popular in the 1920s and 1930s is clearly conveyed in rural churches by suitably dressed individuals in community thanksgiving windows (e.g. St Clement, Hastings) and by groups of jolly, clean-cut walkers striding over the landscape in sensible shoes (e.g. All Saints, Walesby, Lincolnshire, aka the Ramblers' Church), which can only be accessed, appropriately, by a grassy uphill path.

See also KNITWEAR AND KNITTING, PAINTING, SHOES

# WHALES

When looking up at a stained-glass window, you may find yourself confronting a huge-jawed, pop-eyed whale, mouth wide open in anticipation of a good catch, in the act of swallowing a man whole or dragging him into the sea by his leg as he is thrown overboard by a group of sailors, or perhaps spewing him out. The man is Jonah, an Old Testament prophet, and his story of spending three days in the belly of a whale before being spat out onto the shore is one of the Bible's most graphic and vivid.

Whales can be found in medieval windows (the finest are in the great cathedrals of northern France rather than in England), in Victorian and, occasionally, in twentieth-century glass, but most belong to a very interesting

period in the development of stained glass and are fascinating historical curiosities. It is no coincidence that whales proliferated in windows made in the first half of the seventeenth century, because this is when whaling was at its height in the Netherlands and because the best contemporary glass for English churches was being made by Dutch and Flemish émigré artists. Whales were much talked about in London and England at the time, and whale sightings and stage spectacles involving whales were popular. As a result, maritime scenes and disasters were highly topical and mined fears of deep water, sinkings and drownings and the possibility of monsters and mythical creatures lurking below the surface, ready to swallow a man in one gulp. Windows featuring Jonah and the whale thus conflated the biblical and the spectacle, contemporary and religious anxieties, and brought the seventeenth-century taste for allegory and symbolism into the mix.

This era is often regarded as a low point for English church glass, and many regarded – and some still regard – the fashion for painting glass using vitreous enamels (rather than iron oxide paints and silver stain) on large pieces or grids of glass as a travesty of the medieval tradition of pieced and leaded windows. It produced a very painterly style using similar techniques to those for painting on a fired surface such as tiles and plates. Delft tiles and plates, for example, feature a huge range of whales, fish, storms, seas, ships and Jonahs. The larger windows often resemble the oil paintings of the day, but gloriously bright and backlit. Glass of this type was more popular on the Continent, and quite often the examples found in English churches were at some point bought or imported by collectors and clergymen (e.g. the painted glass which features tiny but action-packed whale scenes in the Lord Mayor's Chapel in Bristol and in St Mary, Preston on Stour).

The most skilled artists, such as the brothers Abraham and Bernard van Linge from East Frisia, most of whose work was done in England from the 1620s to the 1640s, produced superb whale scenes which are a joy to behold. They are funny, exaggerated and melodramatic, a wild and lively mix of action, character and scenery (almost like early silent movies but in colour) and clearly influenced by the fine art of the period. They may not be subtle, but it is possible to spend a long time enjoying them – especially

in Oxford, which has the best concentration of large seventeenth-century windows and whales; a mini-tour to the chapels of University College, Wadham College and Lincoln College is highly recommended. The whales themselves are fantastical creatures, the product no doubt of whalers' and adventurers' embellished tales. They are brilliantly imagined and horribly ugly with gaping, cavernous mouths, razor-sharp teeth, bulging eyes, strange fins, spikes, scales and tails, and all the power required to drag a man to the depths with ease. The horror on Jonah's face is always clear to see.

Later whales can be found not only in nineteenth- and twentieth-century windows which tell the story of Jonah, but also in windows that memorialise exploration, travel, adventure, the natural world and even death by drowning. After the vigour and fearsomeness of the seventeenth century, Victorian whales can be disappointingly toned down, almost like friendly dolphins or cartoon creatures. Because they are often designed in a much flatter, blockier, more decorative and less painted style than seventeenth-century whales (some even display carpet-style patterns which make them look like large slippers), they are far less alarming and predatory. Benedicite windows which celebrate all aspects of creation are also a good source of whales in their natural habitat, from the 1906 illustration by William Aikman of a huge spouting whale swimming with a shoal of fish in Worcester Cathedral, which could be from a child's book about the sea, to my favourite, the very finely painted whale set against a royal-blue sky and a bright white Arctic landscape in the quite wonderful 1940s window by Christopher Webb in St George, Toddington.

See also BENEDICITE, EUROPEAN, PAINTING

# YELLOW

The French word for stained glass is *vitrail*. This one short word manages to sum up the concept of a window made with pieces of painted and stained glass held together with lead strips. The English term 'stained glass', on the other hand, is nowhere near as succinct or accurate, and is something of a

misnomer in that it refers to only one part of the window-making process. The only true 'stained glass' is that which has been painted with a silver oxide compound then fired in order to introduce one of a large range of shades of yellow. All the other colour in a window comes from the glass itself, iron oxide paint and enamels.

Silver stain has been used since the 1400s, and the technique has not changed a great deal over the centuries. It is usually applied to the back of the glass – the side that will be on the outside of a window – and is different to paints and enamels (which remain on the surface of the glass after firing) in that a permanent chemical reaction takes place. If you look closely, you can see that the colour is within the glass itself and gives lovely depth to the various shades of lemon, citrine, primrose, honey, straw, saffron, amber and ochre which an artist can achieve.

Silver stain is expensive and is mostly used sparingly for highlights and decorative effects, although there are exceptions to the rule: many seventeenth- and eighteenth-century roundels and plenty of Victorian windows contain liberal quantities, often in a delicate gold/grey/black/white grisaille combination which can be very beautiful. The application of the paint varies tremendously, with some areas looking loose and uneven – almost still liquid – and others carefully controlled, some very lightly covered and others thickly and darkly painted; it is precisely these many variations that remind you constantly of the handmade nature of church windows.

It is fascinating to look at where stain has been used and the ways in which is handled. Windows made with medieval fragments make particularly good case studies as they often contain a fantastic mix of examples in which silver stain is used to create an aura around heads and faces in hair, beards, crowns and haloes. In the same way, it brings bright, glowing areas of rich yellow to patterns on textiles and clothes, and to trimmings and tassels. It can be used in small quantities, as when it forms the central dots in tiny daisies, highlights the gold-edged pages of a book (e.g. the Bibles held by donors in the fifteenth-century Lord's Prayer window in St Laurence, Ludlow) and fills in the tiny spider at the centre of the web in

Geoffrey Webb's maker's mark. Or it may be used lavishly in much larger areas which also play with differing depths and tones of stain, as for example the wonderful fifteenth-century angels with peacock-feather wings in the tracery in St John the Baptist, Cirencester.

Silver stain turns grapes into precious metal, makes architectural details appear to be covered with gold leaf, adds heat to flames (where its unevenness works so well) and lustre to St Michael's soul-weighing scales. It can be used to make lettering stand out, to bring brightness to grisaille, and to add both realistic colour and a lovely idealised glow to sheaves of wheat and fields of corn. Wherever you find it, yellow silver stain tells you a huge amount about the history, process, art and craft of church windows.

See also GLASS, GRISAILLE, PEACOCKS, URINE

# ZZZZZ

Windows are packed with action, incident and grand gestures. But sometimes in the midst of all this the pace slows down, tiredness takes over, and the viewer finds a weary figure fast asleep, leaning against a column or resting his head on his arm or hand, or a number of sleepers, flat out, sprawled in a heap as if a spell has been cast on them.

I find sleepers in stained glass enormously appealing. Not so much because of the stories in which they play a significant part, but because I empathise with their deep need for restorative sleep and am touched by their lack of self-consciousness and self-control as they adopt realistically ungainly positions. Henry Payne's sleeping soldiers in St Catherine, Sacombe, one with his head thrown back and the other, mouth open, head lolling forwards, look as though they have been drawn directly from life. They appear fallible and vulnerable, even when they are at fault and should most definitely not be sleeping, like the worn-out soldiers in the Resurrection scene who crumple to the ground or sleep on their feet when they should be alert and guarding the tomb. The Foolish Virgins, too, succumb to sleep instead of staying awake until the delayed bridegroom

arrives, while the sensible but unsisterly Wise Virgins remain wide awake. This story inspired many brilliant Victorian interpretations in windows, such as those in St Giles in Oxford, St Mary in Putney and St Edith in Bishop Wilton. Sleepers in stained glass grab their sleep where they can. This may be in the corners of windows, wittily propped up against the edge or a section of lead, like the tiny medieval soldiers in uncomfortable chain mail and helmets in All Saints, North Street, York, or luxuriantly stretched out along the bottom edge like the eponymous figure in Tree of Jesse windows, for example in St Mary, Shrewsbury, or on the ground in the Garden of Gethsemane like the disciples who are dead to the world while Jesus prays and the soldiers approach (there is a lovely version, *c.*1622, with tenderly painted, exhausted-looking sleepers, in Wadham College Chapel, Oxford). In some Transfiguration scenes, such as that in the fascinating set of narrative windows by Pre-Raphaelite painter Ford Madox Brown in Holy Trinity,

Meole Brace near Shrewsbury, the three disciples fall asleep on the mountainside (in other scenes they are merely sleepy), proving that a lack of a soft surface or comfort is no bar to dropping off and dreaming. Indeed, Jacob often leans against a hard rock or stone during his vision of the ladder to heaven while the dreamscape action of angels ascending and descending whirs around him (there is a skilfully choreographed scene with angels on a grand staircase like an early Astaire/Rogers musical in University College Chapel, Oxford, *c.*1641).

32. Detail of The Resurrection, maker unknown, mid-fourteenth century. All Saints, North Street, York.

If sleepers have a peak moment in stained glass, it is during the

nineteenth century. In church windows, as elsewhere in art and visual culture, the Victorians had something of a fixation with sleep – which is perhaps to be expected, given their obsession with dying and death, something connected with ideas of eternal sleep. There are some amazing and quite ghoulish deathbed scenes: the pale mother and child in a white shroud, with wreaths at their bedside, in Salisbury Cathedral, is by no means a rare sight. And, as windows were often memorials for sons and daughters who died young, it is no coincidence that the Victorians frequently chose the subject of the raising of Jairus' daughter, always a ghastly, ghostly white on her bed as she wakes and comes back to life. ('Weep not, she is not dead, but asleep.') Not long after, the connection between sleep and death was once again made very clear in World War I memorial windows, which showed soldiers, unharmed and without a scratch, apparently peacefully asleep (e.g. St Mary, Maldon).

A closer look at the subject of sleep in glass also reveals that there are many beds which contain the sleepy, sick, infirm and dying. There is an especially good set of bedside scenes in the wonderful thirteenth-century Thomas Becket Miracle Windows in Canterbury Cathedral; the robbed and beaten traveller rescued by the Good Samaritan is sometimes shown peacefully sleeping in a luxurious bed with pure white sheets and plump pillows (St Mary, Gressenhall); and Acts of Mercy windows have always included beds. These range from NHS iron bedsteads in the window by Harry Harvey in Sheffield Cathedral to a tall, fringed, four-poster bed in the nineteenth-century Annunciation scene in Magdalene College Chapel, Cambridge, even though it is doubtful Mary ever slept in a canopied mahogany bed.

See also MERCY

# 50 PLACES TO SEE
# STAINED GLASS

This is a personal list, and is by no means exhaustive or comprehensive. It includes the places I have seen and visited in person which I would recommend unreservedly.

1. Banbury: St Mary
2. Binton: St Peter
3. Birmingham: Cathedral
4. Bristol: St Mary Redcliffe
5. Cambridge: Jesus College Chapel
6. Cambridge: King's College Chapel
7. Cambridge: Robinson College Chapel
8. Chichester: St Richard RC
9. Cirencester: St John the Baptist
10. City of London: St Sepulchre and St Mary-le-Bow (for details of all City churches and opening times see the Friends of the City Churches website, www.london-city-churches.org.uk)
11. Coventry: Cathedral
12. Crayford: St Paulinus
13. Dennington: St Mary
14. Dunstable: Priory Church of St Peter
15. Ely: Cathedral and Stained Glass Museum

16. Fairford: St Mary
17. Gloucester: Cathedral
18. Harlow: Our Lady of Fatima RC
19. Liverpool: Metropolitan Cathedral
20. London: All Saints, Margaret Street
21. London: Holy Trinity, Sloane Square
22. London: St Etheldreda, Ely Place
23. London: Victoria and Albert Museum, stained-glass collection
24. London: Lincoln's Inn Chapel
25. Long Melford: Holy Trinity
26. Ludlow: St Laurence
27. Manchester: Cathedral
28. Newcastle: Cathedral of St Nicholas
29. Oundle School Chapel
30. Oxford: Christ Church Cathedral
31. Oxford: University College Chapel
32. Oxford: Worcester College Chapel
33. Peterborough: St John the Baptist
34. Potterspury: St Nicholas
35. Preston on Stour: St Mary
36. St Leonard's-on-Sea: St John the Evangelist
37. Salisbury: Cathedral
38. Sheffield: Cathedral
39. Shrewsbury: St Mary
40. Soham: St Andrew
41. Spalding: St Mary and St Nicolas
42. Stoke Poges: St Giles
43. Sturminster Newton: St Mary
44. Swaffham Prior: St Mary
45. Tudeley: All Saints
46. Wellingborough: All Hallows
47. Winchester: Cathedral
48. Wirksworth: St Mary
49. Winchelsea: St Thomas
50. York: All Saints, North Street

# FURTHER READING

The literature on stained glass for general readers is mostly dated, with a significant emphasis on medieval and Victorian windows. There are many gaps which will, I hope, be addressed at some point in the future. For the time being, however, there is a mix of publications of varying quality to choose from in order to build up a fuller picture. The following are some of the sources I have found useful and recommend.

## CHURCH GUIDES

I always buy a copy of a guide to see how a church presents and describes its windows, and what information is included (explanations of subjects and contents are particularly useful). Some guides are extremely well researched and nicely produced, others less so, but even the simpler, more basic guides can often contain a gem or an illuminating fact and are therefore worth purchasing.

## CATHEDRAL GUIDES

If a guide to the windows (rather than the cathedral as a whole) is available, go for this. Many are written by specialists and are useful for their coverage

of the history of stained glass, and for details of individual firms and makers which can be applied when looking at their work elsewhere. For example, the guide to the windows in Coventry Cathedral provides a fine overview of early postwar stained glass, while the Ely Cathedral guide contains a lively commentary on Victorian design.

## PEVSNER AND OTHERS

The most up-to-date editions of the county guides in Nikolaus Pevsner's Buildings of England series, published by Yale University Press, are invaluable in locating stained glass (see the section on Pevsner for more details). In addition to Pevsner's county guides, I have found the following four publications useful when deciding where to visit:

Jenkins, Simon, *England's Thousand Best Churches* (Penguin, 1999).
—— *England's Cathedrals* (Little, Brown, 2016).
Mortlock, D. P., *The Guide to Norfolk Churches* (James Clarke, 2007).
—— *The Guide to Suffolk Churches* (James Clarke, 2009).

## GENERAL AND SPECIALIST

Brown, Sarah, *Stained Glass: An Illustrated History* (Studio Editions, 1992, out of print).
Cormack, Peter, *Arts & Crafts Stained Glass* (Paul Mellon Centre for Studies in British Art, 2015).
Costigan, Lucy and Cullen, Michael, *Strangest Genius: The Stained Glass of Harry Clarke* (History Press Ireland, 2010).
Cowen, Painton, *English Stained Glass* (Thames & Hudson, 2008).
Gordon Bowe, Nicola, *Harry Clarke: The Life & Work* (History Press Ireland, 1989).
—— *Wilhelmina Geddes: Life and Work* (Four Courts Press, 2015).

Harrison, Martin, *Victorian Stained Glass* (Barrie & Jenkins, 1980, out of print).

Hinchcliffe, Henry, *The Stained Glass Windows of Harry Stammers* (Blurb, 2015).

Horner, Libby, *Frank Brangwyn: Stained Glass, A Catalogue Raisonné* (Libby Horner, 2011).

—— *Patrick Reyntiens: Catalogue of Stained Glass* (Sansom & Company, 2013).

Lee, Lawrence, *The Appreciation of Stained Glass* (Oxford University Press, 1977, out of print).

Lee, Lawrence, George Seddon and Francis Stephens, *Stained Glass* (Mitchell Beazley, 1976, out of print).

Little, Joyce (compiler), *Stained Glass Marks and Monograms*, ed. Angela Goedicke and Margaret Washbourn (Arts Society, 2002). Copies available by emailing volunteering@nadfas.org.uk.

Osborne, June, *John Piper and Stained Glass* (Sutton Publishing, 1997).

Piper, John, *Stained Glass: Art or Anti-Art* (Studio Vista, 1968, out of print).

Reyntiens, Patrick, *The Beauty of Stained Glass* (Herbert Press, 1990, out of print).

Rosewell, Roger, *Stained Glass* (Shire Library, 2013).

Swash, Caroline, *The 100 Best Stained Glass Sites in London* (Malvern Arts Press, 2015).

# LIST OF IMAGES

*All photographs © the author.*

## BLACK AND WHITE IMAGES

1. Details of medieval and modern stained-glass workshops in A. K. Nicholson memorial window (1937), G. E. R. Smith with A. K. Nicholson Studios. St Sepulchre, City of London.   9

2. Detail of east window, by Keith New, 1966. All Saints, Branston.   11

3. Detail from Acts of Mercy scenes, designed by T. W. Camm, made by Messrs R. W. Winfield, 1883. St Mary, Wirksworth.   14

4. The Pelican in Her Piety, by C. E. Kempe, 1904. The Parish Church of St Michael and All Angels, Hathersage.   36

5. Details of St Paul window and St Catherine window, both by Christopher Webb, late 1950s. St Lawrence Jewry, City of London.   39

6. Detail of Childhood of Christ, by Ernest Board and Arnold Robinson (Joseph Bell & Son), 1925. Berkeley Chapel, Bristol Cathedral.   47

7. Detail of crown, maker unknown, Netherlands, seventeenth century. Church of St Mary the Virgin, Preston on Stour.   55

8.  Detail of angel in *dalle de verre*, by Gabriel Loire, 1962. St Richard RC, Chichester.                                                57

9.  Detail of Arthur Henry Stanton with his cat, by Sir Ninian Comper, 1928. St Mary the Virgin, Wellingborough.                          62

10. Detail of ermine in donor window, maker unknown, late fifteenth century. Holy Trinity, Long Melford (by kind permission of the rector).                                               68

11. Painted roundel, maker unknown, probably Netherlands, seventeenth century. St Mary, Preston on Stour.                              70

12. Detail of the Wise and Foolish Virgins window (1872), Heaton, Butler & Bayne. St Mary, Putney.                                     73

13. Detail of Corporeal Acts of Mercy window, maker unknown, early fifteenth century. All Saints, North Street, York.                  77

14. Detail of lily crucifix in Annunciation window, by Hugh Easton, 1954. St Paulinus, Crayford.                                        81

15. Detail of 'Prior's Early English' glass patented by E. S. Prior, 1888–9. St Michael, Framlingham. By permission of the rector and churchwarden, the church of St Michael, Framlingham.                                                              90

16. Detail of Grapes of Eshcol, by William Wailes, 1850. Ely Cathedral.                                                                92

17. Detail of the Wren window, by Christopher Webb, 1959. St Lawrence Jewry, City of London.                                           94

18. David and Goliath, designed by Ford Madox Brown, made by Morris & Co., 1873. Jesus College Chapel, Cambridge.                      107

19. Detail of Benedicite window, by Christopher Webb, 1948. St George, Toddington.                                                     109

20. Detail of leading, by Joseph Ledger, 1952. St John the Evangelist, St Leonard's-on-Sea.                                            122

21. Maker's mark with spider, by Geoffrey Webb, 1911. St Mary, Sturminster Newton.                                                     126

22. Detail of St Giles window designed by F. W. Cole for William Morris & Co. (Westminster), 1958. St Giles, Stoke Poges.              135

23.  Detail of Nativity window, by Kempe & Co, 1913. St Peter, Binton.                                                                   139

24.  Detail of the life of St Laurence, maker unknown, fifteenth century. St Laurence, Ludlow. With grateful thanks to the rector and churchwardens.                                       160

25.  Detail of the Parable of the Sower, by Heaton, Butler & Bayne, between 1865 and 1881. St Mary, Banbury.          169

26.  Detail of Thomas Memorial Window, by W. F. Dixon, 1880s. Sheffield Cathedral.                                                 175

27.  Detail of Routemaster bus, by F. W. Cole, 1960. Christ Church, Southwark, London.                                        190

28.  The Bicycle Window, maker unknown, 1643. St Giles, Stoke Poges.                                                                   193

29.  Detail of World War I memorial window, by Burlison & Grylls, *c.*1920. St Peter, Harrogate.                          195

30.  Detail of Pilgrimage Window, maker unknown, *c.*1330. York Minster.                                                               198

31.  Detail of walkers wearing hand-knitted socks in east window, by Hardman & Co., 1952. St Martin in the Bull Ring, Birmingham.                                                            202

32.  Detail of The Resurrection, maker unknown, mid-fourteenth century. All Saints, North Street, York.                 208

## COLOUR PLATES

1.  Detail of Annunciation window, by Karl Parsons, 1912. PCC of St Alban's Church, Hindhead.

2.  Detail of Good Shepherd window, possibly by W. F. Dixon, *c.*1884. St Mary the Virgin, Bruton.

3.  (*Top left*) Detail of quarries, possibly by Lavers & Barraud, second half of nineteenth century. St Peter and St Paul, Lavenham. (*Top right*) Detail of foliage in Suffer Little Children window, by Henry

Holiday, 1891. Salisbury Cathedral. (*Bottom left*) Detail of medieval grisaille, maker unknown, *c.*1225–58. Salisbury Cathedral. (*Bottom right*) Detail of 'Prior's Early English' glass, designed by E. S. Prior, made by James Powell & Sons, late 1880s. St Mary and St Peter, Kelsale (by kind permission of the Churchwarden, Church of St Mary and St Peter, Kelsale cum Carlton, Suffolk).

4. Detail of ruby anniversary window, by Christopher Fiddes and Nicholas Bechgaard, 1997. St Nicholas, Potterspury.

5. (*Top left*) Detail of memorial window, by C. E. Moore, early 1920s. St Nicholas, Potterspury. (*Top right*) Detail of Creation window, by Clayton & Bell, part of a scheme conceived in 1882 and completed in 1925. St Edmundsbury Cathedral, Bury St Edmunds. (*Bottom left*) Detail of fifteenth- and sixteenth-century fragments, maker unknown, reset 1798–1800. St John the Baptist, Cirencester. (*Bottom right*) Detail of dragon with St George, by C. E. Kempe, 1904 (reproduced by kind permission of All Saints Church, High Wycombe).

6. Detail of window depicting repair of the cathedral in the 1660s, by C. E. Kempe, 1901. Lichfield Cathedral.

7. (*Top left*) Detail of Jonah and the Whale, by Abraham van Linge, 1641. University College Chapel, Oxford (by kind permission of the Master and Fellows of University College, Oxford). (*Top right*) Detail of north-west window in cloisters, designed by J. H. Dearle, made by Morris & Co., 1924. Gloucester Cathedral. (*Bottom left*) Detail of window depicting repair of the cathedral in the 1660s, C. E. Kempe, 1901. Lichfield Cathedral. (*Bottom right*) Detail of nave window, by Constantine Woolnough of Framlingham, 1858. St Mary, Dennington.

8. (*Top left*) Detail of Annunciation window, by James Powell & Sons, 1955. St Mary, Wargrave. (*Top right*) Detail of Lady Chapel window, by Harry Stammers, 1961. St Mary Redcliffe, Bristol. (*Bottom left*) Detail of antechapel window, by David Evans of Shrewsbury, 1837–40. Wadham College Chapel, Oxford. (*Bottom*

*right*) Detail of memorial window, by Mayer & Co, 1871. St Giles, Stoke Poges.

9.  (*Top left*) Detail of war memorial window, by A. J. Davies, 1917. Holy Trinity, Southport. (*Top right*) Detail of maker's mark, by M. E. A. ('Tor') Rope, 1959. St Margaret, Leiston. (*Bottom left*) Detail of nave window, by Clayton & Bell, between 1883 and 1919. St John the Baptist, Peterborough. (*Bottom right*) Detail of window in St Benedict Chapel, by W. T. Carter Shapland, 1959. Peterborough Cathedral.

10. Detail of angel with peacock-feather wings in tracery, maker unknown, fifteenth century. St John the Baptist, Cirencester.

11. (*Top left*) Detail of Noah's Ark, Joseph Bell & Sons, late 1880s. St Mary Redcliffe, Bristol. (*Top right*) Detail of memorial window, by Mary Newill, 1906. St Peter, Wrockwardine. (*Bottom left*) Detail of memorial window, by C. E. Kempe, 1891. Wakefield Cathedral (by kind permission of The Chapter, Wakefield Cathedral). (*Bottom right*) Detail of Annunciation window, by J. E. Nuttgens, 1935. St John the Baptist, Windsor.

12. (*Top left*) Detail of 'Pricke of Conscience' window ('plants and trees exude a bloody dew'), maker unknown, *c.* 1410–20. All Saints, North Street, York. (*Top right*) Detail of servicemen, by Hugh Easton, 1947. St Mary the Virgin, Willingdon. (*Middle left*) Detail of donors, maker unknown, first half of fifteenth century. St Laurence, Ludlow. (*Middle right*) Detail of World War II battle, G. E. R. Smith for A. K. Nicholson Studios, 1940s. St John the Baptist, Little Missenden. (*Bottom left*) Detail of World War I memorial window, a copy of James Clark's *The Great Sacrifice*, by Wm. Pearce & E. Cutler, 1920. St Mary, Maldon. (*Bottom right*) Detail of Benedicite window, by Christopher Webb, 1958. St Mary, Wirksworth.

13. (*Top left*) Detail of donor, maker unknown, late fifteenth century. Holy Trinity, Long Melford (by kind permission of the rector). (*Top right*) Detail of donor, maker unknown, late fifteenth century. Holy Trinity, Long Melford (by kind permission of the rector).

(*Bottom*) Detail of 'Pricke of Conscience' window ('the fish make a roaring noise'), maker unknown, c.1410–20. All Saints, North Street, York.

14. Detail of memorial window, by G. E. R. Smith, 1950. Parish Church of All Saints with St Peter, Maldon.

15. (*Top left*) Detail of local bomb damage, by Hugh Easton, 1949. St Dunstan, Stepney. (*Top right*) Detail of photograph in memorial window, designed by Canon Edward Pountney Gough, vicar of Spalding (1913–20), c.1918. St Mary and St Nicolas, Spalding. (*Bottom left*) Detail of Robert Baden-Powell in west window, by A. E. Buss, post-1945. St James, Paddington. (*Bottom right*) Detail of Golgotha, maker unknown, c.1500–15. St Mary, Fairford.

16. Detail of 'It is the Lord' window, designed by Joseph Ledger, made by Lowndes & Drury, 1952. St John the Evangelist, St Leonard's-on-Sea.

17. Detail of Millennium Window, by Rachel Thomas, 2000. St Paul, Birmingham.

18. Detail of Archangel Michael in east window, by Hugh Easton, 1953. St Paulinus, Crayford.

19. (*Top*) Detail of Virgin and Child window, by A. J. Davies, 1926. Priory Church of St Peter, Dunstable. (*Bottom*) Detail of St Barbara's shoes, by Harry Clarke, 1921. St Mary, Sturminster Newton.

20. Detail of maker's mark, by William Peckitt, 1769. St Ann, Manchester (by permission of the rector and churchwardens of St Ann's, Manchester).

21. (*Top left*) Detail of east window, probably by Heaton, Butler & Bayne, 1882. St Paul, Brentford. (*Top right*) Detail of abstract window, John Hayward, 1970. Blackburn Cathedral. (*Bottom left*) Detail of Dame Nellie Melba memorial window, by Brian Thomas, 1962–5. St Sepulchre, City of London. (*Bottom right*) Detail of Nativity window, designed by Frank Brangwyn, made by J. Silvester Sparrow, 1917. St Mary, Bucklebury.

22. Detail of Aaron, by David Evans of Shrewsbury, 1853. Winchester Cathedral.

23. (*Top left*) Detail of St Giles window, by F. W. Cole for William Morris & Co. (Westminster). 1958. St Giles, Stoke Poges. (*Top right*) Detail of Annunciation window, by Christopher Whall, 1920. St Mary's Parish Church, Iwerne Minster. (*Bottom left*) Detail of Pentecost window, by Harry Stammers, 1960. St Mary Redcliffe, Bristol. (*Bottom right*) Detail of Nativity window, designed by Frank Brangwyn, made by J. Silvester Sparrow, 1917. St Mary, Bucklebury.

24. Detail of passion flowers, by Lavers, Barraud & Westlake, early 1860s. Part of the sanctuary window, south side, of St John the Baptist Church, Cookham Dean, courtesy of the vicar and churchwardens.

25. (*Top left*) Detail of maker's mark, by Martin Travers, 1932. St Margaret of Antioch, Iver Heath. (*Top right*) Detail of window featuring local luminaries, designed by Brian Thomas, made by James Powell & Sons, 1968. St John the Baptist, Peterborough. (*Bottom left*) Detail of Nativity window, by Louis Davis, 1921. St Matthew, Surbiton. (*Bottom right*) Detail of Dick Whittington's cat, by John Hayward, 1969. St Michael Paternoster Royal, City of London.

26. Detail of memorial window to Captain Scott's 1912 Antarctic expedition, by C. E. Kempe & Co., 1915. St Peter, Binton.

27. (*Top left*) Detail of St Sebastian, by C. E. Kempe, 1904 (reproduced by kind permission of All Saints Church, High Wycombe). (*Top right*) Detail of wheat in Sower window, by C. E. Moore, 1920. St Nicholas, Potterspury. (*Bottom left*) Detail of Jonah and the Whale, undocumented, possibly by Robert Rudland, 1616. Wadham College Chapel, Oxford. (*Bottom right*) Detail of dice on shirt, by Lavers & Barraud, 1861–3. St Mary Magdalene, Battlefield.

28. Detail of Resurrection window, by Hardman & Co, between 1853 and 1880. Magdalene College Chapel, Cambridge.

29. (*Top left*) Detail of Acts of Mercy window, by Harry Harvey, 1967. Sheffield Cathedral. (*Top right*) Detail of foliage and flowers, by Clayton & Bell, 1858. St Michael, Cornhill, City of London. (*Bottom*

*left*) Detail of tracery windows, David Evans of Shrewsbury, 1820–9.
St Mary, Shrewsbury. (*Bottom right*) Detail of Alexander Fleming
in east window, by A. E. Buss, post-1945. St James, Paddington.

30. Detail of memorial window, by W. T. Carter Shapland, 1960. St
Mary, Stoke Newington.

31. (*Top left*) Detail of memorial window, by W. F. Dixon, 1881.
Sheffield Cathedral. (*Top right*) Detail of Christ walking on the
water, by M. C. Farrar Bell, 1963. St Katharine Cree, City of
London. (*Bottom left*) Detail of Creation of Eve, by Clayton &
Bell, part of a scheme conceived in 1882 and completed in 1925. St
Edmundsbury Cathedral. (*Bottom right*) Detail of *dalle de verre*, by
Gabriel Loire, 1958. St Richard RC, Chichester.

32. Detail of Nativity with children window, by M. E. A. Rope, 1944.
All Saints, Hereford.

# INDEX OF CHURCHES

References to images are in *italics*.

**BEDFORDSHIRE**

St George, Toddington 35, 51, 80–1,
   *109*, 205
St Mary, Woburn 37
St Peter, Dunstable 146, 210, *Plate 19*

**BERKSHIRE**

All Saints, Farnborough 113
Eton College Chapel 150, 171
St James the Less, Pangbourne 45, 84
St John the Baptist, Cookham Dean 84,
   141, 188, *Plate 24*
St John the Baptist, Eton Wick 138
St John the Baptist, Windsor 123, *Plate 11*
St Laurence, Slough 166
St Lawrence, Sandhurst 46
St Mary, Slough 12
St Mary, Wargrave 184, *Plate 8*
St Mary Magdalene, Easthampstead 108
St Mary the Virgin, Bucklebury 90, 112,
   134, 140, *Plate 21, Plate 23*
St Mary the Virgin, Datchet 106

**BRISTOL**

Bristol Cathedral 30, 41, *47*, 49, 50, 78, 98
Clifton RC Cathedral 13, 57
Lord Mayor's Chapel 204
St Alban, Westbury Park 78
St Mary Redcliffe 24, 25, 30, 76, 78, 88,
   141, *163*, 210, *Plate 8, Plate 11, Plate
   23*

**BUCKINGHAMSHIRE**

All Saints, High Wycombe *Plate 5, Plate
   27*
St Giles, Stoke Poges *135*, 192, *193*, 211,
   *Plate 8, Plate 23*
St James the Less, Dorney 196
St John the Baptist, Little Missenden
   176, *Plate 12*
St Margaret of Antioch, Iver Heath 38,
   95, *Plate 25*
St Mary, Turville 151
St Mary and All Saints, Beaconsfield 164
St Mary the Virgin, Aylesbury 93

St Mary the Virgin, Drayton Beauchamp 156

St Mary the Virgin, Fawley 151

St Mary the Virgin, Mursley 72

St Mary the Virgin, Radnage 166, 183

St Peter and St Paul, Great Missenden 174

St Peter and St Paul, Stokenchurch 37

**CAMBRIDGESHIRE**

All Saints, Cambridge 14

All Saints, Huntingdon 29

All Saints, Longstanton 82

Churchill College Chapel, Cambridge 151

Ely Cathedral 25, 28, 43, 44, 49, 64, 86, 92, *92*, 168, 179, 188–9, 210

Jesus College Chapel, Cambridge 80, 84, 106, *107*, 173, 210

King's College Chapel, Cambridge 59, 72, 105–6, 179, 210

Magdalene College Chapel, Cambridge 209, *Plate 28*

Peterborough Cathedral 78, *Plate 9*

Peterhouse College Chapel, Cambridge 98

Robinson College Chapel, Cambridge 151, 210

St Andrew, Girton 59

St Andrew, Soham 116, 130, 131, 167–8, 211

St Bartholomew, Gransden 28

St George, Thriplow 85

St John the Baptist, Peterborough 140, 149, 181, 188, 211, *Plate 9*, *Plate 25*

St Mary, Burwell 83

St Mary, Hardwick 72

St Mary, Swaffham Prior 27, 34, 109, 211

St Mary Magdalene, Ickleton 69

St Mary the Virgin, Haddenham 34

St Peter, Babraham 37

**CHESHIRE** 144

Chester Cathedral 49

St Boniface, Bunbury 191

St Chad, Farndon 62

St Mary, Nantwich 115

**CITY OF LONDON** 67, 144

Dutch Church, Austin Friars 55, 72, 114

St Andrew Holborn 140

St Edmund the King and Martyr (London Centre for Spirituality) 156–7

St Katherine Cree 26, *Plate 31*

St Lawrence Jewry 21, *39*, 40, 43, 48, *94*, 96, 160, 165

St Magnus the Martyr 103, 111

St Margaret Lothbury 65

St Mary Abchurch 65

St Mary Aldermary 69

St Mary-le-Bow 103, 210

St Michael, Cornhill *Plate 29*

St Michael Paternoster Royal 24, 30, 62, 157, 203, *Plate 25*

St Nicholas Cole Abbey 123

St Sepulchre 9, 21–2, 46, 59, 158, 184, 196, 210, *Plate 21*

St Vedast-alias-Foster 46

**CORNWALL**

St Credan, Sancreed 84

St Neot, St Neot 25, 63

**CUMBRIA** 144

Holy Trinity, Brathay 157

St Cuthbert, Aldingham, Ulverston 119–20

St Michael and All Angels, Bootle 52

# Index of Churches

**DERBYSHIRE**

Immaculate Conception RC Church,
    Spinkhill 124
St Anne, Buxton 52
St John the Baptist, Dronfield 197–8
St Lawrence, Whitwell 197
St Mary, Tissington 25
St Mary, Wirksworth *14*, 15, 35, 51, 148,
    193, 211, *Plate 12*
St Mary and All Saints, Chesterfield 95, 98
St Michael and All Angels, Hathersage
    36, 110
St Oswald, Ashbourne 162

**DEVON**

All Saints, Culmstock 167
Buckfast Abbey 13
Exeter Cathedral 40, 49, 71
St John the Baptist, Sampford Peverell 79
St Mary Magdalene, Chulmleigh 168,
    170
St Peter, Budleigh Salterton 38

**DORSET**

St Giles, Wimborne St Giles 163
St Mary, Iwerne Minster 84, *Plate 23*
St Mary, Sturminster Newton 29, 75,
    115, *126*, 135, 162, 174, 182, 211,
    *Plate 19*

**DURHAM**

Durham Cathedral 49, 64–5, 80, 124,
    130, 179
Holy Trinity, Darlington 178
St Cuthbert, Darlington 178

**EAST RIDING OF YORKSHIRE**

Beverley Minster 105
Hull Minster 20, 46, 90

St Edith, Bishop Wilton 208
St Mary, Beverley 197

**EAST SUSSEX**

St Clement, Hastings 98, 203
St John the Evangelist, St Leonard's-on-
    Sea 122, 211, *Plate 16*
St Margaret of Antioch, Isfield 51
St Mary, Rye 52, 64
St Mary the Virgin, Battle 18
St Mary the Virgin, Willingdon *Plate 12*
St Thomas and St Richard, Winchelsea
    17, 211

**ESSEX**

All Saints, Messing 15
All Saints with St Peter, Maldon 41,
    *Plate 14*
Our Lady of Fatima RC, Harlow 211
St Margaret, Margaretting 92
St Mary, Maldon 130, 138, 209, *Plate 12*
St Mary the Virgin, Great Dunmow 93
St Mary the Virgin, Little Bromley 164–5
St Michael, Kirby-le-Soken 29

**GLOUCESTERSHIRE** 145

All Saints, Turkdean 158
Cheltenham College Chapel 102
Gloucester Cathedral 23–4, 33, 49, 75,
    88, 102, 130, 199, 211, *Plate 7*
Holy Trinity, Slad 64
St Catharine RC, Chipping Camden 30,
    75
St James, Chipping Campden 86
St John the Baptist, Cirencester 141, 207,
    210, *Plate 5*, *Plate 10*
St Mary, Deerhurst 158
St Mary, Fairford 19, 51, 66, 72, 76, 79,
    80, 86, 106, 107–8, 159, 162, 164,
    211, *Plate 15*
St Mary, Kempsford 84

St Mary Magdalene, Rodborough 191
St Peter, Dumbleton 52

**GREATER LONDON**

All Saints, Benhilton 116
Holy Cross, Hornchurch 138
Royal Air Force Chapel, Biggin Hill 18,
    77, 112
St Mark, Surbiton 156
St Mary Magdalene, Enfield 138
St Matthew, Surbiton 84, *Plate 25*

**GREATER MANCHESTER**

Manchester Airport 57
Manchester Cathedral 12, 40, 49, 195,
    197, 211
St Ann, Manchester 74, 127, *Plate 20*
St Mary, Oldham 77

**HAMPSHIRE**

St Martin, East Woodhay 52
St Mary, Selborne 37, 136
Winchester Cathedral 32–3, 59, 67, 84,
    88, 98, 118, 148, 211, *Plate 22*

**HEREFORDSHIRE** 145

All Saints, Brockhampton 62
All Saints, Hereford 26, 51, 53, 185, 191,
    *Plate 32*
Hereford Cathedral 113, 130
St Michael and All Angels, Ledbury
    102, 161
St Peter and St Paul, Weobley 29

**HERTFORDSHIRE**

St Catherine, Sacombe 207–8
St Etheldreda, Hatfield 107, 161
St Lawrence, Abbots Langley 34, 109
St Mary, Welwyn 35

St Mary the Virgin, Clothall 153
St Matthew, Oxhey 52
St Nicholas, Harpenden 30

**KENT**

All Saints, Tudeley 12, 54, 72, 113, 149,
    189, 211
Canterbury Cathedral 32, 33, 45, 49, 69,
    73–4, 75, 146, 167, 175, 179, 197,
    201–2, 209
Holy Trinity, Sissinghurst 55
St Nicholas, Barfrestone 106
St Paulinus, Crayford 20, *81*, 83, 210,
    *Plate 18*
St Peter and St Paul, Edenbridge 130

**LANCASHIRE** 144

Blackburn Cathedral 89, *Plate 21*
St Stephen on the Cliff, Blackpool 176

**LEICESTERSHIRE**

All Saints, Cadeby 191
Leicester Cathedral 49, 59
St James, Twycross 92
St Mary, Barwell 163

**LINCOLNSHIRE**

All Saints, Branston *11*, 123
All Saints, Walesby 119, 203
Grimsby Minster 20, 166, 196
Lincoln Cathedral 25, 42, 49, 110, 153,
    165, 188
St Denys, North Killingholme 28
St Mary, Welton 27
St Mary and St Nicolas, Spalding 84,
    146, 184, 211, *Plate 15*
St Matthew, Skegness 83
St Vincent, Caythorpe 28
St Wulfram, Grantham 85, 187

# Index of Churches

## LONDON

All Saints, Fulham 107
All Saints Margaret Street 20, 211
Angel in the Fields (pub), Marylebone
    High Street 85
Christ Church, Southwark 31, 43, 48, 65,
    101, 166, 174, 181, 184, 189–90
Christ Church and Upton Chapel,
    Lambeth North 120
Holy Trinity, Sloane Square 20, 211
King's College Chapel 167
Lincoln's Inn Chapel 69, 72, 77, 104, 211
Morden Station 192
Queen's Chapel of the Savoy 61, 167,
    194–5
Royal Academy of Music 91
Royal London Hospital Medical Library
    72, 124
St Cyprian, Clarence Gate 69
St Dunstan and All Saints, Stepney 40–1,
    Plate 15
St Dunstan-in-the-West, Fleet Street 80,
    159
St Etheldreda, Ely Place 80, 123, 211
St James, Paddington 41, 68–9, 165, 181,
    191, 202, Plate 15, Plate 29
St John, Hoxton 2–3, 131, 172
St Margaret, Westminster 151
St Mark, Clerkenwell 65
St Martin, Kensal Rise 163
St Mary, Battersea 165
St Mary, Isleworth 47
St Mary, Putney 55, 73, 208
St Mary, Stoke Newington 164, Plate 30
St Mary Magdalene, Munster Square
    186, 189
St Mary The Boltons, Kensington 183
St Marylebone Parish Church 88–9
St Paul, Brentford 178, Plate 21
St Peter, Vere Street 93
Sanderson Hotel 151
Southwark Cathedral 48, 69
Uxbridge Station 192
Victoria and Albert Museum 211
Waterloo Station 192
Westminster Abbey 18, 49, 77–8, 89, 98
see also City of London; Greater London

## MANCHESTER

see Greater Manchester

## MERSEYSIDE

Christ Church, Port Sunlight 75
Holy Trinity, Southport 91, 98, 136,
    Plate 9
Liverpool Anglican Cathedral 50
Liverpool Metropolitan Cathedral 13,
    50, 58, 151, 183, 211
St George, Everton 64, 179
St Oswald, Bidston 52

## NORFOLK

King's Lynn Minster 29
Norwich Cathedral 44, 49, 71
St Edmund, Emneth 191
St Lawrence, Harpley 198
St Mary, Gressenhall 209
St Mary, Gunthorpe 107
St Mary the Virgin, Hemsby 120
St Mary Magdalene, Mulbarton 133
St Mary Magdalene, Sandringham 159
St Nicholas, Blakeney 43
St Peter, Clippesby 26
St Peter and St Paul, East Harling 51, 100
St Peter and St Paul, Edgefield 193
St Peter and St Paul, Fakenham 133–4, 176

## NORTH YORKSHIRE

All Saints, North Street, York 14–15,
    33, 51, 76, 77, 155, 208, 211, Plate 12,
    Plate 13
All Saints Pavement, York 59
Ampleforth Abbey 108

Guildhall, York 81
Holy Trinity, Goodramgate, York 88
St Botolph, Carlton-in-Cleveland 52
St Denys, York 33, 63, 88, 157
St Edward the Confessor, York 29
St Helen, Denton 83, 176
St Helen, Skipwith 202
St Margaret of Antioch, Hawes 120, 191
St Martin-le-Grand, York 40, 187
St Mary, Castlegate, York 77
St Mary, Kettlewell 184
St Mary, Muker 84
St Mary, West Lutton 93
St Mary Magdalene, Yarm 97
St Michael, Spurriergate, York 88, 115
St Nicholas, Guisborough 180, 181, 184
St Peter, Harrogate 146, *195*
St Peter and St Paul, Stainton-in-
    Cleveland 196
St Thomas, Scotton 130
York Minster 20, 33, 49, 69, 74, 75, 77,
    88, 95, 97, 112, 134, 153, 157, 198

NORTHAMPTONSHIRE

All Hallows, Wellingborough 25, 151,
    163, 211
Holy Trinity, Blatherwycke 14
Oundle School Chapel 55, 112, 124, 130,
    150, 211
St Bartholomew, Greens Norton 61
St Katharine, Irchester 95
St Mary the Virgin, Wellingborough 62, 69
St Nicholas, Potterspury 72, 98, 116,
    119, 126, 130, 143, 184, 211, *Plate 4*,
    *Plate 5*, *Plate 27*
St Peter, Oundle 106
St Peter, Raunds 118, 163

NORTHUMBERLAND

St Aidan, Bamburgh 133
St John the Evangelist, Otterburn 133
St Mary the Virgin, Ovingham 85

St Maurice, Ellingham 34
St Nicholas, Cramlington 178
St Oswin, Wylam 85

NOTTINGHAMSHIRE

St Helena, West Leake 34
St Mary Magdalene, Newark 89
St Mary the Virgin, Clumber Park 59
St Mary the Virgin, Nottingham 138, 202–3
Southwell Minster 172

OXFORDSHIRE

Christ Church Cathedral, Oxford 50, 61,
    89, 105, 160, 211
Lincoln College Chapel, Oxford 77, 83,
    97, 205
Merton College Chapel, Oxford 63–4, 153
New College Chapel, Oxford 69, 74, 97,
    115, 137
Nuffield College Chapel, Oxford 151
Pishill Church, Pishill 151
Queen's College, Oxford 79
St Bartholomew, Nettlebed 36, 113, 151
St Giles, Oxford 208
St James the Great, Burford 100
St James the Great, Stonesfield 103
St John the Baptist, Burford 42, 161, 188
St John the Evangelist, Cowley 69
St John's College Chapel, Oxford 75, 103
St Kenelm, Minster Lovell 198
St Martin Sandford, St Martin 151, 161
St Mary, Banbury 87, 108, *169*, 184, 210
St Mary the Virgin, Chipping Norton
    165–6
St Mary the Virgin, Buckland 201
St Michael at the North Gate, Oxford 83
St Peter, Wolvercote 151
St Peter's College Chapel, Oxford 75, 193
University College Chapel, Oxford 23,
    98, 172, 180, 184, 205, 208, 211, *Plate 7*
Wadham College Chapel, Oxford 74, 77,
    100, 115, 205, 208, *Plate 8*, *Plate 27*